THE BUS

Also by Daniel Meadows

LIVING LIKE THIS

NATTERING IN PARADISE

SET PIECES − BEING ABOUT MOVIE STILLS MOSTLY

NATIONAL PORTRAITS

DANIEL MEADOWS

THE BUS

The Free Photographic Omnibus

1973–2001

AN ADVENTURE IN DOCUMENTARY

THE HARVILL PRESS

LONDON

First published in 2001 by
The Harvill Press
2 Aztec Row, Berners Road
London N1 0PW

www.harvill.com

1 3 5 7 9 8 6 4 2

A CIP catalogue record for this title is
available from the British Library

ISBN 1 86046 842 X

Designed and typeset in Minion at
Libanus Press, Marlborough, Wiltshire

Printed and bound in Italy by Graphicom srl, Vicenza

JRR 404

Leyland Titan PD1 with Duple coachwork.
Manufactured in 1948.
Commissioned and operated by
Barton Transport of Chilwell, Nottingham.
Engine: Leyland E181, 7.4 litre 6 cylinder diesel,
100 bhp at 1,800 rpm; bore: 111 mm; stroke: 127 mm.
Weight: 7 tons 15 cwt.
Chassis no. 470111.
Length: 26ft.
Width: 7ft 6in.
Height: low bridge 13ft 6in.
55-seater.
Front entrance.

To my wife
Georgie

CONTENTS

The Pictures 2

PART ONE

Beginnings 43

The Great Ordinary Show 43

Revival 47

Documentary: A Brief Lecture 53

Bad Habits 55

Twin Lens Reflex 62

Meadows Acres 63

The God Belling 68

Flat Feet 71

A Head 72

The Enemy 73

Or to Put it Another Way . . . 74

Tony Ray-Jones 75

How to Become a Photographer 76

Begging Letter, 12 May 1973 77

Logic and Lorries 79

Dazed & Confused 81

Play Power 81

Isle of Wight Festival, 1970 83

Journal of the Free Photographic
 Omnibus, 1 December 1973 85

On the Road 86

Journal of the Free Photographic
 Omnibus, 1 October 1973 87

Journal of the Free Photographic
 Omnibus, 2 October 1973 88

Running the Free Studio 88

Strange Company 91

Winter of Discontent 91

Breakdown 93

Journal of the Free Photographic
 Omnibus, 1 March 1974 94

The Telly 94

Journal of the Free Photographic
 Omnibus, 3 May 1973 95

Journal of the Free Photographic
 Omnibus, 26 Oct 1973 95

Journal of the Free Photographic
 Omnibus, 27 Oct 1973 96

The Edge of Sharpness 97

Living Like This 100

White Album 104

PART TWO

I: BARROW-IN-FURNESS 109

Twins 111

Boot Boys 112

Two Christines 120

I'll Still Love Him if He Fails 122

Physog 124

Where's Dot? 126

Punctum 127

A Lesson in Looking 129

II: HARTLEPOOL 133

Journal of the Free Photographic
 Omnibus, 24 September 1974 135

The Bollard Calypso 135

Get Carter 139

The Way We Were 140

Monkey Hangers 147

Two Fat Girls Get It 149

Journal of the Free Photographic
 Omnibus, 25 September 1974 150

It Doesn't Have to Be Like That 150

III: SOUTHAMPTON 157

One of England's Heroes 159

Sniff This 163

Most People Go for Sunsets 168

Bruce Springsteen and Neil Young 169

The King of Gibraltar 176

Cover Girls 185

Confloption 192

PART THREE:
GATHERING COINCIDENCE

Planet Waves 199

Lilliput 199

The Only Plumber in Walton Gaol 204

The People Have Got Clean Hands 208

I Always Loved Pearls 218

EPILOGUE

The Bus Snapped Its Crank 229

Daddy of This Job 230

Notes 233

APPENDIX

Ten Thousand Miles 239

Acknowledgements 243

THE BUS

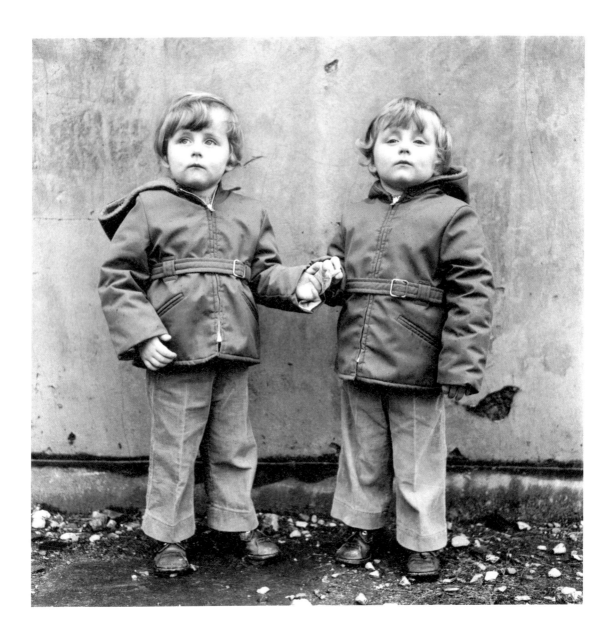

2

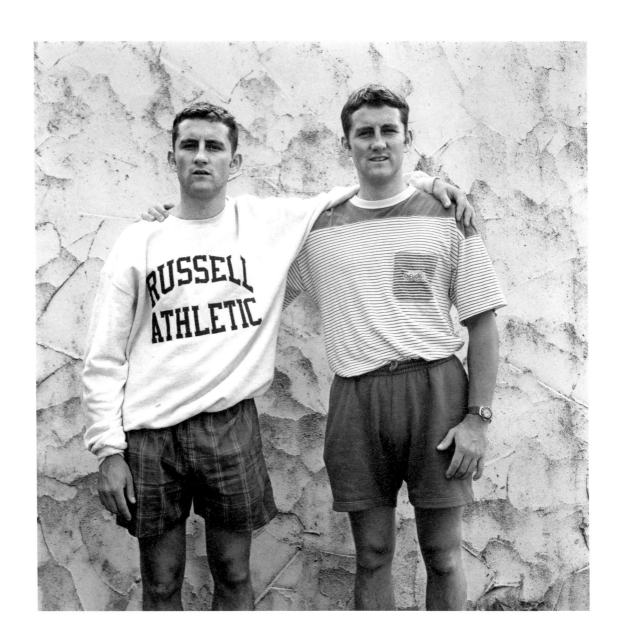

3

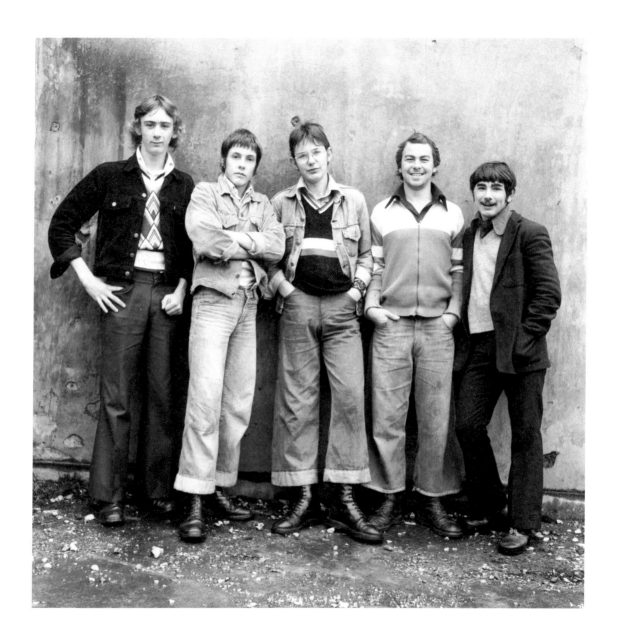

4

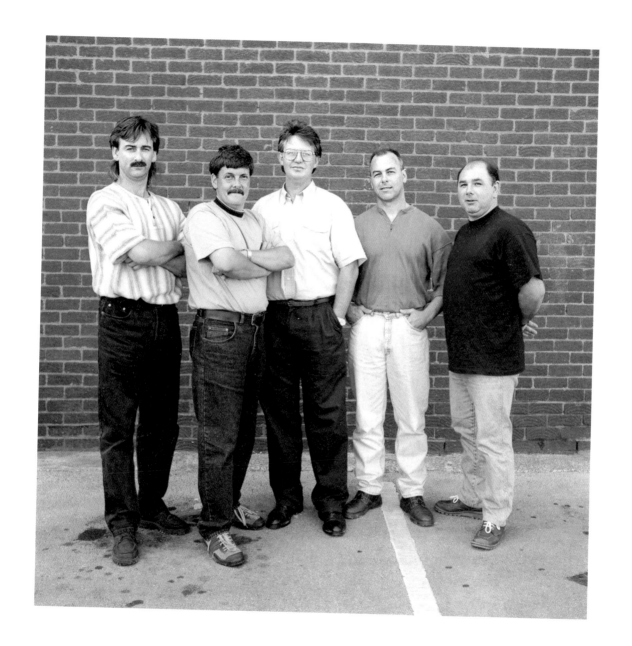

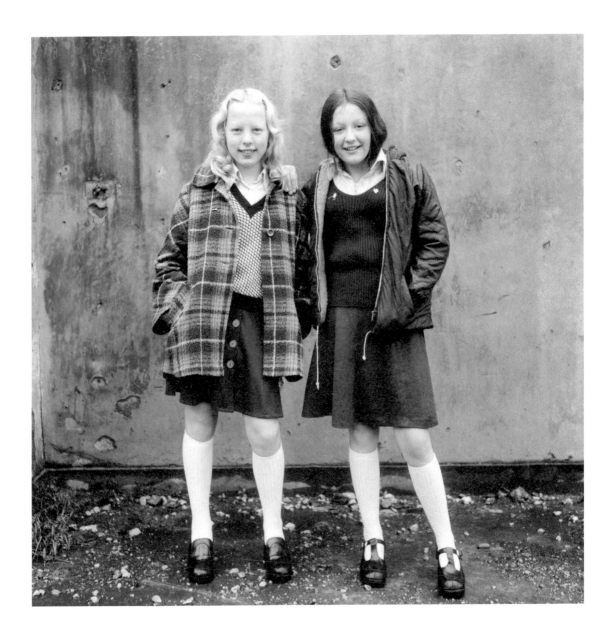

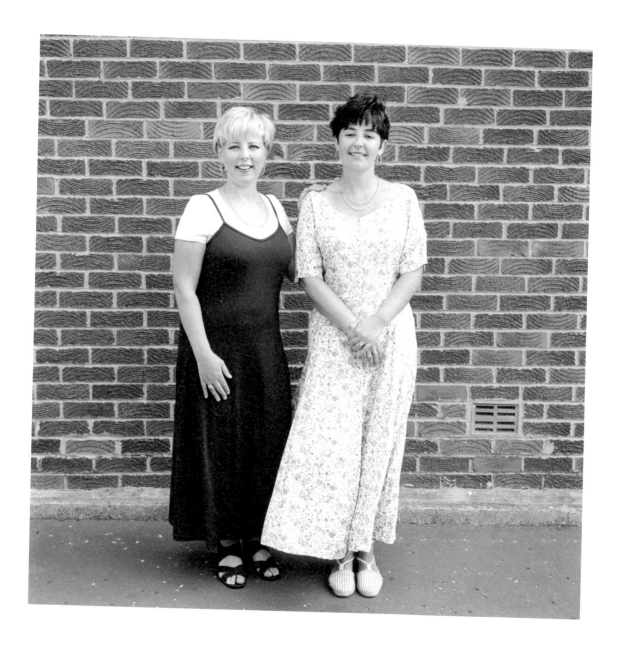

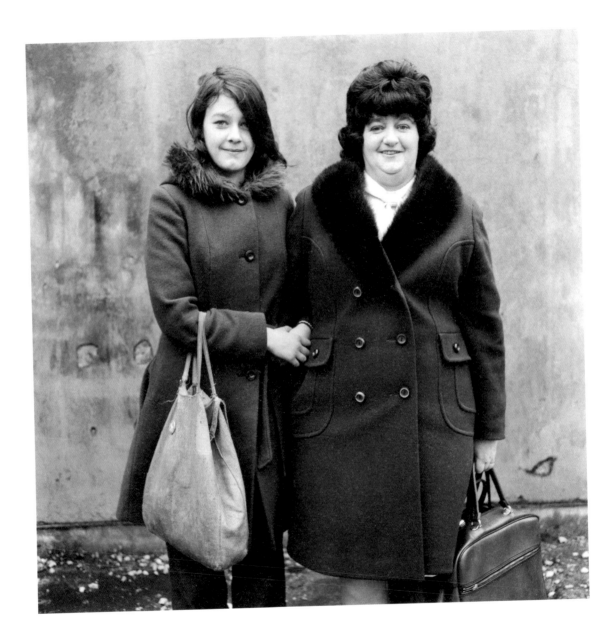

8

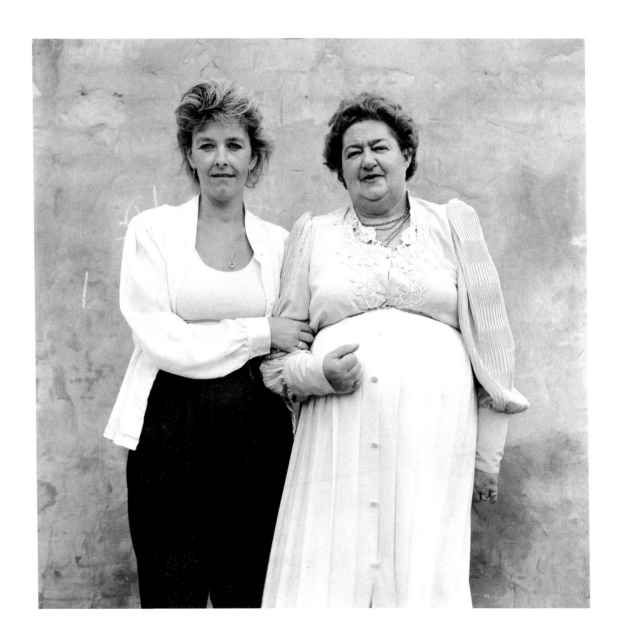

9

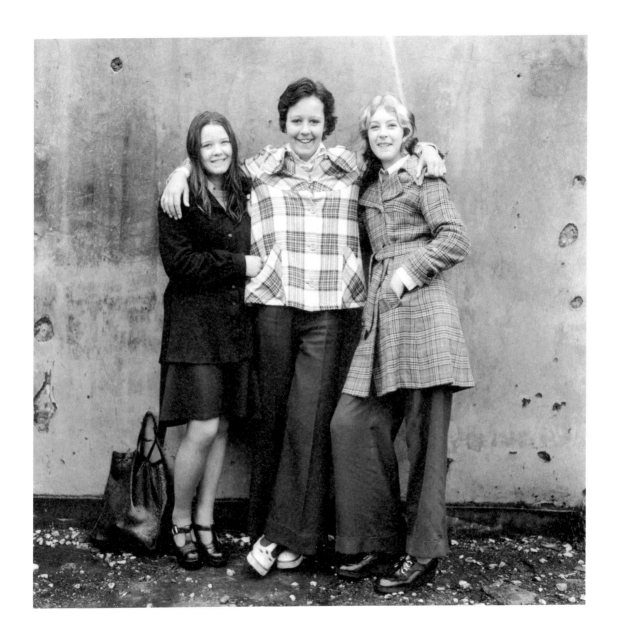

10

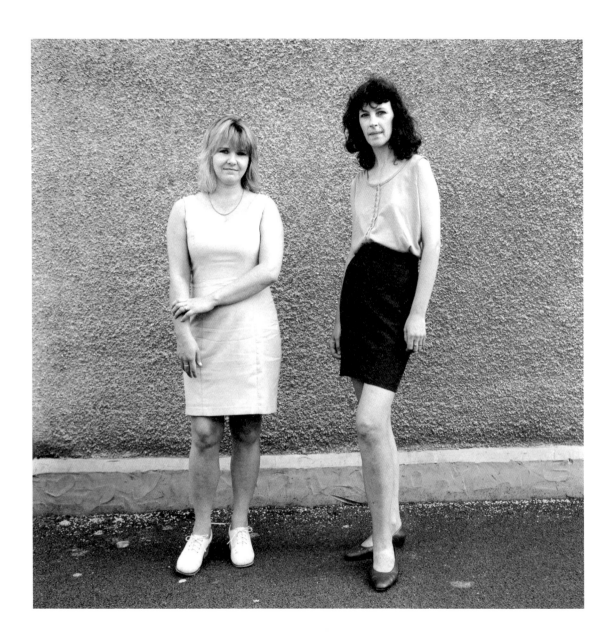

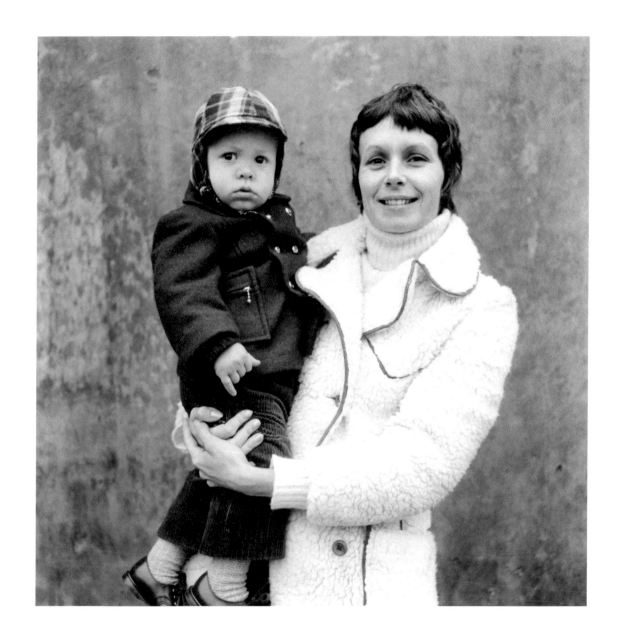

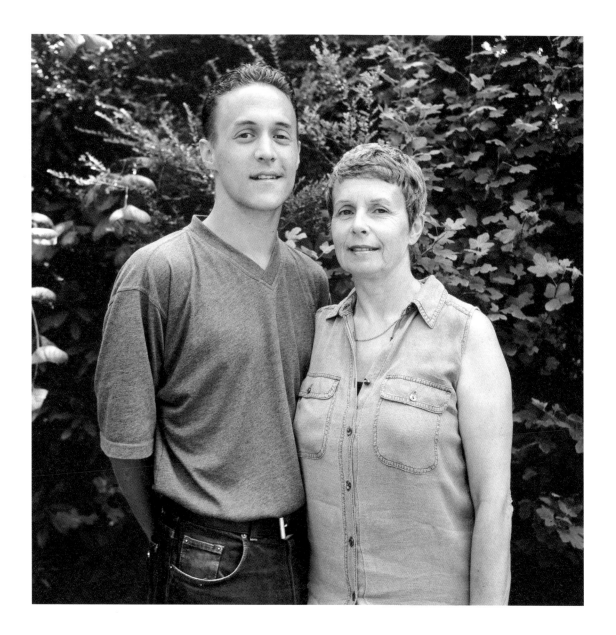

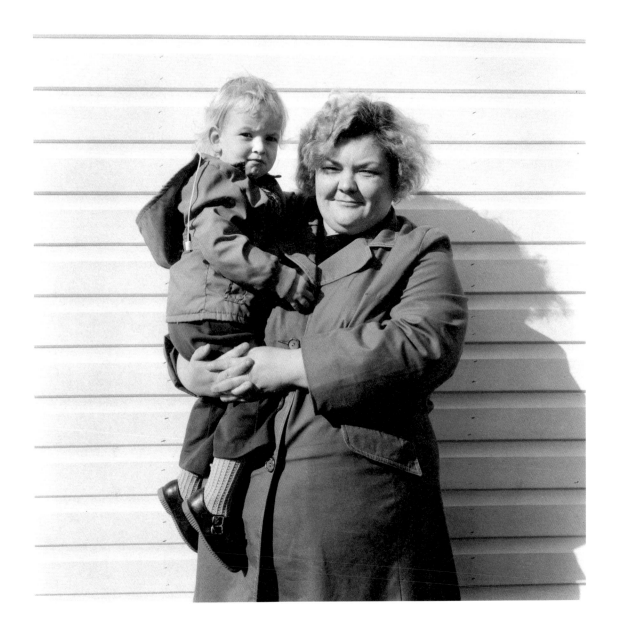

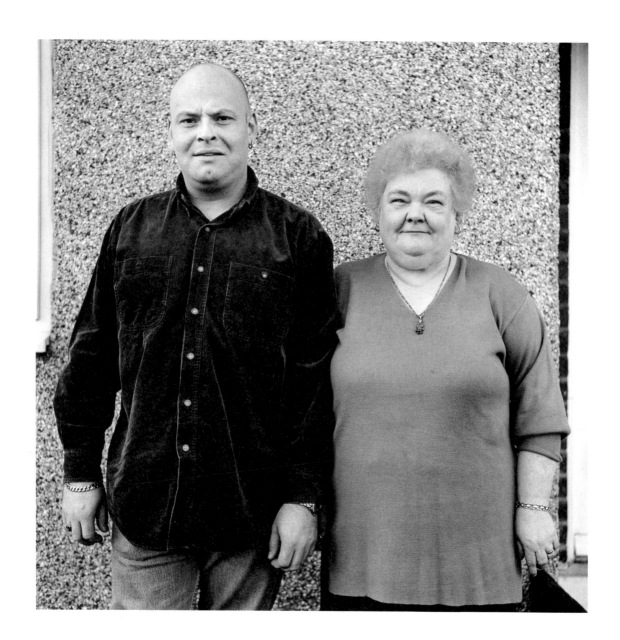

15

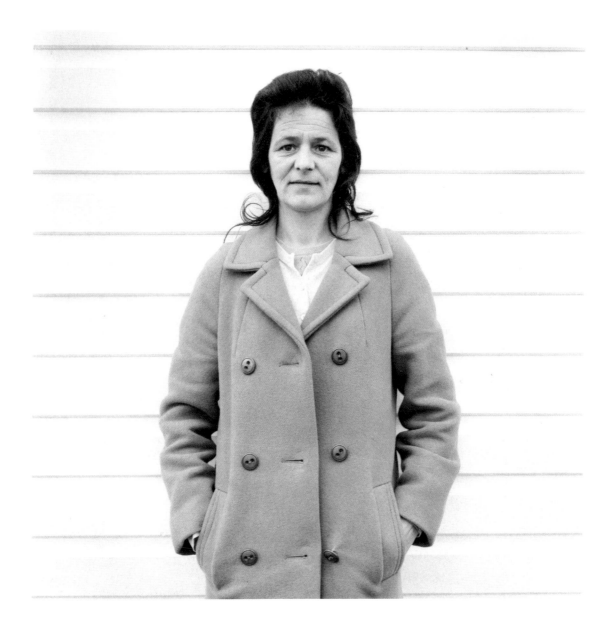

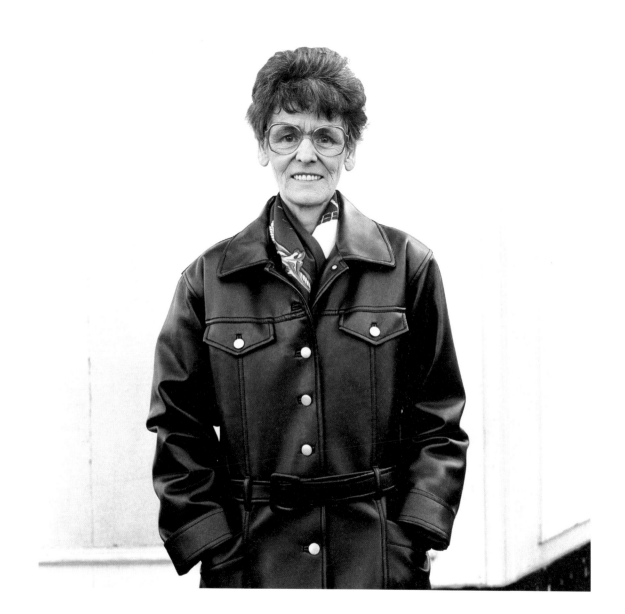

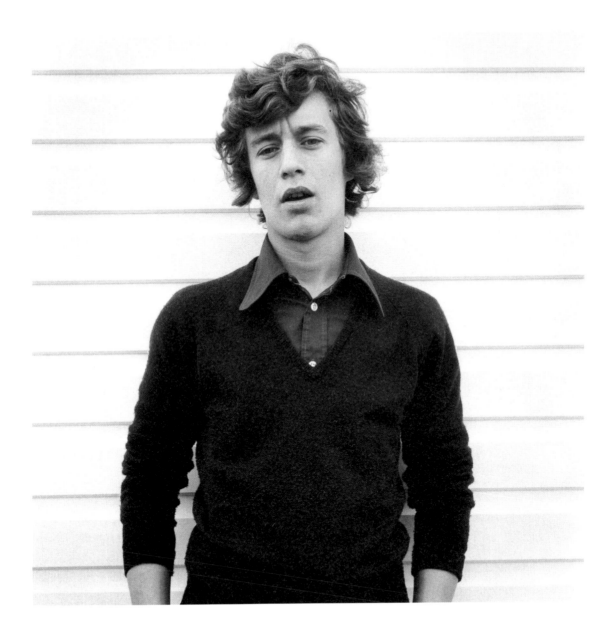

18

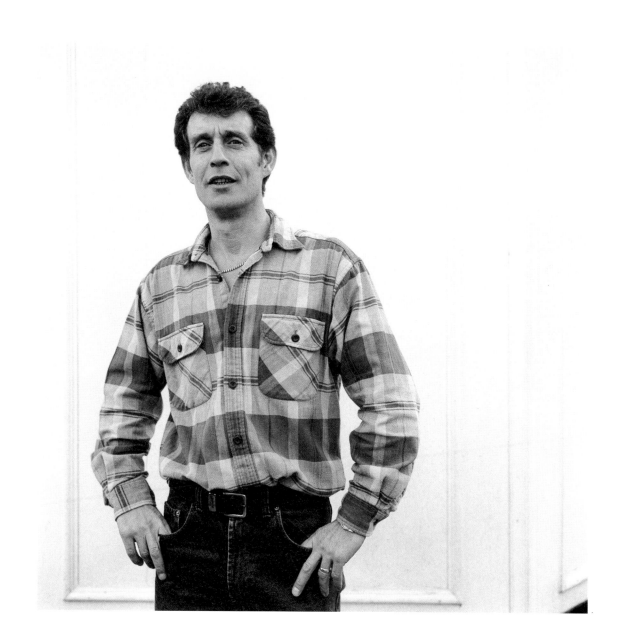

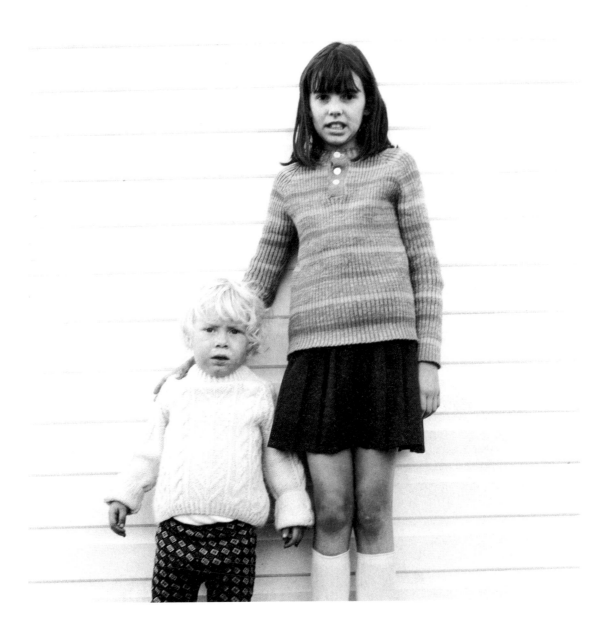

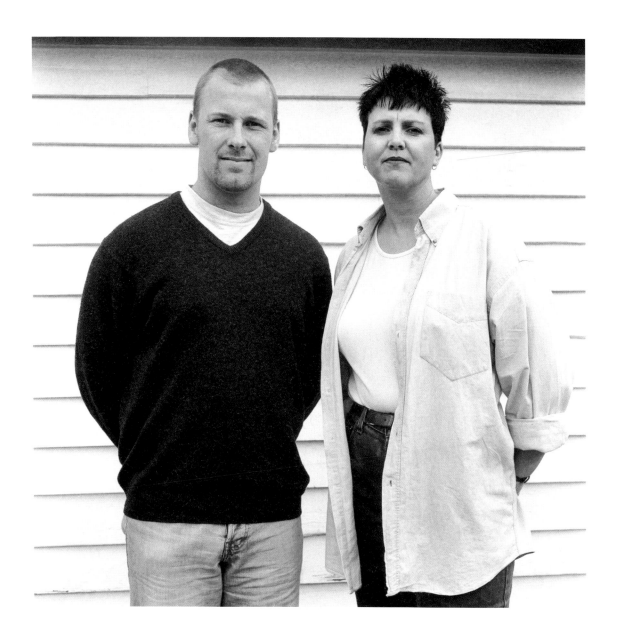

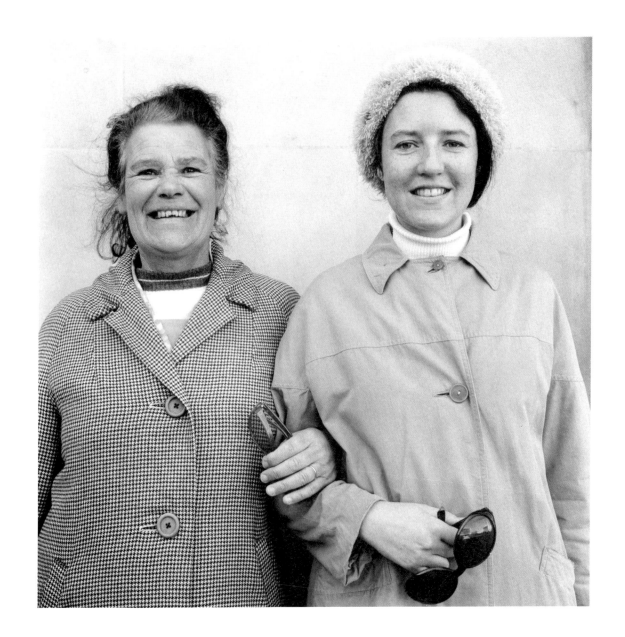

22

26

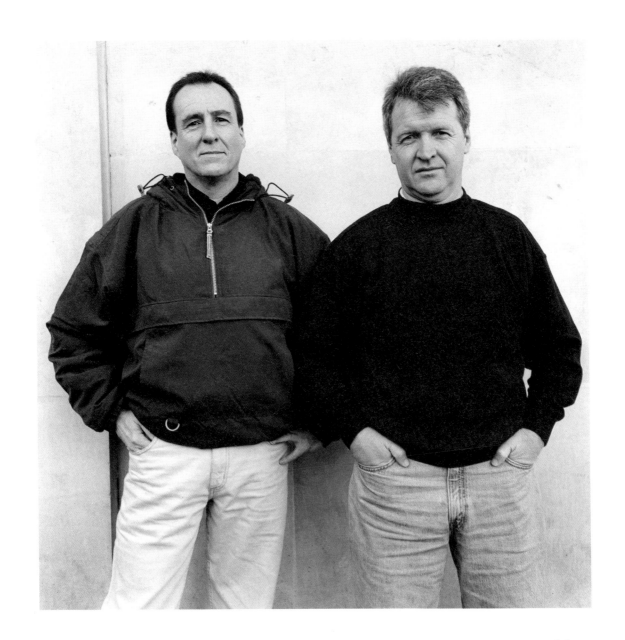

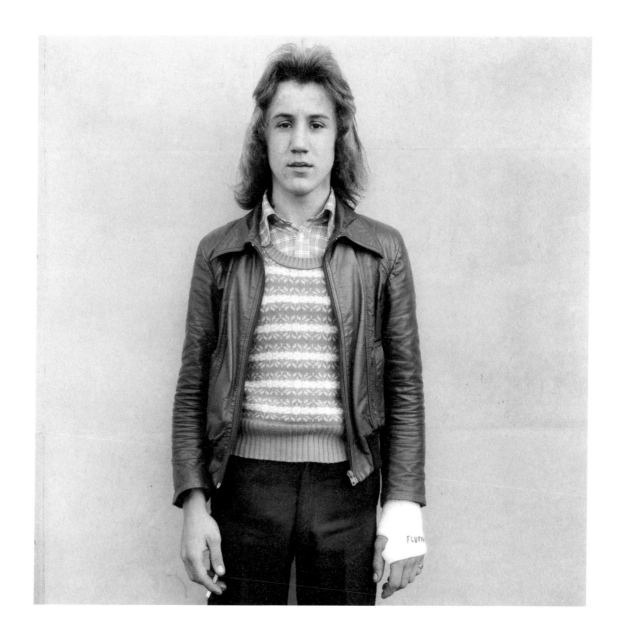

28

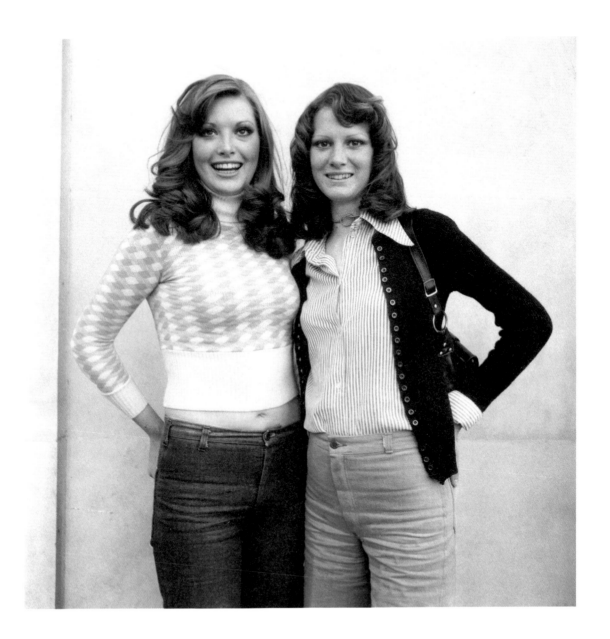

30

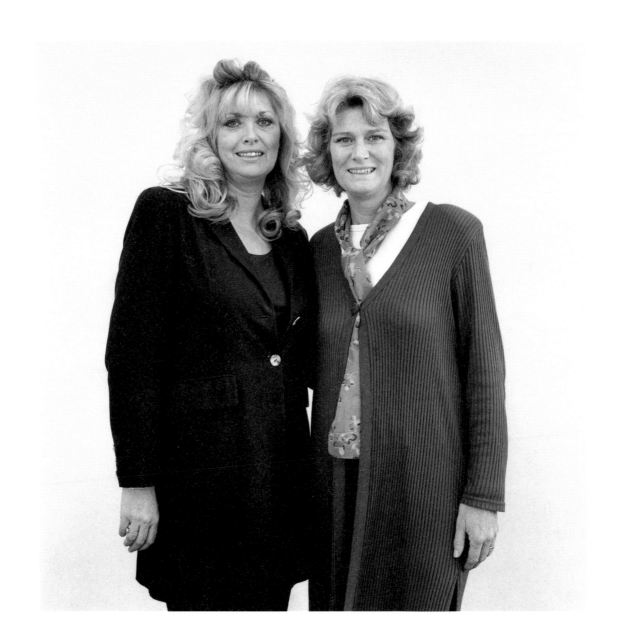

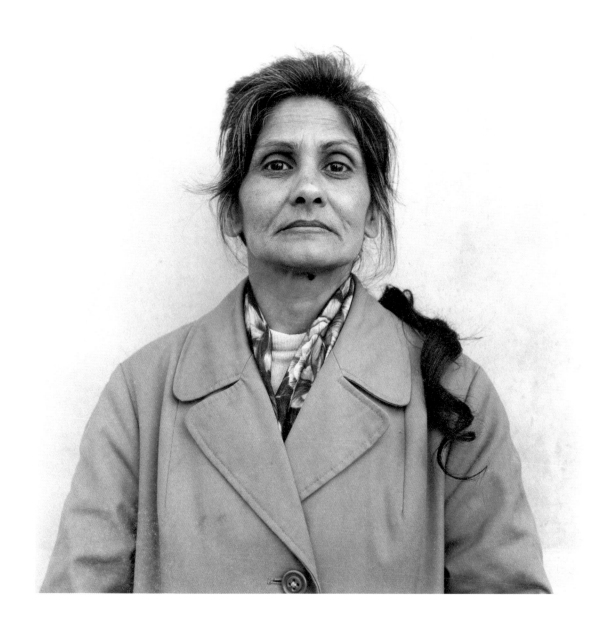

3 2

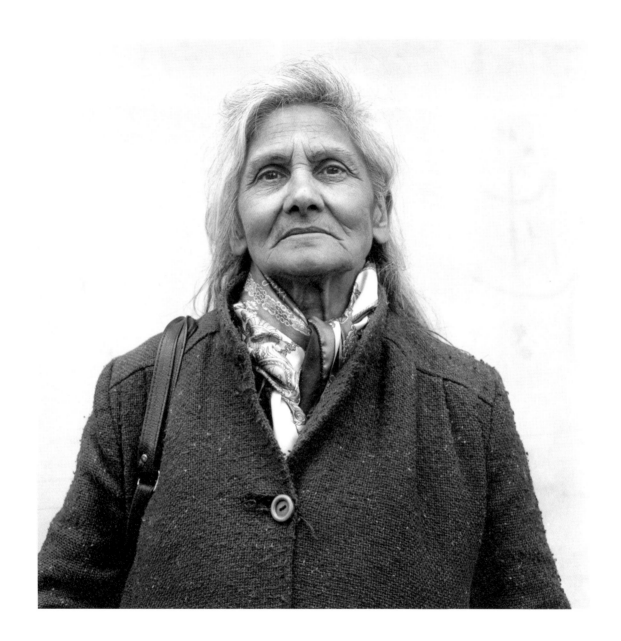

34

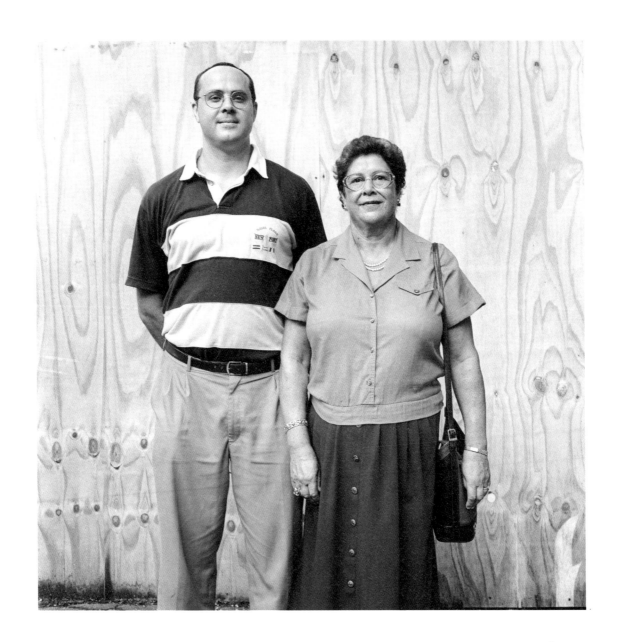

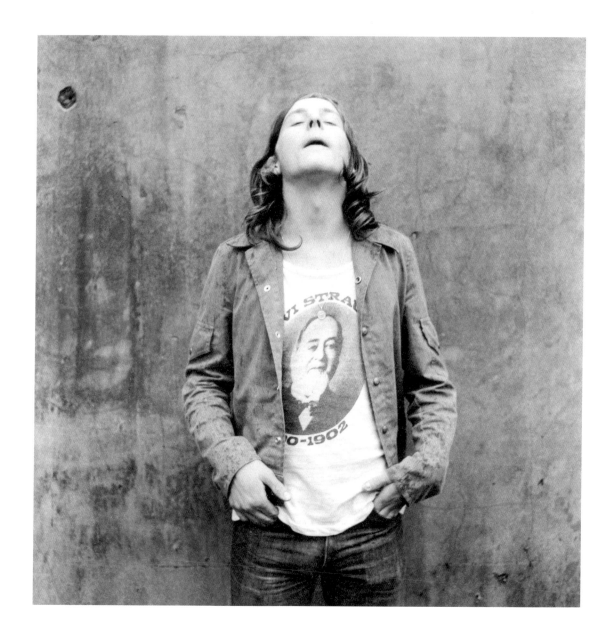

36

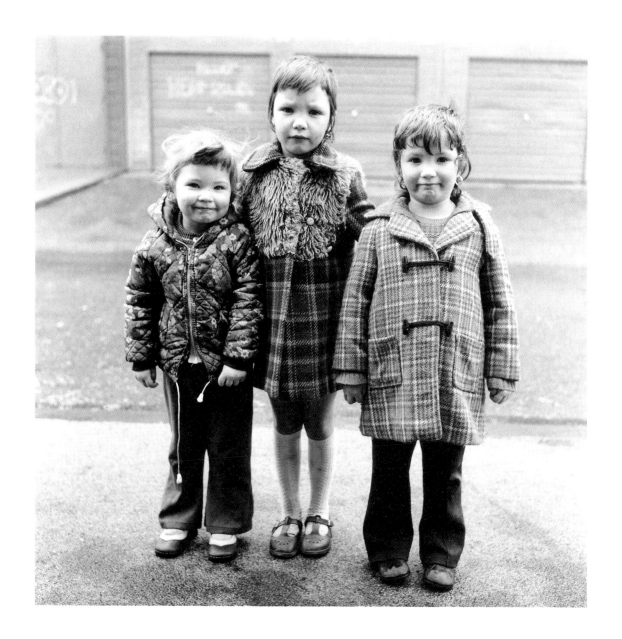

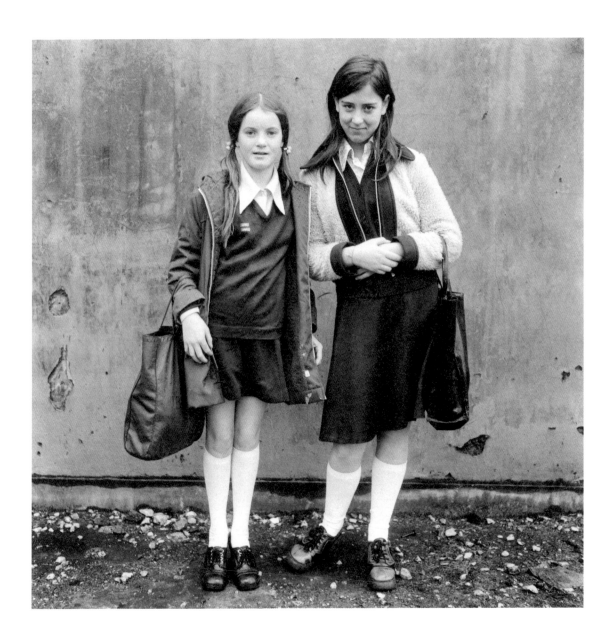

38

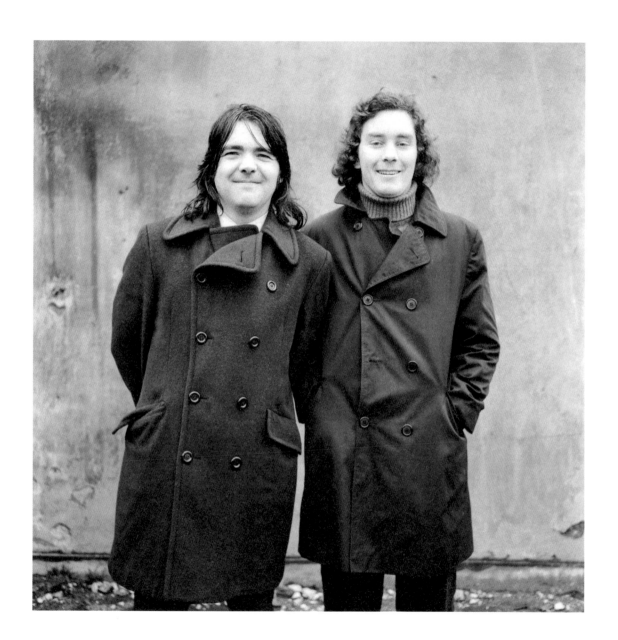

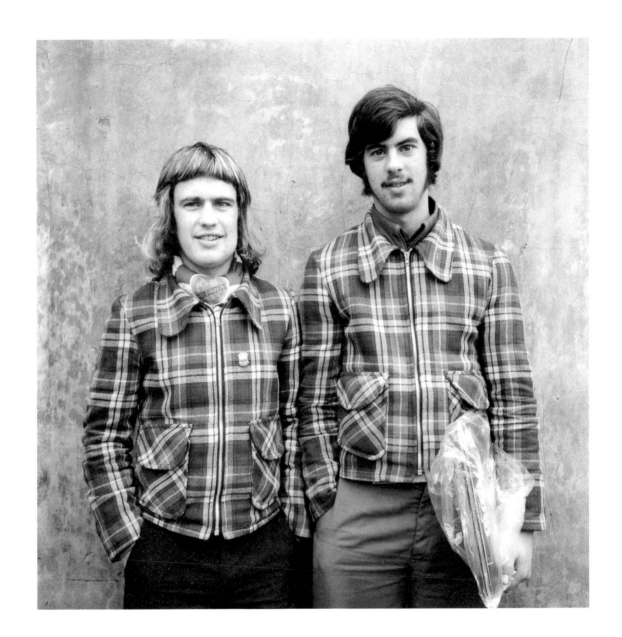

40

PART ONE

Beginnings

In 1973 all my hopes were invested in a bus. I wanted it – no, I expected it – to make a difference.

The Free Photographic Omnibus was (and continues to be) an adventure in documentary photography that I began in 1973 when I was 21 years old and living in Manchester. For three years I had studied photography at the art college of the polytechnic, now Manchester Metropolitan University.

As a photographer my principal subject matter was – and remains – the English people. I'm not interested in celebrities, just ordinary folk. In 1973 I was an incipient hippie, contemptuous of "straight" society. Like many of my generation I grew my hair long and wore my bell-bottoms wide. I wanted to explore "alternative" ways of living. I genuinely believed that by doing so I might be able to help change the world.

The Great Ordinary Show

There were a lot of buses about in the 1960s. The Who sang about a "Magic Bus" ("Too much, Magic Bus!").[1] Ken Kesey, author of *One Flew Over the Cuckoo's Nest*, drove across America with his gang of Merry Pranksters in a school bus with DESTINATION FURTHUR (*sic*) written on it, playing Bob Dylan from speakers mounted on the roof

and encouraging people to take LSD – an idea subsequently ripped off by The Beatles who went on a tacky Magical Mystery Tour of their own.

Far and away the best bus trip of the 1960s was the film *Summer Holiday*[2] (I saw it at the Essoldo cinema in Evesham when I was eleven), in which Cliff Richard as Don the London Transport bus driver travelled across Europe with Una Stubbs and The Shadows in a double-decker they had converted themselves.

Did this film, as Ray Harris has suggested, kick-start British youth culture?

Dear Cliff Richard,

Can bus journeys change the world? When you and The Shadows and Una Stubbs set off back in the 'sixties on your *Summer Holiday*, you set more than a double-decker in motion.

Summer Holiday was not just a film, it was also an allegory – one so powerful it entered deep into the psyche of a nation's youth, spawning a culture that has grown to threaten the very fabric of society. Never mind *Clockwork Orange*, you and your *Summer Holiday* have a lot to answer for.

What was your message to the youth of a golden era of economic expansion? What did you say to Una and the "Shads" that was an abreaction for change? You said: "Hey, you guys, we're gonna run our own show now." The message couldn't be clearer. We, the youth of this country, without parental permission, are taking control of our own lives, taking control of the double-decker bus, and going off to have a good time. And instead of ending up with a good clip round the ear from the local bobby, you did, in fact, have a good time and get away with it. Never mind *Catcher in the Rye*, where were the censor's scissors when *Summer Holiday* was released? It was subversion in bus conductor's clothing.[3]

My Free Photographic Omnibus was dedicated to valuing ordinary people, treating them as individuals not as types. Dylan sang that he did not want to "analyse, categorise, finalise or advertise" the girl in his song "All I Really Want To Do". And that was what

I wanted for the passengers on my bus. They would be self-selecting, never categorised or pegged-out in some ethnographer's glass case, never compared against the entries in a lexicon of social anthropology, not (at the time) even named. But they were treasured. When it came to deciding who to photograph I rejected traditional methods of journalistic research and chose to "take what I could gather from coincidence". Dylan had it right.

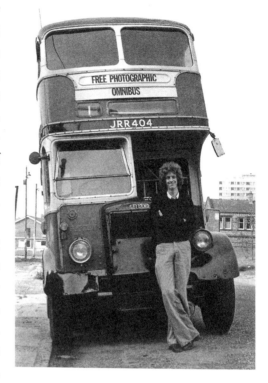

I bought my 1948 double-decker for £360.20, a Leyland Titan PD1. It was to be the only 55-seater ever to carry 958 passengers. I financed the project with £3,500. That's about £23,000 in today's money. It was raised through sponsorship from industry, personal donations and, in time, two grants from the Arts Council of Great Britain. The journey started in York on 22 September 1973 and ended, 10,000 miles later, in Barrow-in-Furness on 2 November 1974.

Casting my net wide, I developed a strategy that relied on the offer of a free portrait. I hoped that, having had their picture taken, people would then invite me into their homes, or their places of work or leisure, where I could make important works of photo-reportage that would eventually form my grand statement. And while I was out making photographs, the bus would still work for me because I could display the pictures I had made in its windows. It was to be a gallery space as well as a mobile home and darkroom.

The free bus portraits were to be both a present and a passport into other people's

lives. The fact that I made no charge for them would, I hoped, give the Free Photographic Omnibus some credibility as a "community art" project with those who sat on the committees of the regional arts associations from whom I sought funding.

That was the idea and, for the most part, it worked.

During the 14 months when I lived on the bus I ran free portrait sessions in 22 different locations, from Southampton in the south to Newcastle-upon-Tyne in the north, photographing 958 people.

Each evening I would develop the films in my makeshift darkroom and the subjects of these black and white prints would come by the bus to pick up their free portraits the next day. I displayed my pictures in the windows and was filmed for television and mentioned in the newspapers. The *Daily Mirror*, then Britain's biggest circulation newspaper, called it "The Great Ordinary Show."[4]

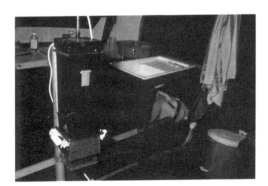

My darkroom, at the rear of the top-deck.

I liked that.

The irony of all this is that, although I did produce an exhibition and indeed a book in 1975 – both of them called *Living Like This*[5] – it is not the pictures that were published and exhibited then, the ones I considered to be my "serious work", that seem to have lasted. A quarter of a century after the event, the pictures that have enjoyed an astonishing revival – being exhibited, published and screened under the title *National Portraits* both in the UK and in Europe – are the free portraits, the ones I took only to give away.

What, in 1973, I considered to be the bait on my photographic hook turned out to be the big fish itself.

46

Revival

In the autumn of 1994, looking though the contact sheets in my archive, I came upon the bus portraits. They seemed fresh, even modern. I made some prints and left them lying around for the diversion of friends and visitors.

One such was Alan Dein, an oral historian then working for the National Sound Archive at the British Library. He had arrived to interview me for "Talking Photography" – a project directed by the critic, curator and writer Val Williams – after buying a dog-eared copy of *Living Like This* at a market stall in London's Brick Lane.

Val Williams was already aware of the Free Photographic Omnibus – indeed I had carried an advertisement for her first gallery, Impressions in York, on the back of the bus for some months back in 1973 – but she didn't know about the portraits. When she saw them she was so excited she was determined to mount a new exhibition.

She made an appointment for me at the National Portrait Gallery. It was not a fruitful meeting. The senior curator did not like the pictures. He operated a policy of only exhibiting photographs of "those who have achieved", and because the people represented in my pictures were "unknown", he refused to hang them. In the first flush of our enthusiasm we had forgotten that the National Portrait Gallery is the *Hello!* magazine of London's galleries.

Frustrated that the only national portrait of ordinary English people ever attempted by a solo photographer should be dismissed so casually, Williams renamed the project *National Portraits* and together we approached Simon Grennan of the Viewpoint Gallery, Salford. Excited by the work's appeal as a "flawed ethnography", he agreed to collaborate in raising the funds to mount a touring exhibition. This was eventually achieved with help from the bus's original sponsors, Royal & Sun Alliance Insurance, who contributed £6,000, and the Arts Council of England who awarded the project

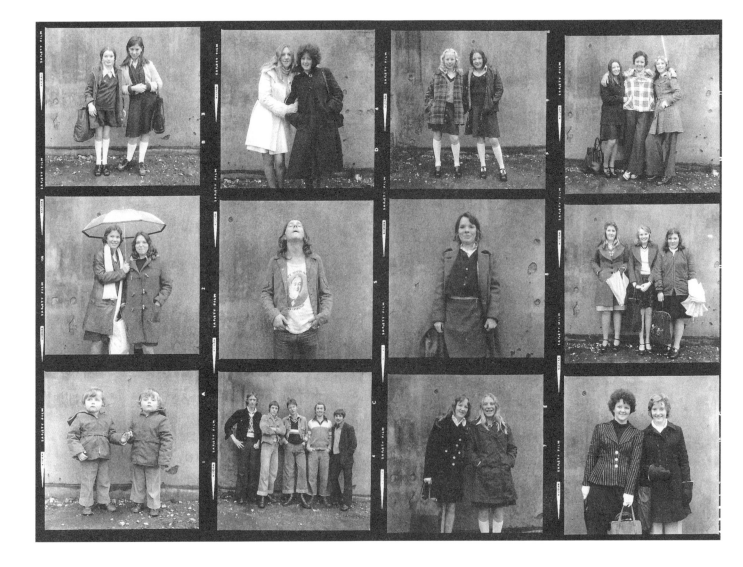

an £11,000 publication grant (in real terms £1,000 more than it awarded my 1970s journey) to produce a quality catalogue.

In February 1997, when the catalogue was published, the *Guardian Weekend* ran the bus portraits as its cover story along with an article by Val Williams. She wrote that my subjects

> stood against concrete walls which dripped and stained as the Welfare State began to totter and Margaret Thatcher bided her time.
>
> In these photographs, there is an aching melancholia; they could have been taken in another century, so little can we recognise of our contemporary world. They are like an anthropologist's record of a forgotten tribe, and there is very little in them that we can place in 'nineties England – a brand name here and there perhaps, and the familiar confrontational stare of youth; but these are only traces. All the teenagers we see in the photographs will be grown up now and the flared trousers, the rayon slacks and the platform heels dumped in the rubbish bin of history.
>
> Meadows often photographed people in pairs: adolescent girls marooned in temporary closeness, or boys full of nervous bravado as they cruised the town-centre of a Saturday afternoon, just waiting for something to happen. In the photos, their shyness is apparent, hands gripped, awkward in the soon worn-out fashions of the mid-seventies. No one performed for the camera in the way they might now, but it was theatre nonetheless, on both sides of the lens ...
>
> Meadows' criteria for photographing people was their ordinariness. When Robert Plant from Led Zeppelin climbed on the bus, Meadows took up his invitation for tea and a hot bath, but refused to photograph him because he wasn't "ordinary" enough. And his decision was probably the right one, for these photographs are a cross-section of a collective memory in which individuals become symbolic. If we dare to look closely enough, we can find ourselves in them – the fat solitary boy in the stripy jumper; the schoolgirls bound by a

friendship which should have lasted forever; the adolescent girls, energetic and distressed; the likely lads in the protective carapace of the teenage gang. Maybe we even remember the aloneness of being a baby in a grown-up world, having to stand still for the photographer.

After it was launched in April 1997 at the Viewpoint Gallery, the *National Portraits* exhibition toured the UK, eventually showing at the National Museum of Photography Film & Television in August 1997. It reached London in the spring of 1998 for the Shoreditch Biennale, the East London photography festival organised by Val Williams and Anna Fox and attended by enthusiasts, writers, curators and photographers from all over the UK as well as from the continent and North America.

When the portraits entered the public arena I began to worry and wonder about the people depicted in them. How would they feel about being "rediscovered"? What had happened in their lives? But how could I find them given that, for the most part, I had no addresses?

I decided to solicit the help of local newspapers in towns where I thought enough of a community might have survived for the pictures to jog a memory or two. I chose Barrow-in-Furness in Cumbria; Hartlepool in County Durham; and Southampton. The response was good and, in 1996, together with Alan Dein and the Radio 4 producer Mark Burman, I made a BBC documentary, *Living Like This*, in which we interviewed some of those who featured in the bus portraits. In due course – and inevitably I suppose – I began to re-photograph the people I found.

In the articles I had asked readers to telephone in if they recognised themselves, or anyone, in the pictures. It was hardly an exact science and it was painstaking work. It is one thing to identify people, but something else altogether to find them again or to persuade them to turn up at the same time on the same day and be re-photographed.

But I was fired by my curiosity and spurred on by something Williams had written in her essay for the *National Portraits* catalogue. "Daniel Meadows has traced many

of the people he photographed then," she wrote, "but this is of little interest to us. It wouldn't even help to know their names."

I couldn't agree with that.

To me these people were only too real.

Interest in *National Portraits* continued to grow. In 1997 the German satellite TV station Sat-3 made a short film about the project and, in 1998, at the invitation of curator Gabriel Bauret, the pictures were featured at the Rencontres D'Arles international festival of photography in France.[6]

It took 25 years, but suddenly everyone was interested in the Free Photographic Omnibus portraits. In May 1998 they were included in the British Council exhibition *Look At Me – Fashion and Photography in Britain 1960 to the Present,* then embarking on its world tour at the Kunsthal, Rotterdam.

In September it seems the Free Photographic Omnibus had acquired "cult status" as one of the top ten eccentric photographic projects of all time.[7]

In December a set of *National Portraits* was published in New York in the $80 *Joe's Magazine* where they appeared between the same covers as a naked Kate Moss, photographed by Bruce Weber.

In due course, word spread that I had begun to do reshoots and, in October 1999, *Dazed & Confused* magazine published four pairs of what I had started to call my *Now & Then* pictures. "It might be more accurate to call them 'Then and Then' portraits, for photographs are always of the past," wrote David Brittain, editor of *Creative Camera,* in *Dazed & Confused.* He continued:

[Meadows] has created short "*photo romans*" (literally photo novels). Each "novel" comprises two photographic portraits, each representing two distinct moments in time. In contrast to the newspaper picture essay, for example, whose meaning is determined by text or captions, the *photo roman* is purely visual and therefore open-ended, offering the possibility of multiple meanings. We are compelled to

compare two fictions to produce a third . . . Daniel Meadows began this project with wildly ambitious expectations that were never fully realised . . . Interestingly, as it continues to evolve, the work pushes the boundaries of what is understood as "documentary photography".

Later that month I went to Finland and exhibited these paired pictures for the first time. The occasion was Backlight, Tampere's fifth international photography triennial. Its theme: "Documents and Identities".

Eventually it was time to put words to the pictures and, at the end of 1999, the literary magazine *Granta* published a larger selection of the *Now & Then* pictures than had previously appeared, along with some of the writing I had done about the lives of the people photographed.

Since then I have built a website for the work (www.photobus.co.uk) and travelled with it on lecture tours to Finland, France, Italy and Ireland. In August 2000 I took it to Moscow as a guest of InterFoto 2000.

The bus itself is now a museum piece – but as an idea with a life of its own the Free Photographic Omnibus travels on.

In the 1970s my journey coincided with television actor Tom Baker's incarnation as Doctor Who. Because I had a knitted scarf and wore my curly hair long, people – especially children – often mistook me for him. A quarter of a century on, it now seems that the bus *was* a kind of time machine. I had thought I was at the wheel, but now I realise I was just another passenger.

Documentary: A Brief Lecture

The pictures from the Free Photographic Omnibus are works of "social documentary photography", a definition I first came to understand courtesy of William Stott.

In 1973, remarkably, no one had ever written a book that examined across its full range the philosophy behind the documentary approach – what Stott calls the "genre of actuality . . . the communication, not of imagined things, but of real things only".[8] Plenty of people had studied documentary film or documentary literature, but no one had examined simultaneously the many layers of documentary including photography, broadcasting and art.

Stott was then a graduate student in American Studies at Yale and his dissertation *Documentary Expression and Thirties America* was published that year, which was fortunate for those of us who were just then setting out on our careers as documentarists.

Stott's book has yet to be bettered. It was revised in 1986 and is still in print. Its author went on to be a professor of American Studies and English at the University of Texas at Austin.

For Stott, social documentary is "a radically democratic genre".

It dignifies the usual and levels the extraordinary. Most often its subject is the common man, and when it is not, the subject, however exalted he be, is looked at from the common man's point of view.[9]

I like that.

What is really glorious about Stott is that, unlike so many latter-day theorists who would have us read photographs solely as texts, he celebrates beauty and even stresses the importance of photographic *feeling*.

Many documents are rhetorically dull and/or philosophically puerile. Social documents, however, increase our knowledge of public facts, but sharpen it with feeling ... put us in touch with the perennial human spirit, but show it struggling in a particular social context at specific historical moments. They sensitise our intellect about actual life.[10]

Chapters such as "The Primacy of Feeling" and "A Documentary Imagination" indicate all by themselves the nourishing richness Stott found in documentary. He argues that at its very best social documentary is "capable of permanent revelations of the spirit". As in *Let Us Now Praise Famous Men* by James Agee and photographer Walker Evans, a study of three sharecropper families in dustbowl Alabama that remains one of my favourite books.[11]

According to Stott, social documentary

shows man at grips with conditions neither permanent nor necessary, conditions of a certain time and place: racial discrimination, police brutality, unemployment, the Depression ... pollution, terrorism ... man-made phenomena.

Today we might add to that list "star-fucking": the dominant and thriving two-and-a-half-million-readers-a-week-fawning-*Hello!*-magazine-culture that is arguably *the* man-made phenomenon of our time.

The Free Photographic Omnibus was the Great Ordinary Show: its passengers boarded for free and instead of a ticket they received a photograph. They were individuals, not types. Special.

James Agee also knew that individuals were special. Sent in 1936 by *Fortune* magazine to write about cotton tenancy for the documentary slot "Life and Circumstances" (an assignment that he turned into *Let Us Now Praise Famous Men*), he rejected the notion that people can be studied as "average" or "representative types". Each of us, Agee insisted, is unique, "a creature which has never in all time existed before and which shall never in all time exist again".

Bad Habits

The photography writer A. D. Coleman wrote that the function of documentary and photojournalism was originally

> informational and / or representational. It was the general purpose of those involved to inform – literally, *give form to* – what would otherwise be a welter of dissociated data; their intent was "to bring clearly before the mind" the events of their time – that being the primary definition of *representation* . . .

Furthermore:

> . . . producers and consumers alike appear to operate on the assumption that such imagery is not primarily concerned with the private life or inner landscape of the photographer. Instead, it is taken for granted that such work addresses events external to the photographer, occurrences in what we refer to as the "real world".[12]

Coleman wrote this as a prelude to examining the consequences of the demise of photojournalism's traditional market (weekly picture magazines) and the considerable changes to the documentary form – structural, conceptual, performative – that have taken place over the last 30 years.

Indeed the many different ways in which we "read" photographic images, both still and moving, is a defining characteristic of our age; a testament to the influence of twentieth-century thought: the ideas of Sigmund Freud ("the unconscious functions by signs, metaphors, symbols, and in this sense it is like a language"); Walter Benjamin ("must we not also count as illiterate the photographer who cannot read his own pictures?"); Roland Barthes ("readers create their own meanings"); and Umberto Eco ("there is no language of photography").

In 1973, when I set off on my bus, we all knew what documentary was. Today we're

not so sure. We've been hoodwinked by photographs so often that we no longer trust what they appear to show. Don't worry, we say, it probably never happened. Not like that anyway.

With its mission to emancipate the ordinary, documentary photography has gradually unwrapped itself as a subtle, subjective and complex medium, as easily capable of distortion and fiction as anything found in literature, but nevertheless a high octane and indispensable injection for the imagination and a fixer of the Zeitgeist.

Documentary tends to be done for reasons that are personal to the documentarist – the author of the idea as well as of the pictures. Documentary is not primarily driven by commerce, although there is frequently a political as well as an aesthetic motive. Motivated by curiosity first and foremost, the documentary photographer takes his time over what he does, trying all the while to impose order on the chaos in front of the lens. Documentary photographs are not always surprising, or at least not in the first instance. They require contemplation.

"While photographs may not lie, liars may photograph," said Lewis Hine, the photographer who did so much to expose the iniquities of child labour in the early twentieth century. "It becomes necessary," he said in a voice that echoes in the very soul of photography, "to see to it that the camera we depend on contracts no bad habits."

It didn't take long for documentary to contract bad habits. In 1936, when Walker Evans learned that the photographer Arthur Rothstein – his colleague in the Historical Section of the Resettlement Administration (in effect a propaganda arm of Roosevelt's New Deal, set up to provide employment for out-of-work photographers) – had carried around in the boot of his car the steer's skull that featured in his famous symbolic photograph of the poverty of dustbowl agronomy, he, along with members of Congress, felt betrayed.[13]

"I never touch a thing!" protested Evans.[14]

In that same year, Bill Brandt published his photographic study of the English, *The English At Home*, which was less a celebration of the English character – as at first

sight it seemed – than an acid critique of the huge privilege gap that existed in England at the time. That documentary photography could be at one and the same time sympathetic and subversive was a revelation. What Brandt concealed, however, was the extent to which the pages of his book were peopled by members of his own family posing, often entirely out-of-character, as lovers, bathing belles, drunks and theatre-goers.

As one by one these documentary fictions were exposed, advocates of the naturally observed – who had always assumed that the valued bond of trust between a photographer and his subject was something that also extended to the reader – turned in the shallow graves of their credulity and wondered.

Today bad habits are the norm – only now we call it "attitude". Contemporary documentary concerns itself less with the "truth" of what has been witnessed than with the meaning imposed by the way the photographer has seen. What today we celebrate first about documentary is the instant connection it makes with our imagination. That something "happened" or didn't "happen" in the precise way that it has been seen by the camera is less important. Nevertheless the archive of the collective unconscious is filled with flat 8 × 10s. As Walter McQuade wrote about the pictures of Walker Evans, "they have become a part of our past, whether or not we were ever there."[15]

Modern documentary pictures are presented and re-presented in a myriad of contexts, each time gathering up new meanings.

Take Martin Parr's oh-so-tender picture of that elderly couple waiting to be served in a seaside café, first published in his 1986 book *The Last Resort*. It shows a man in left profile, his cigarette hanging Andy Capp-style from his bottom lip, his collar and his tie, his balding short back and sides. Opposite him, across a table laid for tea with knives and forks and a plate of sliced bread and butter, sits the wife, toying with her wedding ring. Parr has re-presented this picture frequently, each time allowing (willing?) its meaning to shift. When he included it in his *Bored Couples* exhibition he made an assumption; when he sold it for a Fiat finance newspaper advertisement with the caption "No Interest for Two Years" he allowed in a judgement; more recently it has

been the cover illustration for a book by Simon Armitage and once again its tender origins have been restored.[16] By rolling it around in the market place Parr has kept the picture flickering in our minds. It's not just "out there", it's "in here" too.

When Barthes said that "readers create their own meanings" documentarists worried themselves crazy. Today, though, this is the idea that excites. Like religion, documentary depends upon the faith of individuals for its interpretation. As often sneering, bossy, outrageous or misanthropic as it is "concerned", documentary is alive and cannot be pinned down. Of Walker Evans it was said that he had created "a new set of clues and symbols, bearing on the question of who we are".[17] The same is true of Martin Parr.

Today's documentarists, trusting only their own experience and having little faith in the quaint photo-documentary ambitions of an older generation, turn their lenses on themselves.

Somewhere in the democratic forest[18] of the documentary imagination, Nan Goldin, whose *Ballad of Sexual Dependency*[19] chronicled her own tempestuous love life – including masturbating boys, incidents of violence and men in slips copulating – meets William Eggleston, the enigmatic confederate colonel of new colour, and it is enough that the pictures that emerge are beautiful and colourful . . . and full of whatever you want them to mean.

Today's documentarists value the "navigation of the real" only in so far as it gives us a vehicle for our dreams and a connection with our individual experience. What we trust is what goes on between our ears. If it's true in our heads then it happened sure enough. Whereas once the best documentary photographers – Joseph Koudelka with his epic story of gypsies (posing for family portraits, shaving, sleeping, feeding their babies, making music, drunk, awaiting execution, burying their dead) – always left space for the imagination, now the imagination appropriates the plain fact of what is witnessed by the camera. Thus today's documentarists can barely be distinguished from artists.

In 1998, gallery-goers repeatedly referred to my *National Portraits* exhibition for the Shoreditch Biennale as an "installation", and to me, the photographer, as an "artist". Not

that I mind – I've had a lot of labels. It's just that when I shot these pictures I had no idea what a reservoir they would provide for internal projection.

It is but a short step from dreams to digital reality. To be surprised by the real has been documentary's joy. But now that "the real" is between our ears it doesn't even matter that what looks real has, in fact, been invented and brought before us courtesy of a computer.

In the spring of 1999 I went to see the Andreas Gursky exhibition at the Serpentine Gallery in London's Hyde Park. Gursky's wall-sized colour prints of Times Square, a May Day rave, the Hong Kong Stock Exchange, the Chicago Board of Trade, apartments in Atlanta, tower blocks in Hong Kong Island and so on have been "enhanced". They are a montage of images mixed inside a computer, but because this process is so seamless, it is impossible for the spectator to see the joins. You cannot be sure what you are looking at. Did this image ever exist in reality? Or is it merely a product of the photographer's imagination? Outside the banner read ANDREAS GURSKY: PHOTOGRAPHS 1994–99.

I looked at these pictures very closely, so closely in fact that I drew the attention of an attendant. Young and flushed, she came running over.

"Please don't touch the photographs!" she snapped.

"But they aren't photographs," I replied. "They're pixelgraphs."

She gave me the stare. (Got a right one here – I could see it on her face.) "Just don't touch them, okay?"

"Touch what? There are no photographs here."

A small crowd had gathered. A Saturday morning crowd of gallery-goers: chic young wives with toddlers in pushchairs; elegant ladies; a young man in a blazer with his greybeard father; and an intellectual in a tweed jacket.

"Don't you know anything?" he demanded without waiting for an answer and longing to dazzle us. "*All* photographers put their pictures through a computer these days. They have this software called Photoshop. Digital manipulation. Nothing goes unaltered."

"Oh," I said. "But if everything is altered, how are we to know what has happened?"

The tweed jacket adjusted his spectacles and glared.

"Take that picture from last week's front pages," I said, "the one of the teenage Kurdish demonstrator who set fire to herself. We all saw that. Are you telling me it didn't happen? That she's all right really? That the flames were just painted on?"

Tweedy's gun was cocked and ready to fire.

"It happened if you believe it happened," he said.

Bang!

So there you have it. Believe it only if you want to.

R.I.P. Reportage 1839–1999. Goodbye, old friend.

I turned my attention to the attendant.

"Happy?" she asked.

"No," I said. "In fact, I'm thinking of reporting you to the Trading Standards Office. These pictures are pixelgraphs and yet you are promoting them as photographs."

"Well," she said, "they did *start* life in the camera. Isn't that good enough for you?"

"No," I replied, and then to myself – for I'd caused enough trouble for one day and I *do* like Gursky's pictures (honest) – I added "and shit started its life as food".

When reportage photographers play in the digital sandpit, groping for the meaning of their medium in the electronic age, it is important that they do not lose sight of photography's unique powers of description. Although photographs have no hold on objective truth, it is important that those who make photographs are mindful of that which is truth*ful* in their work.

All photographers know in their hearts – but sometimes choose to ignore – the potentially damaging impact of the documentary photograph. Take, for instance, my own "Boot Boys" (pages 4 and 5). They were recognised by their families and friends, by workmates and acquaintances. Publication of the picture altered the quality of their lives for many days and in many ways. Don't tell these lads that reportage is dead.

But what if I had deliberately misrepresented these men by using the seamless computer-montage effects available to all photographers today? What if I had added information to the picture – a mutilated cat, say, swinging by its tail from a waistband; a meat cleaver placed in a hand; some splatters of blood on their clothes? Now predict the damage caused to each of them in their small community.

As we enter a new century it is worth noting that two of the great photo-documents at the end of the last one were produced by students: Nick Waplington's *Living Room*[20] and Richard Billingham's *Ray's A Laugh*.[21]

Waplington's pictures of dysfunctional family life on a Nottingham council estate were intimate and authoritative in a way that even the most revelatory photo-documents have never been. Billingham's even more intimate study of his own family in Walsall – his alcoholic father, his huge mother, his brother and their various pets – shocked many who felt he had betrayed his loved ones, but it opened the door on a new world of photo-discovery.

Both photographers now enjoy considerable respect as artists on the world stage and their pictures are widely exhibited and collected. This was work done in provincial Britain by people who came from the places they photographed (Waplington's *Living Room* project began in the house next door to his grandfather's). They are fine examples of social documentary photography at its purest. It may not look like it used to, and its look just now might be indistinguishable from much that calls itself "art" (it may even have a life in pixels, who knows?), but for as long as young people have enough curiosity and drive to continue doing it, the future of authentic photo-documentary is assured.

The final paragraph in William Stott's *Documentary Expression and Thirties America* reads: "That the world can be improved and yet must be celebrated as it is are contradictions. The beginning of maturity may be the recognition that both are true."

Twin Lens Reflex

When you photograph with a Rolleiflex things are back to front. The bus portraits were shot with a Rolleiflex. It's a black and grey rectangular box, and you hold it in front of you, waist high. It's mechanical, no batteries. It has two lenses that point towards the subject, one on top of the other. The top one you look through, the bottom one is for the picture. The viewfinder sits flat on the top of the camera: a piece of squared-off plastic with thin black lines to help you get your verticals right as you stare down, framing the image in the gloom of its black metal shade. Up is up and down down, but left is right and vice versa.

It can be confusing. If, out of the corner of your eye, you see someone walk into frame from the right, on the screen they walk in from the left. Because you look down into the camera, the subject looks at the top of your head.

So, from time to time, you glance up and speak to them and they look back. In that gaze energy passes, but you want the charge to be with the viewer, not with you. You tell the subject to look in the lens and then pray that when you press the shutter release Dylan's "ghost of electricity" will howl.

And you talk a bit.

Or not.

There are no rules.

It's a strange business setting up the flow for a picture. Mostly it doesn't work. If they look at you – that is, at your face and not at the lens – the fix is lost. The girl on the left – her name is Lyn – in that picture from Southampton (on the cover) was one of the fittest ever to pose for the bus, with her long hair curling on her shoulders, her pencilled eyebrows, her wide film-star smile and her gleaming, even teeth. No wonder she and her lovely sister made it to the front in 1975 and again 26 years later.

Here a single picture defines the difference between *Living Like This* and *National Portraits*: Lyn's look is with me and, because I liked it so much and was flattered by it, I kept it for myself. But Stella's look is with the camera, it's as if she knows she is staring into the future. Lyn's look was a present. Stella's is history. "The camera," as Roland Barthes had it: "a clock for seeing".

Meadows Acres

"A photograph is a construct and we should not mistake it for unmediated reality." You hear it all the time these days. What this means is that I should not even pretend to be outside the equation that is *National Portraits*.

Nowadays it is almost impossible to appreciate documentary photographs without taking into account at least something of the "inner landscape", as Coleman has it, of the documentarist.

I was born on 28 January 1952 in the Gloucestershire hamlet of Great Washbourne. My father worked there as a land agent. He was the elder of two sons of a Suffolk family. Grandfather had been an army colonel in colonial service in India.

We were a family a little come down in the world. Once there had been a Meadows Acres in Suffolk, but now we lived in a house owned by my father's employer.

Dad had studied agriculture before the war and he came to Gloucestershire in 1938 to work for one Lord Monsell, owner of several thousand acres of old England called the Dumbleton Estate. He managed the farms and woodland, he fixed and collected rents from the farmers and other tenants, and in every way did his best to give his lordship a healthy return on his capital. He also ran a famous pheasant shoot let out to a syndicate of bankers and city magnates.

It was out shooting as a boy that I first saw our part of England as others might see it. Like the old gamekeeper's explanation of the economics of shooting pheasants,

it just didn't add up. "Up goes a fiver, bang goes 20 quid and down comes one and six." Gents in line, skewered on shooting sticks beside numbered hazel pegs. Their scented wives with headscarfs knotted on the very point of the chin. Their trusty chauffeurs doubling as loaders. The khaki tweed, the cherry brandy. The brogues and knee socks, the woollen garters, plus fours and flat caps. Checked shirts. Cartridge bags. Dressed to kill.

I was with the estate workers, beating. Standing in line in a wood, cooing and knocking our sticks against the trees. On the coldest mornings the pheasants wouldn't fly. Each of us would bend over a fat, trembling, hand-reared golden pheasant. At a nod from the keeper we'd put them up. One or two at a time so that the guns wouldn't miss. Bang, bang. And when they did miss you'd hear the disappointment in the cursing of their dogs (bloodlust denied as my mother used to say): "Damn you bitch!" "Blast your bloody eyes!" Cowering spaniels or Labradors named Satan, Blackie or Nigger. My father had a Labrador bitch called Salote, after stately Queen Salote of Tonga who had attended the Coronation, the memory of which was still fresh in people's minds.

Dad worked for the Dumbleton Estate until he died in 1997. Fifty-nine years in the same job, interrupted only by war service. In the 1970s, standing as an Independent, he was elected mayor of Tewkesbury Borough. In his time he had been a good – "useful" would have been his word – cricketer. A slow left-arm bowler. Steady, solid, loyal, ordered, occasionally mesmerising and never wavering in line and length. As in cricket so in life. Duty was carved on his soul. "A very fair man," as a villager described him that autumn after he died and we planted to his memory a maple in the churchyard, its evening shadow set to fall across the ground where, together and a decade earlier, he and I had scattered my mother's ashes.

He had four rules for living, which can be summed-up as follows: don't go abroad, it's full of foreigners; always find out where your watering holes are; always reverse into a parking space; and remember – everyone has his mumbo jumbo.

Until he got married he lived in a pub in a neighbouring village where, during the war, he met my mother. She also came from Suffolk, but had been working in London as a secretary at the Bank of England. When the war started, the Bank's treasures had been evacuated, along with its staff, to the countryside, away from London and the Blitz. My mother had been sent to Overbury Court where, among other things, she was put in charge of a squad of land army girls. Dad married Mum in 1942, just before he left for the war.

He was called Rowland, but was always known as Roddy. Mum was called Kathleen, but was always known as Ann. The first Lord Monsell for whom my father worked (he outlived almost three generations of Monsells) always referred to Dad as Matthew, because the other lieutenants on the estate – the farm bailiff, the gamekeeper and the head gardener – were called Mark, Luke and John respectively.

Great Washbourne is in the middle of nowhere on the edge of the Cotswolds. We lived in Great Washbourne Manor, one of the Monsell's grace and favour houses, and the place where I was born. We led a rustic existence. Much of the food we ate came out of the garden or off the estate.

There was a feudal pecking order in the village. Venerable old men on bicycles would tug their forelocks as they went by and call me "Sir".

Throughout my childhood we had a live-in house keeper called Maysie – whom my mother had first commanded in the land army – and a succession of part-time gardeners. The one I remember best was Jack State, a surly man who always wore a cabbage leaf tucked into the back of his cap. Whenever he saw me he used to mutter: "Daniel Meadows is no good, chop him up for firewood."

Maysie's real name was May Locket Cogbill. Beautiful. She was a simple soul with a large blue growth on her upper lip and a tendency to get flustered and talk gibberish. "Yammering" my mother called it. She was simple, yes, but not stupid or retarded. She hated wind and thunder, loved the summer sunshine. She had a son about my age who lived in a residential home for the mentally handicapped. I met him once, on

the occasion of his only visit. Stephen. He died during the 1960s and left her some small items of wooden furniture made, I think, in his occupational therapy classes with basket weave seating done in strips of coloured plastic. And a music centre that Maysie set up on a table in her room, but never played.

I have two sisters. The elder, born shortly after the war and eight years older than me, was already away at boarding school by the time I arrived on the scene. The younger one, with whom I grew up, is 20 months older than me. As "the boy" I was, perhaps, privileged over my sisters.

My mother didn't go out to work, she stayed at home. She had multiple sclerosis and, although when I was a small child it wasn't diagnosed, it was clear even then that she wasn't right. She wasn't really happy either. She had enjoyed her time in London and missed it terribly. Quite a society girl, she had made some well-connected friends. (God help me, but before the war she even went out with Keith Joseph, later Sir Keith, architect of Thatcherism.) Living in the countryside was, I think, quite traumatic for her, especially during the war when my father was away. But she did her duty, running charitable functions to buy coal for the old people and driving them to their chiropody appointments in the village hall. She knitted jumpers and did crossword puzzles and, in the evenings, played canasta or read her little green hardback volumes of Shakespeare. At her funeral in 1989 her cousin told us from the pulpit that "she was electric with anagrams". Indeed.

After the war Dad broadened the base of his business. He took on the management of all the glebe land – church-owned land, that is – for the Diocese of Worcester. (I remember him, on occasion, explaining to my mother that he would go out for lunch, attending a meeting of the Dilapidations Board. Such a wonder in that name.) And he took on work for other landowners beyond the estate.

This is the England I come from.

Mine was a contained life. Mostly my friends were chosen from the families of equal or superior rank in the district. I would be dressed up and driven to meet them. We

would have tea parties, posh ones sometime with a conjuror and dancing. Everything was structured. Penelope this, Emma that, Ben and Charlie, April double-barrelled.

Occasionally we would be visited by relations, but they were rarely invited to stay overnight. The wider family was kept at arm's length because no one was supposed to know about my mother's illness.

My mother's health deteriorated throughout my childhood so that eventually she was wheelchair-bound and incontinent and could raise her head only with difficulty. Despite her illness she remained strict about ways of behaving and the use of language. These things defined us. We weren't allowed to call a lavatory a "toilet" or the drawing room the "lounge" and we had to hold our knives in a particular way.

If it wasn't for the fact that she could laugh uncontrollably so that the tears ran down her cheeks and she had to shake out her serviette – sorry, "table napkin" – and throw it over her face and laugh some more from inside it so that it puffed in and out with her breath before falling to the floor, taking her monocle – sorry, "eye glass" – with it, and all this repeating several times before she could regain her composure, you might have thought she wasn't much fun. She also told, from personal experience, a good cautionary tale about the hazards to one's knickers of igniting farts.

We didn't have television. We listened to the radio – sorry, "wireless". Evenings we played a lot of family games, card games, board games . . . *Bonanza* was one I remember, a sort of gambling game with plastic counters. And so we learned our manners. There was a way you held your cards, always a special order.

For treats we sometimes went to the cinema, but more often we were taken to the theatre. My parents would go almost every week to the Everyman Theatre in Cheltenham, and then, every school holidays, we'd go to Stratford and see a proper Shakespeare play. My father didn't like the theatre very much. He used to snore and we'd say he was "making his Stratford noises", a sort of grunting and shuffling. My mother used to sit perfectly still and we children all had to sit perfectly still.

Despite being a member of the MCC and a card-carrying Tory, my father

occasionally displayed an anarchic streak. In the run-up to my departure for prep school he took me aside to give me some advice:

"Now then, Med." (He always called me Med.) "When the Headmaster's wife comes to sit beside you at lunch one day, as she surely will, you must be polite and engage her in conversation."

"Yes Dad."

"So you will need an opening gambit."

"Yes Dad."

"I suggest the following: as she takes her seat, you should lean over and in a loud, clear voice say, 'Tickle your arse with a feather, Mrs Berkley.'"

"Tickle your arse with a feather," I repeated faithfully.

"But," he continued, "and this is the important bit, when she looks as though she is about to explode you must quickly interject with 'Peculiar nasty weather, Mrs Berkley.'" And he roared with laughter, as indeed he always did at his own jokes, and I do at mine. "Remember that, Med. 'Tickle your arse with a feather,' but keep a straight face at all times. No laughing now!"

The God Belling

As a boy in that large manor house in Gloucestershire I came to believe – in the way that only children can believe these things – that God lived in a single-bar Belling electric fire on the bathroom wall operated by pulling a dangling chain. Today, of course, I no longer believe in the God Belling though I do believe that the place in my head where he once resided is now filled with something else, equally spooky: my library of remembered photographs.

For me, taking a bath was like going to church. I had my own ritual and it had to

be observed. I would enter the bathroom, switch on the light, slam the door and slide the bolt all in one swift movement. Then, without looking up at the fire, I would undress and put my folded clothes on the little stool beside the lavatory where my father kept his seed catalogues. I topped out my little pile – socks, aertex shirt, underpants and shorts – with the weight of my sandals, securing it. Then, naked and shivering, I would begin my checks.

Apart from the WC with its attendant stool, a washbasin and the bath itself, there was only a large cupboard against the wall opposite the window. It was made of wood and painted white. Standing on tiptoe a six-year-old boy could just see the top of it, formica covered in blue, bare and chipped. I would steel myself before opening its double doors, knowing exactly what I should find in there, but terrified that tonight it might be different. I was looking for weapons. If something was lurking, some demon waiting to pounce, then I would have to take it by surprise. So I would clamber up on top of the cupboard and crouch there on my haunches with my knees up around my ears like a gargoyle. I'd bang on its doors, demanding in a forced whisper (so my parents downstairs wouldn't hear): "Come out!" Then I would press the catch and fling open the doors.

The cupboard was a repository for an assortment of odd medicinal applications and toiletries, many of them unwanted Christmas presents: Santa droppings. I would take an inventory, assessing in turn each item's murderous potential. Unopened bars of Fairy soap could be stuffed in my mouth. One yellowing bandage in a crinkly cellophane wrapper might gag me. My mother's under-arm razor could slash my face or put a nick in my tendons. Near the front, Dad's electric razor could be plugged in, turned on and tossed into the bath to electrocute me. A half-used bottle of after-shave might be poured into my eyes to blind me. A frilly bath hat with perished rubber flowers attached, put on back to front and slitted with eye and nose holes, might provide my assailant with a mask.

On the lower shelf there was a dispensary of 27 medicine and pill bottles. These

I kept lightly dusted with talcum powder so that, if one had been moved since the last time I looked, I would notice straight away the mark of its former position.

Satisfied all was well I would then give my attention to the bath. Before turning on the taps I would jump into it and, lying back against its cold and crusty enamel just far enough so that my head didn't drop beneath the rim, I'd survey the room. Here I was at my most vulnerable.

On a shelf in the corner between the hand basin and the lavatory, there was an oval shaving mirror on a chromium swivel stand. I would lose count of the number of times I jumped out of the bath, crossed the room, adjusted the mirror and jumped back in the bath again before I could see right down inside the lavatory bowl. I would even smear the mirror with some shampoo straight from the bottle to stop it misting up. Thus reassured, with all the bathroom's exits and entrances covered, I would turn on the taps.

As the brown-tinged water rose about me I would consider the next step, for I knew that one day I would have to confront God in His fire. I knew He was there because that was how God appeared to people, in a fire. The biblical Daniel saw Him in a fiery furnace. Moses saw Him in a burning bush, a fire that "burnt but was not consumed" just like the Belling. I wasn't an idiot and I knew it: you always have to confront your demons. Eventually. So one night I did. Naked and dripping wet I climbed out of the bath, crossed the blue bathroom lino and looked up into the chromium curve of God's smile. Then I reached out a foot and kicked the little seed catalogue stool free of its load and positioned it where it would give me a step-up. Standing on tiptoe with my left arm at full stretch I managed to reach God's grey element. I gripped it in my palm. With the other hand I reached for the chain of the pull-switch.

When I pulled it, God hit me very hard between the shoulder blades and threw me to the floor.

I told some whopping lies that night as I sat wrapped in a towel on my mother's

knee in front of the drawing room fire. She could not understand what had happened and I was not telling. Had I told the truth she would not have believed me. That is something religion and photographs have in common: they both require faith.

Flat Feet

The first eight years of my life were spent in that house at Great Washbourne. Then I was sent away to a boarding school founded by Quakers.

The Quakers were all right. They taught us to *think very seriously* about everything we were going to do before we did it. That's what Quakers do: *think very seriously*. If you've got flat feet and you are made to get up very early each day by Quakers because of them, then you not only think about your feet a lot, but you think about them *very seriously*.

I took my feet to the gym with the physical jerks and our teacher, Snappy Ricketts, who was a good man.

The physical jerks weren't just flat-footers. Among our number were the obese, the emaciated and the hunch-backed. Some of our number were hard core: National Health specs held together with sticky tape and sticking-out teeth held together with braces. One boy had the habit of reading with his face very close to the book and, as he turned the page, he would press his nose against it and sniff it, carefully.

But in Snappy Ricketts's company we never felt bad about ourselves. He taught us to walk away our flat feet by treading on the sides of them and he taught us how to deep breathe away our pinched chests. He taught us to stand tall and he taught us self-esteem. He could inspire confidence in even the most timid of souls. My crowning achievement with Snappy Ricketts was to stand straight up on the top of his cropped head with my arms spread wide and a big grin on my face while he walked the length of the gym.

Snappy Ricketts is probably dead by now, but he lives on in my head.

A Head

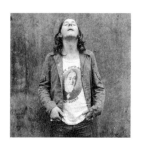

The bloke on the cover of *National Portraits* is a "head" – you don't know for sure, but lads who looked like him in 1974 were putting out signals to let you know they had tried LSD. "Head" because he is out of it. "Ahead" because he'd taken it and you hadn't.

We see more neck than face. His Adam's apple prominent. Clean shaven, he is probably about 17. At the low camera angle from which we stare, the slits of his closed eyes are in line with his upturned nostrils, spelling out in Morse code: dash, dot, dot, dash. I look it up. It's "X". Our man, Mr X, from Barrow-in-Furness, his mouth hanging open. His lank, dark hair, long and curling loosely on the collar of his open denim shirt. Raindrops dapple his shoulders and fore-arms. He is under-dressed for the weather, to show off his T-shirt, a Levi Strauss special edition with the proprietorial bearded face of the aged jeans manufacturer printed in an oval as big as a long-playing record.[22]

Mr Strauss is confident. Mr X is diffident. Mr Strauss is bearded. Mr X is callow. Mr Strauss is direct and proud, beneficent in wing collar and bow tie with Mr X's medallion briefly crowning his pate. A ten-penny bullet hole. Mr X poses like a cowboy waiting to draw. He's a hipster with no gun. A holsterless hero wearing Mr Strauss's jeans, very tight and creased at the crotch.

The fingers of his left hand are knuckle deep in the tight pocket. That's as far as they go because there is something square in there already. Cigarettes? Probably Players No. 6. That's what we smoked. The green and purple packet. Like Dad's Woodbines only with a filter. Not King Size, but sweet and cheap.

His picture appeared in the *Evening Mail,* but he didn't step out of the past and show himself. No one recognised him either.

"Who is he?" they asked.

Just some head.

The Enemy

In 1965 I was sent away to public school in Somerset, Monkton Combe; a very bad experience that wasted my childhood and destroyed my self-confidence.[23] It also poisoned me against all those who would claim me for their class. Show me a pinstripe or a pair of cavalry twills and I'll show you the enemy.

Neil Ferguson knows the score:

> Having spent your formative years away from your mother and father and brothers and sisters and neighbours, in a closed male community that promulgates an ethos of self-reliance, there isn't much chance you won't turn into a fledgling little fascist cunt. Alienation is all you know about. The point of sending your child to such a school is not to sharpen his wits, but to cripple his soul. Public school does to the heart what silk bandages did to the feet of aristocratic Chinese girls. That is the mistake socialists always make: their answers to the problems of capitalism are intellectual. They don't understand, as Orwell did, because he went to Eton, that Middle England is not interested in culture or ideas.[24]

Or to Put it Another Way . . .

LIBBY PURVES: What started this out, Daniel? Were you a child that looked at people on the street and was very aware of his surroundings?

MEADOWS: No. I was locked up in a boarding school for ten years right throughout the 'sixties and was quite resentful of the fact that The Beatles and the Stones and Martin Luther King had all happened on someone else's television set. And by the time I was 18 and it was 1970, I was raring to go, I was having a late adolescence really.

PURVES: So it gave you a great hunger for looking at the world outside the wall . . . You'd studied photography, were you always inclined towards pictures of ordinary people, rather than being Norman Parkinson or David Bailey?

MEADOWS: I hated Norman Parkinson and David Bailey because I hate celebrity. I mean . . . all of you sitting here talking about *Eastenders* – do you know I've never seen it?

PURVES: How did you get the bus project going? You were very young. How did it start?

MEADOWS: Yes I was very young and I couldn't get a job. It came out of desperation really. You have to believe I was useless at everything. The only reason I did photography was because I couldn't do anything else. "You can't do maths, can't do English, can't do Geography – what do we do with this man? His parents are paying money to put him in a public school and he's just useless. Fails at everything, can't do the sport, when he does the CCF [*marches with the cadets*] his right arm goes with his right leg, everything is wrong." So what do you do? You put him in the art room. So I was put in the art room and there I met my first northerner, a wonderful man called Pat Twombly and he said: "Well, can you paint, lad?" And I said: "No." And

74

he said: "Well try." And I painted a bit and he said: "No, no, you can't paint ... What about photography?" And thank God he had the wit to put a camera in my hands. And so I went to art school and did photography.[25]

Tony Ray-Jones

It was while I was at art school, in 1970, that – together with fellow students Brian Griffin and Martin Parr – I discovered images that were strong enough to compete with the God Belling. And they were photographs. Pictures by Robert Frank, Diane Arbus and, in particular, Tony Ray-Jones. I remember so well that exciting day in Brian's flat in Moss Side when we first sat down to study pictures.

The point about the work of Frank, Arbus and Ray-Jones is that when we looked at them we saw things differently ... and afterwards the world was never quite the same again. These photographers were not just recording what they saw, they were interpreting what they saw. The filter of their subconscious, their humour, their subversive take on the human condition and, above all, their facility for noticing things and making connections, this is what makes their pictures work. When Tony Ray-Jones photographed the Bacup Coconut Dancers he didn't just

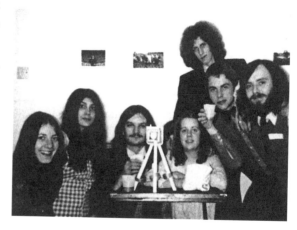

At Brian Griffin's flat in Moss Side, 1972. (*Left to right*) Rose Greenwood, Shireen Shah, Martin Parr, Jackie Ward, Daniel Meadows, Brian Griffin, and an unidentified man.

show us men blacked-up wearing white skirts and bonnets, black tights and clogs. He had them jogging in step across a piece of waste ground behind some stone terraced

7 5

houses led by a running child in a black duffel coat while a man in his garage lay beneath a car, oblivious to the strange company briefly passing. It was the stuff of dreams. And still these pictures work their magic. A woman drinks tea seemingly waited on by a stuffed bear in an apron. Will the bear eat her? Another woman impatiently taps at the door of a telephone booth where a horse appears to be taking too long over a call. Three buxom bathing beauties – bored, sexy, numbered and wonderfully spilling out of their tight swimming costumes – are completely ignored by a bald, middle-aged man in a dark suit seated just a few feet away. He sips tea with his cigarette trapped between the fingers of his drinking hand. In the background a younger man sniggers and eyes the girls. A sign reads: PLEASE DO NOT EAT YOUR OWN FOOD.

This is what photography can do. This is what excited us and what excites me still. And the label stuck on it – the name that excited us so – was "documentary". Noticing things, making connections, seeing sense in nonsense and bringing all this clearly before the mind. We were hooked.

How to Become a Photographer

Some 20 years after I left art school I ran into the London-based photographer Peter Marlow who had been a student at Manchester University in 1973. He confessed that he had once hung around the bus for an entire afternoon looking at the pictures in its windows and waiting for me to return, because he wanted to find out how to become a photographer.

The truth is, if he had asked me, I'd probably have said: "Fuck knows, mate. Why do you think I'm living in this bloody bus?"

In 1998 at the Rencontres D'Arles international festival of photography in France, Val Williams – talking about the Free Photographic Omnibus at a press conference –

referred to me as "a radical pioneer of British documentary photography" as if it was something I had chosen to be. The truth is that, in 1973, living in a bus was all I could think of to do.

Begging Letter, 12 May 1973

Dear Sir,

I would like to draw your attention to the enclosed leaflet which concerns the Free Photographic Omnibus. Since the appeal for money was launched last October the following organisations have given money to the scheme:

	£ p
The Arts Council of Great Britain	750.00
Coutts & Co	10.00
East Midlands Arts Association	100.00
Granada Television	50.00
Methuen & Co Ltd	50.00
Sunday Times Magazine	100.00
Yorkshire Regional Arts Association	165.00
There are also a number of private individual sponsors whose donations amount to	214.00
TOTAL	1,439.00

The response to the scheme has been very encouraging and I am looking forward to setting off on July 1st as planned. However there is still over £1,800 to be raised.

The necessity for this scheme cannot be over-emphasised since the environment in this country is changing quickly. We might soon forget those interesting relics of

the past that are so quickly disappearing under the redevelopment of the future.

The following is an extract from a letter written to *The Times* in January 1972:

> "Most people confuse change with progress and anyway why should change be necessary even if it is progress?
>
> "Why must we always have bigger things to live normally? The population is being attacked by reconstruction, redevelopment, clearance, abolition, innovation, reorganisation, centralisation, and of course the root of most changes taking place today, inflation. Who can negotiate a truce?"

I feel that the Free Photographic Omnibus can go some way towards negotiating the truce. The photographs will provide a stimulus to reflection and give us a chance to review the rapid changes in the environment. Perhaps we will begin to ask ourselves if the future we are building is better than the past we are destroying.

The scheme is already receiving publicity. There was a BBC Radio Manchester *Midday* report in March, and *New Society* and the *Yorkshire Post* have both run short articles on the scheme. *Creative Camera* magazine will be running an appeal on my behalf in their next issue. I have also been asked to run the Free Photographic Omnibus in Hyde Park for two weeks in the summer as part of The Serpentine Gallery's Young Contemporary Photographers' Exhibition.

I trust that you too consider the project worthy of your support and hope that I shall be hearing from you shortly.

Yours sincerely, etc.

Logic and Lorries

Alternative England and Wales is a great fat book printed on recycled paper in 1975. It told us what we wanted to know about squatting, communes, avoiding arrest, complementary medicine, bio-technics, publishing (everything from leaflets to books), starting a theatre workshop, entering the mystic, joining an encounter group or a radical political party, going on a retreat, travelling abroad, taking drugs, and dealing with the two STDs: sexually transmitted diseases and subscriber trunk dialling.

If you needed to know how to repair the WC, rewire a ring circuit, change a Yale lock, construct a hanging bed, make home-made yoghurt, bulk supply health food, claim family income supplement, make a living in the country, get an abortion, help foreigners, erect an inflatable building, set up a freeschool, it was all there in *Alternative England and Wales*.

Its principal author was Nicholas Saunders. Travelling the country in a converted Ford Transit van for roughly the same amount of time, the same distance and at the same period as I travelled in the bus, he produced the survival handbook for my generation.

Reading it again I find a page on "living in vans". Under a diagram of his vehicle – showing the papier-mâché ceiling lining with fairy lights, a batik image of the Fool, the sink draining over the rear near-side wheel and the window concealed inside the rear shutter door – he writes:

My bedroom on the top-deck of the bus, 1974. The curtain to the left of the bedhead is the entrance to the darkroom.

I lived in a van while researching this book and also met several other more permanent van dwellers – two couples I know have given birth in their vans.

My van was only 30 cwt but for less travelling and more living, larger older vans are better and cheaper. Unless you have an HGV licence you can't go over 3 tons.

Big vans with wooden framed bodies are ideal and are sold cheaply when they can't pass the very strict tests for vehicles over 30 cwt: but living vans are exempt . . .

. . . People living in vans call them "lorries" while lorry drivers always say "wagons". A "Luton" is the type of body which extends forward above the cab – ideal for bed.

Later Saunders gives us his philosophy:

I believe that we should ignore the lifestyle and values of whatever flock we're a part of, whether it's typically bourgeois or super-trendy. Instead, I'd like each person to develop their own personality as an individual by exploring any direction which isn't destructive, always being aware of all aspects of what they're doing. This involves accepting other people's different values and taking complete responsibility for our own situation. Not easy, but it allows one to find fulfilment.

I also believe that real knowledge comes from experience rather than learning through the intellect. Logical thought and words are useful on a purely physical level but useless when it comes to anything more subtle. Even emotional problems, like in relationships, can't be solved intellectually though intellectualism has such a hold on our culture that most people feel compelled to justify their actions as though they were logical.

Justifying my actions as though they were logical was precisely what I was doing when I sent those begging letters.

Dazed & Confused

Meadows was flushed with enthusiasm for "alternative" living and very curious about the lives of other people. The model for the Free Photographic Omnibus was the weird work of the English documentary photographer and MP, Sir Benjamin Stone, who became lionised by Meadows and his fellow student Martin Parr after he was recovered from obscurity by, among others, the photographer Tony Ray-Jones.

Ray-Jones helped to popularise Stone after stumbling across a book on a junk stall. It may have been Dr George Williamson's *Curious Survival Habits and Customs of the Past that Still Live In the Present* which used many of Stone's deadpan pictures of strange and arcane rituals, such as "the dancing of the furry dance in the streets of Helston".

In the posthumous publication, *A Day Off: An English Journal* (1974), Ray-Jones acknowledged Stone's influence (though not his style) by cementing English identity to the cult of eccentricity.

Determined to create his own picture of England, (and mindful that something authentic was becoming eclipsed by mythical representations such as *Coronation Street*), Meadows hit the road.[26]

Play Power

Never having played any part in the Underground of the 1960s I recently reacquainted myself with its values through former *Oz* editor Richard Neville's book *Play Power*.[27] Although my pride would have led me to deny it at the time, it is obvious how much

the philosophy of the Underground inspired the thinking behind the Free Photographic Omnibus.

Neville sums up the objectives of Underground activists as follows. They should:

> Transform Work (i.e. work = play)
> Sow their own wild oats
> Fuck the System

All of which was most appealing.

> . . . work is done as a pastime, obsession, hobby or art-form and thus is not work in the accepted sense. Underground people launch poster, printing, publishing, record and distribution companies; bookshops, newspapers, information bureaux, video and film groups, restaurants . . . anything that they enjoy doing. First advantage: Every Monday morning is a Saturday night.[28]

And in one of the book's several appendices I find:

> Grants: If what you're into qualifies at all as a New Artistic Activity, send in an application to the New Activities Committee, Arts Council, 105 Piccadilly, W1; it is said to be in the majority control of a group of heads, who have £15,000 to play with this year.

This I had sussed for myself. I'd done Latin at school and I knew "omnibus" meant "for all". My "New Artistic Activity" was photography *for all the people*. I was taking pictures and giving them away. All you had to do was ask.

Hold very tight please.

Perhaps Play Power, rather than naiveté, is what we recognise when we look at a bus portrait today and wonder why it touches us so.

In 1973 I would have had no difficulty reconciling two equally compelling but opposing rallying cries from my youth – the first from the Anglican Blessing:

Go forth into the world in peace. Be of good courage. Hold fast to that which is good. Render to no man evil for evil. Strengthen the faint-hearted, support the weak.

The second from Richard Neville's book:

Onwards to the 'eighties, Motherfuckers.

But, tempted though I might have been to write both as mission statements on my destination boards, one on the front of the bus and the other on the back, I would never have had the courage to do so.

Martin Parr

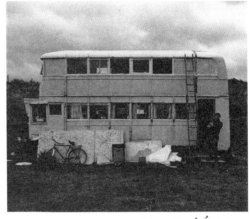

Daniel in 10 yrs time – Martin XX.

Photographer Martin Parr sent this "thank you" after staying a few nights on the bus in the late summer of 1974.

Isle of Wight Festival, 1970

E-mail from Julian Colbeck, 28 August 1995:

Hi Daniel,

Isle of Wight, yes. I do remember it pretty well as it happens. Wasn't Charles Alexander our third member?

In no particular order I remember: Eating: yoghurt. This was in fact the first time I'd ever eaten yoghurt. I seem to remember we all came to the conclusion this was the safest and most vaguely tasty way to stay alive.

Sleeping: At an angle of 45 degrees. We camped on the hill. I remember going to bed IN the tent. And then waking up about 30 yards below the tent as we'd all slowly slid downhill.

Washing: I don't believe we did. In fact, filth was one of our prime reasons for leaving when we did as I recall.

The corrugated iron fence bashing down I remember very clearly. There was a whole bunch of pleading and whatnot from the stage. But the fence was way back so I don't think anyone inside much cared or felt threatened by any of it.

The music was just brilliant. I remember pretty much everyone who was there. The Who (who I seem to remember claiming this was the last time they were going to play anything from *Tommy* – Ha!), The Doors, ELP (their debut), and, as you correctly say, a bit of J. Hendrix's farewell performance – a lifelong regret we didn't see it through.

Amazingly enough I still have a programme. Probably worth a few bob by now.

The overriding vibe was mellow, that's for sure. I don't remember ever feeling threatened. (I think I remember seeing someone with a knife, or something about a knife . . . don't know). I don't think any of us smoked (dope) at the time so we probably missed out on that aspect.

I also remember coming home and my folks being absolutely apoplectic with worry since news reports had the festival pegged somewhere between Fellini's *Satyricon* and the Battle of the Somme. Are we going to be happy to let our offspring hive off to some mind-altering multimedia fest or whatever it might be, when the time comes? Oh Lord.

Let me know how your Bus Revisited goes. Sounds great. You should do one cross-country over here, when you're done.

Love to all.[29]

Journal of the Free Photographic Omnibus

1 December 1973, Manchester (*extract*):

During my Yorkshire trip I was pursued by telephone calls from a Mr K. from Newton-le-Willows. In Teesside he eventually ran me to ground and I gave him a ring. "Hello, yes K. here. I've got lots of money, lots of time and no common sense. Where are you? I want to come and see you. I'm a photographer myself, but I don't have any legs. I have a car."

When I got back to Manchester I rang him and told him where to come to see me. We arranged a time and place, but he failed to turn up. However, the following evening – when the bus was parked in a completely different part of the town – he came to see me. I had been working in the college all day and hadn't been in the bus since the morning. It transpired that he had been parked in his specially adapted Daf Variomatic van since lunchtime. He was huddled in the driver's seat – a gaunt figure with a lean, bearded face wrapped up under a greasy trilby in sheepskin rugs and overcoats. He was chain-smoking.

I got into the passenger's side of the car and, since the seat had been removed, sat on a foam rubber cushion. He showed me some photographs (commercially printed, instamatic enprint size) which he had taken mostly from the window of his car. The pictures showed no great merit, although one or two of a fight in a warehouse were quite interesting.

I gave him a cup of tea and we talked about the bus and about him. He asked me what I needed. I said I needed a Uher tape-recorder which I couldn't afford, but which would mean that I could get some really good quality tapes. He said that he had a tape-recorder and would I like it? I said, "Let's have a look." So he leant forward in his chair and lifted a cushion that was on the floor where his legs ought to have been. Under the cushion was a revolver.

He placed the cushion to one side and put the revolver on top of it. All that was left on the floor now was a tape-recorder (cassette dictaphone, no good for me). He offered it to me for £5. I told him it was no good thank you very much.

"Now," he said, "I have a proposition. There's a thousand pounds in it for you if you let me come and live with you on your bus."

As told to Alan Dein for the National Sound Archive, 12 April 1995:

And I just said: "No way! I don't even have a girlfriend living on the bus!" And I tried to explain all the reasons why: that he wasn't physically capable of being able to move round a double-decker; that he wouldn't be able to get his wheelchair down the gangway between the seats because it was so narrow and upstairs it was sunk in a well; that he wouldn't be able to get upstairs anyway and that was where the only washing facility was. On and on. A million reasons why he couldn't come . . .

I remember thinking: What's he trying to tell me, this guy? What's he trying to tell me? Showing me his gun like that!

On the Road

I had no time for thinking because all my energy was taken up with doing. As the winter of 1973 turned into the spring of 1974 and my 22nd birthday came and went, the operation of the Free Photographic Omnibus rapidly became a bureaucratic nightmare.

Taking pictures was the fun bit, but the paperwork soon drove me mad. These were the days before the fax, the answering machine, e-mail and the mobile telephone. Living on a bus it was almost impossible for people to contact me, yet the bureaucracy always insisted that arrangements be confirmed in writing. I had just the one mailing address,

at Manchester Polytechnic (where I was registered as a fellow of the Institute of Advanced Studies) and letters forwarded to me at the offices of regional arts associations sometimes took weeks to reach me. For the rest it was "push button A" public telephones and telegrams.

The free portrait sessions only worked when they were properly planned, a process that began about six weeks prior to the event with telephone calls from wayside call-boxes to town clerks and borough surveyors in strange towns far away.

They frequently failed to understand my basic requirements: that I needed to park near a good flow of pedestrians, next to a market place or a shopping centre, and that the bus had to be prominent. I needed space, enough for people to move around and look in the windows while they queued up for their pictures. The success of the portrait sessions depended entirely upon getting these conditions right. Occasionally, when I didn't get my own way, I would lose my cool.

Journal of the Free Photographic Omnibus

1 October 1973 (*extract*):

Arrived in Sheffield to find that the Estates Surveyor at the Town Hall hadn't received "early enough notification" of my arrival (at least 2 weeks) and hadn't bothered to do anything. After many protestations and much bullshitting over the phone he offered me the exhibition site on The Moor at £10 per day. Told him where to get off and finally ended up going to see one of the publicity officers who was v helpful. He got it down to £5 per day and I agreed to take it for 2 days – Tuesday & Thursday. He is even now trying to reduce this sum and if he can't he will consider paying it himself.

Journal of the Free Photographic Omnibus

2 October 1973 (*extract*):

Up at 7.30 to get an early start. What a hope. Saw Estates Surveyor Mr B. at 9 am to see about parking on The Moor exhibition site. B. is a scraggy little official with bad teeth who talks in clichés and acts only on the authority of his superiors. He is unimaginative, totally deferential, very boring and incapable of making decisions. When I got to Hereford Street it was closed for demolition and the exhibition site (£10 per day remember) was a bombsite. I asked the parking attendant how many people walked through his site – he replied that he might get 5 visitors a day. I was so cross that I reversed into a No Entry sign. I stormed back to B.'s office and let rip. "I'm not taking the bus down Hereford Street, you couldn't get a bicycle down there!" Well, there was nothing he could do about it without the authority of his superiors. The little runt.

If my intention was to fuck the system, I was a five-star failure, for I rarely progressed much beyond maddening its minor officials.

Running the Free Studio

Running the free portrait sessions was a discipline. It was a Quaker thing and also something I got from my Dad, I suppose. Duty. I had been brought up to be true to my word. It was a contract, plain and simple.

On a good day I would get 60 or 70 people through the free studio, and because I had no film to waste I would try to photograph them all on just three rolls of medium format

film. Twelve frames to a roll, two people per frame, 24 people per roll, give or take.

When making any kind of judgement about the bus portraits it is important to remember that they were presents. I tried to get the people who posed to stay still and take it seriously. I wanted them to like the picture when I gave it back to them the next day. I didn't want to do all that hard work in the darkroom only to have it tossed in the bin or dropped on the ground.

But the contact sheets of the earlier sessions show guys baring their arses to camera or making a V-sign over the heads of their friends, or girls giggling uncontrollably. I quickly learned that people didn't like those kinds of pictures of themselves.

So I began to boss them around a bit, telling them not to muck about. I became a director. I didn't have film to waste and I was giving myself only the one chance – one frame, one click of the shutter – to produce a portrait, even a group portrait. This, of course, made things easier in the darkroom because there were fewer films to wash. Water was always in short supply. I had to carry it upstairs to the darkroom in jerry cans. Sometimes I used the sinks in public lavatories to wash the film, or taps at filling stations or, failing that, rainwater from the bus's guttering, even water I gathered from streams. I was always very careful to wash the films as best I could, because I wanted the negatives to be archivally useful. If they weren't washed properly, I knew they would fade or stain.

One of the things I like best about these portraits when I look at them today is the way the people present themselves to the camera. Not one of them expected to be photographed when they dressed that morning. No one had time to change their clothes or do any sort of preparation. There was no mirror on the side of the bus. The people in those portraits are wearing the clothes they would have worn to go shopping or to school. They were on their way to or from work. None of the people photographed had dressed to be photographed.

The best portraits are always a collaboration. They rely for their success on a creative tension between the photographer and his subject. The person being photographed

tries to show off his or her best side, whereas the photographer tries to get beyond this performance, beneath the surface. Both photographer and sitter are very much aware of what is going on and the process is not always easy. It can be very stressful. The trick is to try to turn all this tension into the creative energy that makes a picture work. As long as the photographer's and the sitter's differing objectives balance and don't cancel each other out, the picture stands a chance of working.

I developed the photographs in my little darkroom on the top deck at the back of the bus, while my little Honda generator, pop-popping away downstairs, provided the power. The enlarger was made from a flattened-out and re-worked biscuit tin with a Taylor Hobson lens screwed into it. It had two pieces of pink lavatory paper wedged into the negative carrier to stop the light leaking out.

If it went well I could, in one evening, print all 70 pictures. I printed postcard-sized prints – two on a single piece of 8 × 10 inch paper, and then I trimmed them with a Stanley knife. I used Veribrom – Kodak's first resin-coated paper (then new on the market) – because it had a much-reduced washing time compared with conventional fibre papers. I rinsed the prints in a bucket. The handful of pictures I've held on to from that time are, for the most part, badly stained.

A photographic portrait can be a lovely thing. It allows you to look at someone in a way that you wouldn't dare to look at them if they were sitting in front of you. You can stare for a long time – a lot longer than would be polite if the subject were there in the flesh – and imagine.

Strange Company

I was very lonely on the bus for a lot of the time. But when I was developing pictures in the darkroom I found the company of all these strangers in my developing tray comforting.

Looking at the archive today there are a lot of pictures of girls and I recall all of the opportunities I had to fulfil the expectations of the Underground and sow my own wild oats . . . and how I let them slip away. For I never did take up with a girl while I lived on the road. I wouldn't have been able to look myself in the mirror if I'd discovered that staying with a girl was more important than travelling on the bus. Anyway, I just wasn't ready for relationships, however temporary. In many ways I was a lost creature, content to be no longer a child, but clueless as to how to become an adult.

And I didn't use drugs either, despite the "psychedelic bus tour"[30] tag that sometimes sticks to this project. It wasn't that sort of trip. I was especially wary of drugs because I was always dealing with the police. They'd knock on the door at all hours and ask for a cup of tea as payment for helping me with the parking arrangements. And so, as regards at least two of the objectives of the Underground, I was a total failure. What kept me going was the picture-making and the bus always came first. I would have spent my last penny on the bus – as, in fact, I did.

Winter of Discontent

As my journey progressed, the number of problems mounted up. Even the political situation seemed to be against me. During the winter of 1973–74, Prime Minister Edward Heath responded to the OPEC countries' quadrupling of the price of oil by implement-ing a three-day week. Meanwhile, the coal miners took on the Tories by refusing to

increase the amount of coal they supplied to power stations. There were power-cuts. Then the transport workers came out in support of the miners. It was the first Winter of Discontent.

Ted Heath decided that the best way to run the country was to switch it off for most of the time, so people just lit candles and crawled into bed to keep warm. Motorists were issued with petrol rationing cards and I couldn't do anything without diesel or petrol. Without fuel I was completely stuck: no power for my generator and no light for my enlarger.

This is how bad it was: one day a garage owner let me have just two watering cans filled with diesel. That was all he would spare. And he only let me have that because I'd completely run out and the bus was blocking his forecourt. You need quite a lot of fuel just to prime the diesel engine on a bus and he sold me just enough to get me off his forecourt.

Parking was a daily problem, but I suspect it was nothing compared to how it would be today. Travellers of all kinds have had a raw deal since the Criminal Justice and Public Order Act came into force in 1994. Now gypsies are herded into local authority compounds and New Age travellers have been driven off the road. A Free Photographic Omnibus wouldn't be allowed in the current climate. It wasn't easy in the 1970s, but it was possible. No one ever put a police car on my tail and I used to just pull up anywhere if I wanted to sleep. Sometimes I might wake of a morning and find I'd been given an overnight parking ticket, but that was as bad as it got.

I remember once I asked a traffic warden in Sheffield if I could park across two car meter bays and he said yes and, laughing, added that if I was late back he'd give me two tickets, one on either end. I thought he was joking and laughed along with him. But when I returned – inside the time limit – the bastard had done just that. Two tickets. Two fines.

I did waste a vast amount of time looking for exactly the right location. I liked it when there was a fish and chip shop close by, or a pub – somewhere I could get a meal

and find company. I did cook for myself – I had a cooker and gas sponsored by Calor – but at the end of a long journey I yearned for someone to talk to. I could get very depressed if I was alone in the bus for 36 hours. It wasn't just the travelling, but also running a free portrait session that no one came to, because it was raining or because I hadn't found a good site.

Breakdown

The bus kept breaking down. I couldn't have managed without Joe Parker, the maintenance foreman at Barton's.

The worst breakdown happened during the winter on the M5 near Birmingham. It was bitterly cold and bang in the middle of the fuel shortage. I was towed into a garage. The bus's gearbox had gone and nobody had the parts, so I rang up Mr Parker at Barton's and he quoted me £75 for a new one. When I told the garage mechanics the price, they didn't believe me. "£375 more like," they said.

Back on the road I went round to Barton's to thank Mr Parker. We sat in his office. He gave me a cup of tea and asked me how it was all going.

"I owe you a favour," I said.

"Why?"

"You charged me £75 for something that should have been £375."

"Did I?" he said. "Goodness gracious me!" And he began riffling about in the papers on his desk, feigning surprise and confusion. "Look! A typing error!"

Another time, driving across Salisbury Plain, the gear stick went limp in its socket. And in Manchester the bus was vandalised. Some kids smashed a window and the headlights.

There were times when I really thought I would have to pack it in. There were endless privations and problems, but the adventure I was having, the adventure in other people's lives, was so intense that I was a long time travelling before it occurred to me to give up.

Journal of the Free Photographic Omnibus

1 March 1974 (*extract*):

Emergency resources in the bank now reduced to £28.

The Telly

The people I photographed, though curious, were not always trusting. Mostly they thought I had something to sell. "What's it in aid of?" I'd hear that all the time.

To help overcome this mistrust I began to exploit the media. If I planned everything just right, on my first day in a town the local newspaper would come and write about me and publish a picture of me standing in front of the bus parked in their town centre. Better still, I got some TV coverage – a short item on a tea-time magazine programme. Then the free studio sessions usually went well. All suspicions evaporated because people knew what I was about.

One of my regrets, now that there has been such renewed interest in the project, is that none of these films has been kept. I've checked in my journal the dates when they were made and the names of the companies who made them. But they always say the same: it's been scrapped. And I don't have anything on tape either. The Free Photographic Omnibus lived its life before the days of home video.

Journal of the Free Photographic Omnibus

3 May 1974, Midhurst, Sussex (*extract*):

Have been eating in the *Crusty Loaf* café. This morning when I ordered my bacon and eggs the proprietor was all smiles.

"I saw you on the telly last night," he said. "Now I know what that bus of yours is all about."

When he cleared away my dirty things he slipped me a £5 note. I was embarrassed and followed him into the kitchen.

"I can't accept this," I told him.

He looked hurt. "I don't care if you're a millionaire, I like what you're doing. Keep it."

Journal of the Free Photographic Omnibus

26 October 1973, Middlesbrough (*extract*):

Something is going to have to be done about my relationship with the Press. Of course I want publicity, but I somehow didn't bargain for the amount of interest the bus would cause nor the amount of time each reporter would take. They all take the same boring photographs and ask the same boring questions. On arriving at Middlesbrough yesterday it was a good job that I had a good site and got 3 rolls of free portraits done on Thursday morning before

(a) the *Sunday Times*: Michael Ward, very nice guy and couldn't tell him to go away as his paper is one of my sponsors. In fact, we had quite a pleasant afternoon travelling around the town photographing things of interest; e.g. driving along and I saw

a rag and bone man + boy and horse and cart. Stopped bus; ran outside, asked man if it is okay to take a picture; stopped Michael, who is driving behind "How about this one?" Michael says okay, but could costermonger please bring cart around front of bus? So I organise the poor rag and bone man. Backing the cart proves a little difficult. Eventually I pose rag and bone man in front of me; Michael poses me in front of rag and bone man; I photograph rag and bone man; Michael photographs me photographing rag and bone man with bus in background. All totally contrived and *not* really the way I work at all.

(b) BBC Radio Teesside: "Just drive the bus alongside the studio and we will hang a mike out of the window and do an interview with you live. Okay? Okay, yes, but half the morning gone by the time it's over.

(c) Just got back to the bus and started printing when a BBC *Look North* TV crew roll up. "Oh, we just want an interview." Am working at night to catch up on the printing and processing.

Journal of the Free Photographic Omnibus

27 October 1973 (Saturday), Middlesbrough (*extract*):

Got so distracted by TV people that I left lights on downstairs while working in darkroom and drained battery. When I came to drive off this morning after returning the free pictures, the engine wouldn't start. Thank God I had my generator. Using the battery charger I was able to raise enough power to start the engine though it took about 5 hours.

The Edge of Sharpness

In the spring of 1974 Ted Heath called a general election. He lost by the narrowest of margins and Harold Wilson formed a minority Labour government. A few days before the election, on Thursday 7 February, Bob Greaves, anchorman of Manchester's evening TV programme *Granada Reports*, presented a short film about the Free Photographic Omnibus. It had been shot the previous Friday in the notorious new housing development of Hulme.

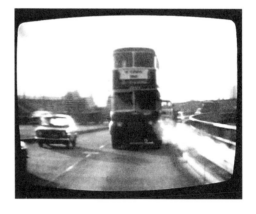

All that remains of that broadcast are the handful of colour stills I took of the TV screen and a scratchy audio-cassette recording. But it gives a flavour of the kind of media coverage I was getting and it's typical of broadcasts made by other regional TV stations around the country.

GREAVES (*voice over footage showing the bus driving along the Mancunian Way towards Hulme*): One person who is sure to have plenty to photograph during this election period is the maverick photographer Daniel Meadows. Since we last saw him in September he has pressed the shutter on his camera over 2,000 times and he's now in Hulme which is where we join him.

MEADOWS: I'm travelling round the country in the Free Photographic Omnibus in an attempt to make a photographic documentary record of England in the 1970s. I set off last September for Yorkshire; I visited Yorkshire for about six weeks. I travelled round the whole county. I returned to Manchester to print up an exhibition for the regional Arts Association and now I'm in Manchester parked here in Hulme with

97

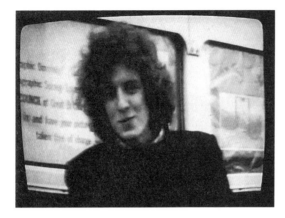

the idea of trying to photograph people living in this modern environment. When I was a student in Manchester I was photographing people who were moving out of terraced houses owing to redevelopment, and now I'm trying to photograph people living in a new environment. New houses with a new lifestyle.

There follows a short clip of me taking Polaroids of the children of St Philip's Church of England Primary School. I carried a Polaroid camera expressly for the purpose of doing TV broadcasts. TV people always wanted to see the results, but they never had time to wait around while I developed film in the darkroom. I reckoned the publicity justified the expense.

In 1973 I wrote a letter asking Polaroid for sponsorship. A few hundred packs to shoot some free portraits, please. They turned me down . . . and a good job too, for if they hadn't, all the bus portraits would have been made on instant film and given away, leaving none for posterity. No archive of negatives and no files full of grubby contact sheets. No *National Portraits*.

But I shouldn't be surprised. All photographers know how big a part luck plays in their lives – both good and bad.

MEADOWS: I'm going to be parked here on the corner of Loxford Street by St Philip's C of E Primary School over the next week starting tomorrow [*This is an error. In fact I was only able to be in Hulme for three days as I was already committed to running a free studio in Stoke-on-Trent from the following Monday. Greaves corrects this in his closing remarks.*] and I invite anybody who lives in Hulme to come and see me and to

have their pictures taken and I'd very much like to come and photograph people in their own homes. What I am trying to achieve is a social document of what ordinary life is like. Newspapers, to a certain extent, do document what life is like in England, but it's more by accident than design; because they tend to photograph the sensational things, the exceptional things, whereas I want to photograph the ordinary things – the very ordinary things we do every day and in ordinary life; in an attempt to produce a book at the end of twelve months of what life is like in England in nineteen seventy-three and four.

GREAVES (*voice over a street map showing the location of the bus*): And Daniel Meadows will be at St Philip's School Hulme in Manchester for the next three days. So if you like, you can join him there.

I see from my journal that after the Hulme portrait sessions I followed three people home. A Mr E. S., who had moved to the area from Cheetham where he had been a cutter in the clothing trade. A Mr L. F., who expressed regret that now he had moved into a block of Hulme "housing units", he couldn't cross the street, turn round, look back at his home and say: "That's all mine." And finally a Mrs E., married to a West Indian and a mother of three. She wanted to be photographed drinking Guinness and sitting in front of her pride and joy: a £40 bar with a padded plastic front. In my journal I recorded the fact that she had allowed an enormous amount of dog shit to accumulate on her balcony, where there was an Alsatian in a kennel and also two doves in a cage.

None of these people made it into *Living Like This*.

Generally, though, I valued the works of photo-reportage which resulted from forays away from the bus and I exhibited them in its windows. It was in these pictures that I invested all my desire to create a lasting record of the times through which we were living. Indeed, ever true to my purpose, when *Living Like This* was finally published, it contained a total of 123 pictures of which 104 were shot away from the bus and only 19 at the free portrait sessions.

 In 1996, when Val Williams edited the pictures for the exhibition catalogue of *National Portraits*, the one she chose from my Hulme visit was a group portrait taken in the rain that Saturday following the TV broadcast.

Three ragged little girls aged about three, five and six – they must be sisters – stand on tarmac in front of some graffitied garage doors. The bigger girl, in the middle, wears sandals and white knee-high socks. She is taking responsibility for the other two, her arms around them, controlling. She wears a check-patterned overcoat, as does one of her sisters. The youngest wears a quilted anorak with a flower pattern. They all have earrings. The depth of field is very narrow. They stand on the edge of sharpness, fragile and in three descending degrees of smiling: grinning hard, tolerantly resigned, and serious. The only thing they look more of than poor is vulnerable.

Living Like This

Living Like This was launched at the ICA in London's Mall on 7 October 1975. The Press reviews were kind, for the most part.

The Bolton *Evening News* liked the eccentric characters. It ran two pictures – the evil fish-fryer Roy Rigali and a knee-dressing in the Hobnails Inn – together with a short piece:

> Even in the plasticated, prefabricated 'seventies, the great British eccentric lives on . . . Like the 69-year-old Yorkshireman who insists on riding his moped on the motorway. Incensed when a chunk of his farmland near Ripponden disappeared under the M62, a Mr Turner dismantled part of the motorway fence and put in a gate for his moped. Once, during a dispute, he fired a shotgun into all the tyres of a Water Board official's Land Rover.

In Weymouth [*Meadows*] found a man who keeps a stuffed poodle in his front-room window. In the same town a comedian who – no kidding – actually gives away trading stamps.

Quotes collected during his 10,000-mile trip ranged from unconscious comedy to bitter resignation. In Goole a docker went on record with "It's not much of a life, this, you know. Up at five to start work at six. Work right through the day till six. Get drunk, home to bed and start all over again. You only get time to watch television once a week. Last time I turned it on I noticed the knob was rusty."

At Market Lavington a shoe repairer said: "I worked it out the other day. Since I started in business as a cobbler I've mended 93,000 pairs of shoes, and it hasn't done me any good. I was broke when I started, and I'm broke now."

Peter Lewis of the *Daily Mail* liked the book as an historical document and, under the headline DISCOVERING THIS LAND WE LIVE IN ran four pictures: a boy with a kite, three lads holding a racing pigeon, a teddy boy elver-eating, and the Bacup Nutters clog dancers.

Last year a young photographer called Daniel Meadows decided to record England 1974 before it is swept away by change. He travelled 10,000 miles in a double-decker bus converted into a dark room photographing English people straight. In 50 years, perhaps only 25, they may look as curious to someone as Victorians do to us.

Reviewing the exhibition in the *Sunday Times*, art critic Marina Vaizey wrote:

Daniel Meadows's *Living Like This* at the ICA is a treat. Mr Meadows is a sensitive, amusing and straightforward photographer . . . [*The exhibition*] is an enthralling selection of images, combined with text: Mr Meadows's own reasons for his choices, his letters to and from authorities, and interviews with his subjects. He is a passionate observer, free from cant, undisturbed by theory. The result is eye-opening, refreshing, informative and enjoyable, and has also been neatly gathered together into a book.

Victoria Radin in the *Times Educational Supplement* also reviewed the exhibition, and at some length:

> The exhibition and book (which contains a slightly different selection of photographs) works on two levels – as a documentation of people living in Britain in 1973–74, and also as a record of Meadows's project. Pinned on the wall at the ICA, along with the photographs, are bills for breakdowns, stern letters from local councils, and – usually on lined paper – acknowledgements from recipients of the free photographs (one of them, beginning with "Thank you for the wonderful description of me and the dog," ends with a dissertation on the state of the weather).
>
> The book is more revealing. In addition to his Pentax and Rolleiflex, Meadows travelled with a tape recorder (he usually put the microphone up his sleeve, so that people would not be intimidated by the sight of it, though they knew it was there). And he has a real eye – and an even stronger ear – for the idiosyncratic, the curious. The full force of his stories comes through the texts accompanying the photographs, which are more complete and satisfying in the book.

The photographic press, more knowing perhaps, was sceptical. In *The British Journal of Photography* Myke Treasure wrote:

> Out of [*Meadows's*] trip came a book called *Living Like This* and an exhibition that has just made its debut at the ICA. It is of course no mean achievement. The value of the expedition however may be a different thing.
>
> Apparently there were two aims behind Meadows' journey: "to photograph a cross-section of the English people," and "To document the lives of those whose quality of life was threatened by the apparent necessity for rapid social change." Both ambitions are considerable and the dilemma of the book seems to be that it never decides which of the two courses it most wants to follow. The result is that it flits from one theme to the other with an insufficient look at either . . .
>
> Where are the pictures of the bank clerks, the teachers, the salesmen and the technicians? The photographic omnibus operated on the basis that Meadows would

take for free a picture of anyone who wanted one; the idea being that he felt that there was no better way of getting to meet the ordinary man in the street. And so he subsequently commented: "The people whose pictures are left out of this book are not it seems the kind likely to be tempted by the offer of a free photograph. In an attempt to accommodate the majority, I accidentally excluded the minority."

The opposite has in fact happened. By working in such a fashion Meadows has hived off a minority and proposed it as the majority. Instead of meeting a cross-section of society we meet a segment which seems to be largely made up of old people and manual workers.

The spiel on the jacket says the book is "a fascinating glimpse of the nation at work and in its leisure hours; it is a formidable protest against the apparent necessity to change our way of life and it is a mark of one man's determination to show the people of England what their country is really like."

It's a glimpse all right, but a glum glimpse that is unrepresentative and uncritical of its subject. And the protest is hardly formidable. [31]

These things I knew in my heart to be true and, so it seemed, did the great reading public, for the plain fact is the book did not sell. Not at its cover price anyway. Three years later I walked into a remainder bookshop in Manchester and took away three carrier-bags full of *Living Like This* sold to me for just 25p a copy. I was so embarrassed that I hid them in a cupboard.

But I couldn't hide them all. Somewhere out there were seventeen and a half thousand of them.

White Album

On 11 March 1997, more than 20 years later, in London's East End at the Standpoint Gallery in Coronet Street, the *National Portraits* exhibition catalogue was published.

I heard Val Williams say to someone: "Don't put it on a bookshelf, keep it with your records, it's supposed to be like The Beatles' *White Album*." That was the first I knew about it. But, yes, it *is* the same size as a vinyl LP and, sure, it's white. Twelve inches square and not a mark on it. The cover front and back, the spine too . . . they are all white.

The Arts Council hadn't given the publisher quite the money he required to make the hardback he wanted. They said it should be a more affordable softback. All that lovely paper and incredibly expensive printing risked between floppy covers. Ever resourceful, the designer made a loose dust jacket for it to stiffen it up and put the Levi's "head" on the front.

The nationals largely ignored this book, but the photography writers were kinder.

Colin Ford, BBC Radio Wales:

It's a very valuable and important archive. We learn an enormous amount about people. I think [*the pictures*] fill you with a sense of hope and confidence in the human condition. Photographers usually work on the edges of life. They take people *in extremis*. They look for the worst, the dirtiest, the frightfully grand, and Daniel is actually photographing ordinary people in ordinary situations in real life and that's the rarest kind of photograph of all and I think the most valuable.

David Lee, *Art Review*:

The style is simple, no trace is there of those dual faults characterising the work of so many brainless contemporaries, namely pomposity and pretentiousness. This work falls comfortably into a literature of unfussy, direct portraiture, of which

Nadar is the Messiah and Sander, Arbus and Avedon the more recent apostles. This estimable genre is founded on the truism that there is nothing more curious than a human fact simply observed.

Creative Camera:

Crucial reading.

Val Williams's selection of pictures for the book centred on her liking of the portraits shot against blank walls. Of the 41 pictures in the book, 34 are of people standing in front of blank walls. Only seven of them show people standing out in the open.

In her essay Williams wrote:

Coming across these photographs in the late 1990s is to witness a forgotten land. High quality chain store fashion was in its infancy and any ordinary person who wanted to be fashionable had to mix and match or make it themselves. And where was there to go when you were all dressed up at a time when the word clubbing had not entered the vocabulary? Saturday afternoon was still the big time for youth in provincial England, girls went round with girls and boys with boys until partnerships were irrevocably split by the opposite sex. Teenage girls went shopping with their mums, and often looked just like them. Children still played on the street and allowed themselves to be photographed by men they didn't know. Sociologists and politicians courted the working class; on TV *The Likely Lads* and *Coronation Street* flourished and *The Sunday Times* magazine sent star war photographer Don McCullin to photograph the slums of Bradford.

Daniel Meadows and his photographs are both part of this and separate from it. Meadows was too quirky and individualistic to be completely acceptable to the mainstream media. He didn't portray people in desolate kitchens and back-to-back houses, and when he photographed people on the street, they seemed to be as curious about him as he was about them. You could say it was a collaboration. Both Meadows and his subjects were engaged in the mysterious process of

portraiture, in which both the photographer and the photographed give something of themselves, but never tell the whole story. From Meadows' own accounts, we know where his interest lay, to make an authentic document of English life in the mid 1970s. But what of his subjects? Looking at these photographs we can only guess, for these are open documents in which we can invest our own fictions . . . Their faces, their clothes and their demeanour are stilled documents of time and place, sombre and full of sadness, and the melancholia they induce is potent.

Distanced from us by over a quarter of a century, these photographs look more modern now than they did in their own time, but nevertheless they are an archive, a record of a disappeared world. They reinforce what we all knew anyway, that documentary photography, in its constant striving to tell the truth, recounts very partial stories, realistic chronicles from the imagination.

PART TWO

I

BARROW-IN-FURNESS

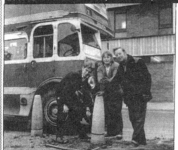

DEAR DEAR! £10 to remove that bollard

ARE you a face of 1974? Did you have your picture taken by travelling photographer DANIEL MEADOWS when he brought his double decker bus to Barrow 21 years ago

If so Mr Meadows, now a university lecturer, would like to hear from you.

If you can help, phone our Ulverston office on 582010 and ask for Julia Gregory.

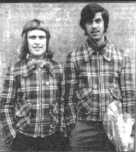

DEEP PURPLE: The lads with that LP

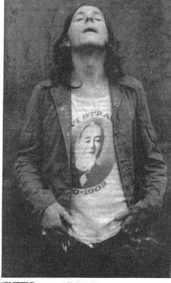

LEVI FIRST? The youngster with that t-shirt

WHAT A PICTURE! BUT ARE YOU IN IT?

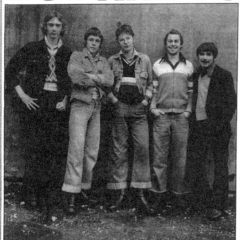

SHANGALANG! Short flares and Doc Martens set the fashion trends way back when

TWINS: Where are they now 21 years on?

TWENTY-ONE years ago a young photographer rolled up to Barrow in a double-decker bus and set up his studio on Dalton Road where Kwik Save is now.

He had to convince people his offer of free pictures was genuine, but so many people turned up he had a long night printing up pictures in his makeshift darkroom.

On one cold October day he captured the images of dozens of people who walked past his bus, giving them free copies of the pictures when he returned.

It was part of an epic trip round the UK which was at times very lonely, cold and sometimes the money looked like running out.

But Daniel Meadows looks back fondly on his travels in 1974.

"It was a time when there was a cult of young people and people wanted to encourage young people," he said.

But it was still difficult to get the money together for the trip which cost £3,000 — no small beer in 1974.

"I wrote ten letters a day every day for three months and got a lot of response."

The Arts Council gave him a £750 grant and the Northern, Southern, Yorkshire, West Midland and East Midland regional arts associations also contributed to the fund.

He bought a 25-year-old double decker bus for £300 and took out the seats, converting it into his home and office on wheels for the next few months.

Out went the seats and in came a darkroom, bedroom, cooker, sink, desk, bookcase and lavatory.

Mr Meadows also displayed pictures on screens fixed to the windows so people could see his work even when the studio was closed for business.

He put together a book about his travels, packed with excerpts from his diaries and tape recorded interviews with people he met along the way.

He came to Barrow because the name fascinated him.

"Some places had magical names to me. It was at the end of the motorway and looked like it should belong to the Lake District."

He is now trying to track down some of the people he captured on film and for that he needs your help.

"I want to find out how people have lived their lives, the people with the Deep Purple LP and the twins who must now be about 25. Have they ever worked?

The two school girls, have they stayed in the area?"

If you recognise yourself or a friend in one of the pictures Mr Meadows would like to hear from you.

Once he had got over people's initial suspicion of the free photo studio, he had a busy time.

"Barrow just went perfectly. Reading through the diary and looking at the pictures I remember it was a good site with lots of people. The council came and removed a bollard for which they charged £10."

He still has the receipt and a letter from the council clerk telling him where he was allowed to set up shop.

As with all the other towns he visited on his travels Mr Meadows remembers it as very bureaucratic.

"I had to plan everything in advance," he remembers.

"Had it not been the very last free studio, I would have had a row with them about charging me for removing the bollard. £10 was a lot of money in those days (about £80 today) and I could have lived on that very happily for a fortnight."

But the people in Barrow soon became enthusiastic about the scheme.

"One kid appeared twice," he recalled. He also remembers with affection the fashions of the day, including the polished Doc Martens worn with flares and Bay City rollers outfits.

One subject in Barrow was wearing a Levis t-shirt which Daniel believes must have been one of the first of its kind, perhaps it is languishing in the back of a cupboard somewhere.

"I used three rolls of film in Barrow and gave each person a picture. I must have printed about 80 or 70 prints.

"It was my last free studio and I think it was the best in the way people took it seriously."

Mr Meadows went on to become an artist in residence in Pendle and worked as a freelance photographer for New Society, The Observer and The Times before becoming a picture researcher for Granada Television.

He has also worked for the British Film Institute with stars such as Richard Burton and worked on television programmes including Inspector Morse and Seaforth.

He is now a photo-journalism lecturer at the Centre for Journalism Studies at the University of Wales, College Cardiff.

That is his story — but what's the tale of the subjects in his pictures?

Words: JULIA GREGORY

Twins

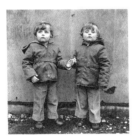

1974 1995

Teresa McParland was out shopping in the northern coastal town of Barrow-in-Furness, Cumbria, when she came across the Free Photographic Omnibus. She was pushing a double-buggy in which sat identical twins Michael and Peter, then only two years old. Teresa's immediate concern was that if she were to pose the children for a photograph she would first have to rouse Peter who was asleep.

Today, with the original photograph safely pasted in the family album, she's glad she visited the bus.

Her husband Mike is well known in the town because he has run boys' football for as long as anyone can remember. After school the twins both served their time in Vickers's shipyard as apprentices. Michael is a sheet metal worker and Peter a plumber. Following the downturn in the nuclear submarine business after the end of the Cold War, there were no more jobs for them in Barrow so they began working away from home on contract. At the time of the reshoot, 19 August 1995, they were 23. Michael was working in Sweden and was home only once every eight weeks. Peter was working in Wales. They don't get together as often as they might.

Boot Boys

Brian Morgan, Martin Tebay, Paul McMillan, Phil Tickle, Mike Comish, "Boot Boys" from Barrow-in-Furness.

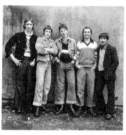
1974

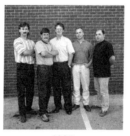
1995

Two pictures also taken in Barrow, 21 years apart. In 1974 these five men called themselves "Boot Boys". They were 15 years old and in their final year at school. A year later they became apprenticed tradesmen; four of them at Vickers Engineering (where the British nuclear deterrent is made – Polaris then, Trident now) and the fifth, Brian Morgan, at North West Gas.

When I persuaded the local newspaper in Barrow, the *Evening Mail*, to help me trace them in 1995 by publishing the picture across its centre spread, I gave little thought as to how the lads might react to being contacted again.

I report here, in their own words, their reactions to the picture when, without warning, it dropped into their lives.

BRIAN MORGAN: I'd nipped home on the Wednesday afternoon and my girlfriend said: "Sit down I've got something to tell you." And I thought it was something really serious (*laughs*), which it turned out to be. Her hairdresser had phoned her up saying: "Go and buy an *Evening Mail* and open the middle pages." And that's what was produced on my lap. A photograph from 21 years ago. And then the phone started ringing.

I was in too much of a state of shock to answer it. But the next day was the worst. Just like the other lads in the photograph . . . the amount of stick they got, and sarcasm, it was unreal. Suicidal. I thought I'd go to work early to get away from everybody before they turned up. But they had the same idea, and turned up at the same time. So I took it like a true man and went out to do my job and tried to forget about it. But I couldn't because everywhere I went people had made photocopies of the picture. Enlargements.

Every cupboard door, and locker door, every drinks machine you went to there was a photocopy on it, and sarcastic comments underneath.

MARTIN TEBAY: A lot of lads the same age as me who see that photograph now are jealous of the picture and wish that they'd had their photograph taken around that time, because it is just exactly as it was.

That's as it was in 1974. And a lot of lads aged 14 or 15 don't often get photographs taken like that. You know, when they're young children – eight, nine and ten – their parents take a lot, but as you get older you don't gang around with your mum and dad, you want to go somewhere on your own and you don't get so many photographs taken.

PAUL MCMILLAN: I was in Lanzarotti on holiday when it was printed in the *Evening Mail*. I found out at Manchester airport when I landed. My mate's wife picked us up and I was putting my suitcases in the back of her car and she turned round and said: "There was a picture of you in the *Evening Mail* about two weeks ago."

And I thought it might have had something to do with mini rugby which I was involved with. And I said: "What was it?" And she said: "Oh it was you and four of your friends." And as soon as she said "four of your friends" I knew which ones she was talking about. And it all came back. My mother's got the original picture in an album.

PHIL TICKLE: The first thing I knew about the photograph was when I opened the *Mail*. My partner Karen, she works in the *Evening Mail* and you'd have thought she'd have warned me, wouldn't you? And I was reading through and I turned to the centre pages and God! I nearly choked! I mean the first thing I thought was: They can't do that without asking your permission! Surely not! Luckily, when I looked at it, I saw I was right in the crease and I thought perhaps people wouldn't look. So I shouted to Karen and I said: "What's this in here?" And she said "What?" She hadn't recognised me! So I thought, it's not so bad, if she didn't recognise me no one will. Plus I've had a moustache all my adult life until about four months ago when I shaved it off, so I thought: that picture of me without a moustache . . . no one will recognise me. So

I went to work the next morning, and before I'd got there they'd been round, and there were photocopies stuck up all over the place. How they recognised me I don't know. I could hardly recognise myself!

MIKE COMISH: [*of the 1974 picture*] You'd taken another picture of me earlier that day. And I met these lads and told them to come and get their photograph taken. And when you gave the photographs to us you wouldn't give me one. You said: "You've already had a free one, so sod off." And I didn't get one.

So the first time I saw it was when it was printed in the *Evening Mail* the other week. I had a phone call on the way home [*he is a British Telecom engineer and carries a mobile phone*] and my wife had the paper and told me. Luckily I wasn't in work, I'm on the sick. I had a dislocated elbow playing football, so I've had a couple of phone calls, but I haven't actually seen the photocopies. That's yet to come.

Phil told me that in 1974 "all the lads had read" the book *Boot Boys* by Richard Allen.[32] This was the third of a highly successful series in which pulp fiction writer Allen (real name James Moffat) exploited teenage violence. He has been described by the publisher of his Charles Manson cash-in *Satan's Slaves* as "an archetypal hack who measured writing time in bottles". Allen's two earlier books were *Skinhead* and *Suedehead*.

Tom Walsh, the thuggish "hero" of *Boot Boys*, is the leader of a gang of cronies called "The Crackers" and "a law unto himself". His pleasures in life are "bashing heads, kicking the shit out of anyone too weak to defend himself, and laying anything from 12 to 60".

During the skinhead era, Tom had geared up with a Ben Sherman shirt, Levis, Doctor Martins' (*sic*) boots and a sheepskin. Somewhere at home he still had his bovver boots.

That had been then. No longer. The fuzz crackdowns on soccer crowds wearing skinhead "uniforms" had been the camel-breaking straw that started the rot.

Personally, Tom did not mourn the "passing" of skin-headism. He enjoyed being

individualistic. At least where dress was concerned. He spent more money on gear than his father did keeping the household going in groceries. He had a wardrobe many a Mayfair socialite would have been proud to show off to some skinny dolly bird.[33]

PHIL: That is the worst picture I have ever seen of myself! Whether you agree or not, a lot of people would back me up on that. The first thing everybody noticed was the curled up cardigan at the bottom. It looks like I'm going to hand-glide home. It's some bad gear isn't it really?

We all wanted to be Boot Boys. It was the fashion at the time. Obviously it's what you could afford. We all wanted to be Boot Boys, but we didn't all have the gear. Instead of Doctor Martens I had what we called Major Domos. They had the same effect. The reason Mike isn't in that gear is because he went to a school that required a uniform whereas we didn't. And Brian liked flares (*laughs*), but he still had his Doctor Martens on. Our pants were "parallels".

We all read the book *Boot Boy* (*sic*). It was obviously meant to appeal to people of our age and almost tell you how to behave. Fighting all the time, and looking cool and being in trouble. It relates so well to the things that we knew. There were a few books out at the time: *Boot Boy*, *Skinhead* . . . have you never read any of them? They were good books. It was what you wanted to read. How to behave, treat people like muck and do what you wanted to. We all had ideas that we were little tough guys. In our own little bunch we thought we were something. We used to get in the odd fight. Martin looks the most threatening, but he was probably the softest out of us all. But he had the best gear, he looked like the bloke on the front of the book. Whereas I had to wear what my brother wasn't wearing that day. I've got two big brothers.

I was a vandal. Not a great vandal. But you know you felt like you had to do your bit at that time. But I don't think I did anything particularly bad in my life.

MEADOWS: Broke a window or two?

PHIL: Oh yeah. Things like that. Snapped the odd car aerial perhaps. And you look back and you think "God if anyone snaps my car aerial I'll kill them!" Know what I mean? But that's part of growing up. And I don't think we were such bad kids in those days to be honest. I mean there was no such thing as drugs. We tried the odd fag and that was it really. We weren't a proper gang. Not really. We met 'cos we were in the Army Cadets. It was great because we had it to ourselves. Paul was the sergeant and Mike was a corporal. We used to go down the rifle range and shoot a .22. And Paul was in charge. He was in our class so, as you can imagine, the discipline down there was nil. We went on a camp to Glencorse Barracks in Edinburgh. It was an all-important part of growing up and kids these days don't get it. They're thrust into adulthood so soon that they don't go through all these little traumas and adventures that we used to go through. They are starting to act like adults when they're 14 and it's such a shame.

MEADOWS: You were 15 at the time and a year later you would have left school. What did you do then?"

PHIL: We did what everybody did. Applied to get in the yard – Vickers Shipbuilders as it was then – and luckily I was successful. I mean you get given a trade, but you don't know what it is. Doesn't matter what they tell you. I applied to be firstly a draftsman, secondly an electrician, thirdly a fitter and turner – none of which I knew what it was – fourthly a plumber. Well when I went to my interview he looked at my record and said: "Perhaps a plumber or a coppersmith." When he said "coppersmith" I didn't know what it was. Basically it's the same thing as a plumber. That's the only job I got offered. I took it.

MEADOWS: You were putting the plumbing into nuclear submarines?

PHIL: That's right. I still do now. Well, in as much as I don't do it now myself, now I make sure it's done right. I'm a quality control inspector. It's a promotion. I'm on the staff. I wear white overalls. I'm not a blue-collar worker any more. I'm a white-collar worker. But you know I'm still one of the lads really.

MEADOWS: Did you get involved in union activities?

PHIL: It's funny you should say that. I used to be on the union when we had a bit of power. In those days you could go and argue with the managers and actually say what you felt. Up until probably four years ago when all the redundancies started coming in and all of a sudden, whereas a union man's job was safe in the past, it became that a union man's job was targeted. So you are going out, putting yourself on the front line. It's all right saying "Don't shoot the messenger", but unfortunately they do shoot the messenger. So now I do make my points, but obviously you've got to do it politely.

MEADOWS: What are your views about nuclear protesters?

PHIL: I've got absolutely no time whatsoever for CND, especially people who work in the yard and are in CND. To me they're people who have nothing better to do. I'm a great believer in the nuclear deterrent. I understand what it is and I think it's the only thing that has stopped this country being at war in the last 40 years. Also it keeps us in employment. Members of CND wouldn't be in the position to be able to complain if it wasn't for the fact that we're building nuclear submarines. I find them such hypocrites.

It sounds callous and I don't mean to sound callous, but what's better, you know? Four thousand people having meals and regular income rather than the one person who might die from leukaemia? You've got to look at it in terms of the general good.

I've no time for these protesters who turn up [to demonstrate against nuclear weapons]. I think we're too soft on them. They [the police] should hit them with their truncheons rather than just lead them off. You can see by their appearance that these people have put nothing into this country whatsoever, they make no contribution to the common good. They're travellers. Travellers to me are worthless.

I work for my living, I don't like going to work, I'd be happy not to work for the rest of my life. Unfortunately it's something I have to do. Whereas these people turn up in their old flipping combat jackets, they just mosey around from protest to protest and they think they're doing something for us; they're not doing anything for the people of Barrow. We don't want them. They lie on the bridge, waving at the submarines. They

should just chuck 'em over the bridge as far as I'm concerned. I've no interest in them. They're not from this town, they've nothing to do with this town and they don't know what it's like to have to work for a living. And I think in this country we do make too much allowance for minorities. I think [*the travellers*] are beyond saving. If a gypsy wants to be a gypsy that's fine, if a traveller wants to be a traveller that's fine, but their children should have a steady one-place environment in which they can become valid people for the future. [*Travellers*] can only travel thanks to people like us who have a steady job.

MEADOWS: Some people might say I was a New Age traveller, going round the country in a double-decker bus.

PHIL: But you didn't do any harm. You were doing something constructive. You had something with an end to it. They drift where the wind takes them. Twenty-seven earrings in their ears. They look like dregs and they act like dregs.

MEADOWS: You've got a family of your own now. Have you got children who are the same age as you were in my photograph?

PHIL: I've a boy of 14, yeah.

MEADOWS: How do you feel about what he is growing up into compared with what you had?

PHIL: I live his life for him every day. I might have a rough exterior but . . . my outlook is so different. I think: "Did my dad care about me the way I care about my boy?" Well the truth is he didn't. Because people's attitudes to their children are changing. My dad came home at half past four. Up until four o'clock I'd give my mum hell. I wouldn't do a thing she said. She could slap me all day 'cos she couldn't hurt me. I'd tell her to F off, everything. At a quarter past four I'd go: "Mum, don't tell dad, don't tell dad, mum, give me a chance!" And she wouldn't tell my dad because my dad was a disciplinarian. Now, I see myself as being on a par with my children. I take them everywhere. I walk with them. I play with them. I don't do it as much as I should, but I do it 900 per cent more than my own father did. I've never been for a walk . . . I've

never been on a holiday with my parents in my entire life. I've been for a day in Morecambe, Blackpool, Southport and one day up the lakes in my entire life with my parents. I've never walked to the end of the street with my parents. But that's the way things were then. I still kiss my son and he's 14 . . .

MEADOWS: Well I do with mine.

PHIL: He can't go home without kissing me although he doesn't want to. He won't let me go without it. He looks around and then "See you dad!" and off he goes.

MEADOWS: What are his prospects in Barrow?

PHIL: The way things are you don't have an apprenticeship any more. Not as such. You go to college and get an NVQ – National Vocational Qualification. But I'd still like to see him in a trade.

MEADOWS: How would you feel if your boy did his A levels and went off to university?

PHIL: I would be proud of him but, tell you the truth – it's probably a working class concept – I sometimes think to myself: "If he ever did that, would he be really happy?" Because I know what happy is at my own level. Being a working class person it doesn't take a lot to make me happy to be honest, you know? You want enough money to have a good life. Maybe a holiday every year. Whereas I think sometimes when people go to university they are searching for something that they never actually find. They come back over-qualified, they've gone into a different class system. I want him to have a good life and be comfortable. And I want it for all my children, not just my oldest. I've got a lot of worries about them and you can only hope things turn out right.[34]

Two Christines

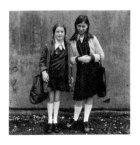 Twenty-seven people are photographed on the second film I shot in Barrow-in-Furness that November Friday in 1974. Thirteen of them appeared in the *National Portraits* catalogue. In 1995, with the help of Julia Gregory, a reporter on the North West *Evening Mail*, I identified and re-photographed nine of them. Two of the three people I never found again were a pair of schoolgirls aged about eleven or twelve.

Today you wouldn't photograph children without getting parental permission. No more would you be awarded public money to finance a project like the Free Photographic Omnibus without first being subjected to a risk assessment exercise, publishing your articles of association, establishing an equal opportunities policy – and God knows what other mumbo jumbo, as my Dad would have said.

These two anonymous schoolgirls are a delight, each in white knee-high socks and their school uniform. The shorter one on the left is more forthright, or perhaps she's just sporty. Physically she is still a child. Her skirt is short not so as to show off her legs, but so that she can run about. She wears no grown-up things – rings, bangles or jewellery – except for her expression. She may have been giggling or about to burst into fits of giggles. But at the moment the shutter clicks she has a straight face and she gives the camera a gaze of such intensity I wonder that I didn't blink. She is confident, direct, open, and at the same time curious. Her anorak stops in line with the hem of her skirt and her hair is tied loosely in bunches and held with elastic. On her V-neck jumper are two strips of what look like school teacher's Dymo labelling tape, their legends indecipherable. Was she a school monitor, a team captain perhaps?

The girls mirror each other in their dress and, most particularly because they each

carry large, dark, square, capacious bags, in leatherette or some such, looped over a right or a left forearm. They look like bookends.

The taller girl is darker, her hair long and loose, pushed back over her ears. She is fighting shyness, her gaze strong, but her chin tilted down. She might be a little older than her friend. She has learned how much she can get away with as regards the school dress code. Her shoes are two-tone rather than black. Her white blouse has a flower pattern at the collar. She has a bangle on her wrist. She wears a fashionable light-coloured fleecy jacket with its zipper undone and a wide collar in dark cloth matching the cuffs. She leans towards the centre of the frame as though she believes a picture is only made in the middle. She tries a smile.

A double portrait of certainty and doubt, discovery and reluctance.

Christine Staunton and Christine Laughran, friends, from Barrow-in-Furness.

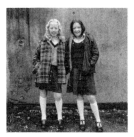 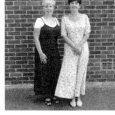

1974 1995

Another pair of schoolgirls on that same film did turn up when their picture was published in the paper, so I photographed them again. They were 13 then and 34 now. The Christines Staunton and Laughran. The blonde and the brunette. Long hair then and short hair now. Daughters then, mothers now. Their smiles haven't changed. The brunette's is sleepy still.

I should have taken that grey cement wall in Barrow around with me, the one with the stains and what look like bullet holes. It's a backdrop in a million. In 1995 the Christines stand in front of a brick wall. Knitting pattern brickwork of 1980s origin – Thatcherite – and the bricklayers have inverted them alternately, they smile and frown.

In an ideal world I would have placed my subjects ten feet in front of that wall and used a wide aperture to throw those "me first" bricks right out of focus. But then the Christines would have had to stand in the road, and anyway, that July day it was bright and sunny and my film was too fast for such tricks.

It is the appearance of the people that is important, not the poses or the similarities of background. When I started doing these reshoots I would drop an acetate contact print of the original negative into the viewfinder in order to line up the poses accurately. But it was not a sensible idea. Over a quarter of a century people change shape. Forcing them into an old pose is like asking them to dress in clothes they've outgrown. And, yes, the clothes . . . this time they are dressing to be photographed.

No, I'm not re-creating these photographs. I'm re-recording the people who are in them. The original is always the more evocative, but it's the combination of the two – past and present – that opens up a new dimension of appreciation.

In 1995 the Christines occupy the same amount of space in the frame as they did in 1974, yet they are a foot taller. It doesn't matter. And the blonde Christine has her hand on the shoulder of the brunette Christine instead of the other way about. Again it doesn't matter. The reference is made. That is sufficient. I always start these sessions by suggesting that my subjects pose like they did in the old photograph, but by the time the shutter clicks, things have always changed . . .

Take Brian, for instance (page 5, far left). He had his hands on his hips in the original Boot Boys photograph, but he wasn't going to be caught out doing that again. Oh no. People were already making remarks. So this time he'll fold his arms if it's all the same to me. And of course it is. These details are valuable in themselves. They are the very units of measurement by which we mark the differences between then and now.

I'll Still Love Him if He Fails

Brian Grafton was 23 in 1974, 44 when I re-photographed him in July 1995. I was lucky to catch him. He works in the oil business, on contract abroad. He had just returned from Algiers and was visiting his parents. He was due to be off again shortly. At the time of

Brian Grafton and John Helling, friends, Barrow-in-Furness.

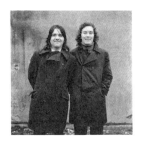

the 1974 picture he was married and working with John Helling in quality control at Vickers, but they have since lost touch.

I told Brian the picture was taken during a Friday dinner time. "We were probably out for a drink. I was working nights then," he said.

Brian had done well at school and went on to study physics at university where, during his first term, news came from Barrow that his girlfriend was expecting a baby. He did the right thing by her and everything went well for a while. He passed his first year exams with flying colours. But during the second year the pressure of being a father and a student got to him and he came back home to work in the shipyard.

He told me that his chirpy expression in the 1974 picture concealed his real situation, for he was miserable living on Barrow Island's notorious council estate and he felt trapped. He hated looking out of his window and seeing his children playing in the dog shit.

"I'm a grafter," he said, "it runs in the family. After all, it's in the name! But there was no reward for hard graft at Vickers. The union decided who got overtime and they handed out favours to their own."

So he left and "went contracting" in the North Sea. "It was a decision we made together, me and my wife. But she didn't stand by me." The marriage broke up and he began the life of a travelling contractor. He has travelled all over the world. He lived in Holland for a while and speaks Dutch and French. "I was in love in Holland," he said, but revealed nothing more. His biggest regret is dropping out of university. Today his son is at university. "I told him to do his best, not to worry so long as he does his best. I'll still love him if he fails."

The reshoot I did is not much of a picture at all. We couldn't find John so Brian is on his own and it doesn't work. Also he had fallen on his way home the previous night, grazing the side of his face.

Physog

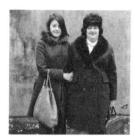

1974

1995

Barrow-in-Furness, November 1974. Karen, photographed on the arm of her mother Barbara, remembers the picture being taken. "You were a young guy out there taking these pictures and I thought I'd get me physog on it." She was 15 at the time and recovering from an appendix operation. Either that or she was playing truant . . . something she admits she did a lot. "Jigging school. Hiding in multi-storey car parks, sitting in cafés with mates, pool rooms, walking round the park." Did she ever get into trouble for it? "Loads of times. I was always getting caned."

We know for sure it was a Friday and that Karen and Barbara were on their way to market because they would only take the big plastic shopping bag that Barbara is carrying – the one with the zips and rings on it – when they went to the Friday market.

Karen's bag is more of a sack. It was her school bag, she says, "full of Smartie tubes". A small canvas sack with a ragged strap and a button badge pinned on it. And they are both wearing overcoats with fur collars. Karen's is done up to the neck and fastened with four big buttons. Barbara's coat is double-breasted. The neck of a white blouse visible at her collar with its white tie neatly knotted. She is wearing a wig, dark and thick. Not so much like a skid-lid, more an over-enthusiastic perm, with a wave here and there.

When I took the new picture in July 1995 Barbara told me that she wore the wig because she had been ill in 1974 and her hair had begun to fall out. Earlier in the morning she'd been to the hairdresser's and he had tried to give some body to what

was left of her hair with a perm, but it had gone wrong. More hair had fallen out and he eventually gave up.

"There's nothing for it, Barbara," he told her, "you'll just have to wear a wig." So she put on the wig and walked home. She collected Karen and the shopping bag and – somewhere between Dalton Road and the new covered market – she met this nice young man who had lots of hair, standing by a double-decker bus. He offered to take her photograph for free and she only agreed because she wanted to know what she looked like in the wig.

But this is not how Karen remembers it.

KAREN CUBIN: I don't know why, but she had all kinds of different wigs. And she used to have these wig stands and we used to bite off the noses or pull the polystyrene out. She had lots of different wigs. All kinds, ginger ones . . . she said it was a perm gone wrong. It wasn't. She just had this thing for wigs. And we used to put them on when she went up town and pull 'em to bits and wreck 'em more-or-less. There were six of us. I have two half-brothers.

Karen is 36 now, runs a pet shop and is married to Barry with whom she was going out at the time of the first photograph. Childhood sweethearts, they married when she was 19.

KAREN: I was very young, very naive. Didn't know very much at all about life or anything. My mother never taught me anything, you see, about anything that should be talked about such as the facts of life. My girls know all about that. I can always remember, when they were younger, my friend had a baby and she was breastfeeding. The kids were asking: "Mam, what are boobies for?" and I said: "Well, when you have a baby you can breastfeed. You've got milk in there to feed your baby." And I was glad I told 'em that because I went round to my friend's and she was breastfeeding and they never batted an eyelid. You know, they didn't stand there gawping: "What are you doing?" sort of thing. They knew. They just looked at the baby and walked away and I felt really great. I thought: Yeah! I've achieved that with me kids. They knew what she

was doing. And my kids know a lot. And they can come and talk to me about anything as well. Anything. Whereas I could never do that with my mother. I can do that with my girls because I'm like one of them. We're not like mother and daughter, we're just like sisters. I act like 'em, I can act the way they do and I love 'em to bits. They're my world them two. If nobody else, them two are my world. Anybody will tell you that. They do what they want to do. Do what they feel happy in doing. And try and be good at it. Which I know they will. They've got a good teacher.

Where's Dot?

Angela Hendley, Dot Rooney and Kim Hillman, originally from Barrow-in-Furness.

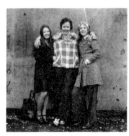 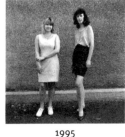

1974 1995

Three girls. They were 15 then and playing truant. Now they are 36. Angela was a brunette 21 years ago and now she's a blonde, whereas her cousin Kim was a blonde and now she's a brunette. Kim says she didn't want to wear a skirt to school. She didn't like her legs, thought they were skinny, so she took trousers in her school bag and changed into them for the walk home. But she's wearing a skirt today, short and black. Angela is in a pink shift.

But Dot, in the middle, her arms around her pals, hasn't shown up.

Big smiling Dot. Everyone knows Dot. Short hair and Bay City Roller checked shirt. She promised, only yesterday, that she'd come, but she's not here and we've all travelled some distance so we're disappointed. But Angela and Kim are not quick to blame. They make excuses for Dot, even though they wish as much as I do that she was here with us for the photo. Things have been difficult for Dot they say. She doesn't have much to celebrate at the moment.

We met this morning at Kim's mum's house and we've been hanging around ever

since waiting to see if Dot will change her mind. There have been phone calls, hushed and urgent. But she hasn't shown. Kim's mum makes sandwiches and the kids play outside climbing a big sycamore in the churchyard. Kim tells me about her mum's house. It was the one house in the street no one wanted to live in because a man died there. Gassed himself in the kitchen.

Kim's mum got hauled up to the school once to be told that Kim and Angela had missed school for a whole month. They were terrible tearaways. Always lagging off. "We went with fellers," says Kim. "And to your dad's," adds Angela.

Kim and Angela left home and tried to make a go of it working in London hotels. But they soon came back again and went to work in the wool factory when they were 19.

Today Angela is a carer. It used to be called "home help", but there's no cleaning with the job any more. Carer. She takes in foster kids too. She only gets £1 an hour, but she does it because she likes it. One day she'll become a foster mother proper, but she's in no hurry.

Kim lives in Preston now. She has three kids. A fourth, the eldest, was born brain damaged and died last year. He was 15.

Punctum

David and Maureen Wade, son and mother, from Barrow-in-Furness.

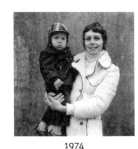

1974

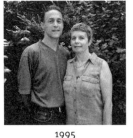

1995

When I turned up in Barrow to photograph him with his mother, Maureen, on Monday 10 July 1995, 22-year-old David Wade was preparing to set off for his degree ceremony at Salford University and celebrate his BA (Hons) in Business Studies. And there were some job interviews in Carlisle and Ulverston lined up for him when he came back.

Maureen, who still runs the Bath Street Post Office with her husband, remembers

having her picture taken in 1974. She had two children then, David and a daughter who was out of frame in a pushchair. Another two were to follow. "I'd just nipped out to do some shopping when you popped up and asked me if I'd like to have my picture taken. I said: 'Yes but you'll have to be quick.'"

That's about all I know about Maureen and David Wade. I didn't interview them – we just chatted a bit and had a soft drink as it was a hot day. Maureen had done well by her children and she possessed a quiet pride in them.

The little sign (Barthes's "punctum") that touches me most can best be seen in an exhibition print. Enlarged to 15 inches square and printed on fibre paper, you get to see detail that is otherwise almost invisible. Her fingernails on elegant hands. The nails shaped to a point and the pale varnish carefully applied. Except, that is, for the middle nail of her right hand, which has been broken and filed flat. Working hands. A family to bring up and a Post Office to run. All those forms to fill in, stamps to lick, sheaves of documents to be flicked through with a middle finger dampened on the wet sponge in its brown bakelite tray on the counter. (I'm guessing now.)

And then there are David's new shoes, the laces tied in a double knot. Perhaps they were new that dinner time. Did a shop assistant tie them? But Maureen would have tied his laces like that too. No nonsense. The right shoes for his feet. A sense of the correct priorities on a family budget. And then there's his hat. Fashionable tartan, but sensible too. Keep his ears warm.

In the new picture Maureen's hands are out of shot.

Pity.

I should have thought about that.

A Lesson in Looking

During the 1998 Shoreditch Biennale I gave an "artist's talk" at the London debut of *National Portraits* at Back Gallery, the London College of Printing.

The following is a transcript of my talk, which Colin Jacobson recorded in his capacity as editor of *Reportage*, the international magazine of photojournalism.

MEADOWS: I became very uneasy about re-presenting these works without actually first meeting some of the people who appear in them.

When I say that it has altered the way in which I think about documentary, what I mean is that I suppose I have been living under the assumption that in some way the photographs were saying something greater than what was apparent in them.

We know, for instance, that these people stood against these walls on these days wearing these clothes, but I also always had a sense that there was a bigger truth that the pictures were telling. And what I discovered when we went back to meet the people was that there are many truths around these photographs . . . we assume an awful lot from photographs and I don't think we should.

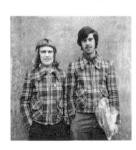

For instance, two people already today have asked me about the big picture by the main entrance of the two lads in the tartan jackets. Now then, it's quiz time – you can tell I'm a teacher can't you? Two people have said to me already what they think that photograph is about. Anybody like to venture what we think this picture made in 1974 of two teenage lads in tartan jackets is about?

VOICE FROM THE AUDIENCE: The Bay City Rollers?

MEADOWS: Yes, everybody looks at that picture, and I did, I looked at it and I thought tartan jacket, it's the Bay City Rollers, they had a lot of hits at that time . . . [35]

VOICE FROM THE AUDIENCE: Sing one!

MEADOWS: I'd have to have another glass of this champagne before I could do that. I was more into Abba actually. (*General laughter*) Anyway, when we were tracing people, the journalist from the Barrow-in-Furness paper wrote: "Tartan jackets, Bay City Rollers fans".

And the bloke on the right – he's a lorry driver now, he lives in Scotland, but his sister lives in Barrow and she sent him the newspaper cutting – he rang me up and said: "I'm *very* cross with you. Fancy not being able to look at your own photograph." And I said: "What do you mean?" He said: "Well, you just make an assumption that because I'm wearing tartan I'm a Bay City Rollers fan. But look at the record I'm carrying, will you just look at the record I'm holding in my hand?"

Will someone just look at that record and tell me who it is by, please? You can read it if you look carefully.

VOICE FROM THE AUDIENCE: Deep Purple.[36]

MEADOWS: Deep Purple, right. Well a Deep Purple fan would never, ever have listened to the Bay City Rollers. (*General laughter*)

So what we know is that those two guys were carrying a number of records which were wrapped in polythene. Why were they wrapped in polythene? Because it was raining. Why were they carrying them? Because they were taking them from one house to another and playing records in each other's houses, which is what people did in the days when we had records. Now you just have your personal stereo so it's different.

So how do we explain the jackets? Will someone else look at the picture and look at the bloke on the left, the one with the – what did you call that haircut, Val?

VOICE FROM THE AUDIENCE: Crap.

(*General laughter*)

VAL WILLIAMS: Sealed Knot

MEADOWS: A Sealed Knot haircut! That's it, brilliant. Look at him, the bloke on the

left. He's wearing a scarf and he's wearing a badge. This is the beginning of the football season, a clue.

VOICE FROM THE AUDIENCE: West Ham?

MEADOWS: No, not West Ham. Manchester United actually. What you are seeing there is the gear Manchester United sold to its fans in the days before they began selling the football strip . . . In those days you couldn't buy the football kit, but the clubs would sell items of clothing and badges and things which in some way made a connection with the club. And Manchester United sold tartan jackets because they had a Scottish manager.[37]

So, when we look at pictures we need to be extremely careful when we talk about the facts and we need to be extremely wary when we allow our imaginations to run over them. And I'm still trying to resolve these issues to do with documentary truth . . .

Thank you.

II

HARTLEPOOL

EVERY PICTURE TELLS A STORY

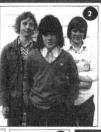

Are you in these photos from 24 years ago?

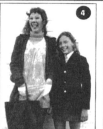

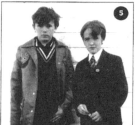

DANIEL Meadows could teach Cliff Richard a thing or two about public transport.

The singer merely spent his vacation on a double decker bus for the movie Summer Holiday, while Daniel made one his home for 13 months, travelling 10,000 miles around the country capturing ordinary people on film.

This was 1974, the year of the Guildford bombings, a General Election and when Sweet and Slade were all the rage.

Daniel, then just 21, came up with an idea for an unusual arts project – riding round the country in his bus taking pictures which he hoped would be part of a social documentary of the time.

His idea was to offer to take people's photographs for free in the hope they would invite him to come and be part of their daily lives; watching them at home, at work and at play and then snapping those moments.

Focus

As it turned out those photographs have actually been of less interest over the years than the portraits which are now to become the focus of attention for the second time.

And the photographer is now anxious to track down the people he captured in Hartlepool all those years ago, to see if he can get them involved in another project.

Daniel, now a lecturer in photo journalism at the University of Cardiff, came to the town because part of the funding for his adventure came from Northern Arts and he was committed to carrying part of it out in the region.

"I had to get an amount of money from private sponsorship and from the Arts Council and from regional arts bodies," he explained.

"Some of that came from Northern Arts so I took some of the photographs in Hartlepool and in Newcastle."

Daniel parked his mobile home in the town, offering his free studio to passers-by.

"I took pictures of people for nothing as a way of being able to meet them at random," he explained.

"I didn't want to do it as a journalist or a sociologist, it was just get to people and show how they lived at the time."

His hope was to show people "in dance halls and bars" at work and at home.

Yet somehow it is not these but the actual portraits which have caused the most interest and were featured in a book called Living Like This, which was published in 1975.

Daniel went on with his career, working as a freelance photographer for a number of top publications including The Times before becoming a picture researcher for Granada Television.

It was only when some critics found the boxes of negatives from that project more than 20 years ago that they suggested he should pick it up again.

The result was an exhibition and a catalogue called National Portraits, highlighting many of those snaps from 24 years ago.

In 1995 Daniel travelled back to Barrow-in-Furness, one of his ports of call during the 70s and tracked down many of his original subjects.

Campaign

He financed this with the cash he got from a radio documentary and is now hoping to carry out a similar exercise in Hartlepool

His plan is to travel back to the town and explain to people how he hopes to use the then and now pictures for a campaign which an advertising agency has expressed an interest in.

● IF you were one of the subjects in these photographs – or know who they were – contact the Mail features department on 01429 274441 ext 4392 or alternatively drop us a line and we'll pass the information on to Daniel.

"It was an important period because teenagers were becoming fashion-conscious in a new way," he said.

"It was a time when hair was crazy, when flares were huge, where you can see all kinds of influences.

"I would just love to meet up with the people who I took photographs of them to see how they are now."

Twenty-five years ago photographer Daniel Meadows came to Hartlepool and captured anonymous townspeople. Now he's trying to track them down for a completely different project. BERNICE SALTZER reports.

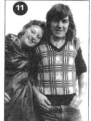
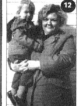
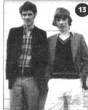
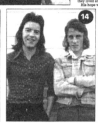
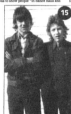
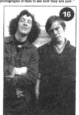

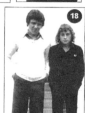

Journal of the Free Photographic Omnibus

Tuesday 24 September 1974 (*extract*):

I'm in Hartlepool. On Monday, yesterday, it pissed with rain all bloody day. It absolutely piddled it down so I was really pleased I'd got the Hartlepool free studio done in the sunshine last Friday and done really well. So I spent the day in the car park in Hartlepool printing up all the pictures.

The Bollard Calypso

The A1086 from Hartlepool to Sunderland winds north through the old colliery villages of Blackhall, Horden and Easington. A sign reads: COAST ROAD – 7 KILLED, 127 INJURED IN THREE YEARS. DRIVE CAREFULLY.

It is bleak country, pebble-dashed brick houses and shops. Oh the names of things! *Blackhall Wok, Baker's Fish Bar, Snips Hairdressing Salon, Wood and Crake Electrical Services, Fruitz, Edkins* . . . A police station looking more like a bus stop. The Ken Shu Combative Arts Centre next to the Nicola School of Dancing, a thin woman and a child going inside. Gangs of lads in baseball caps looking slightly threatening outside the fish and chip shop. The Sion Calvary Blackhall Methodist Chapel. Blackhall Industrial Estate. *Manners Harrison Estate Agents.* Houses round here have Manners FOR SALE notices pinned to them. *Menace Taxis.* There's poetry in this place.

And now we're heading for Easington. A huge fat man holding three daffodils. Graffiti: *Owl Rat Skins. Blackhall Skins OK.* Spring has not yet arrived. The scrubby hedges aren't touched by the green bloom seen further south. A big viaduct of epic

brickwork. A road sign: DEER. Here? Horden village. *Ian Wright The Dick.* Lads in shell suits. NCB EASINGTON COLLIERY painted out and someone has written *Bucket Town On Tour* over it. *Castle Eden Brewed Ales. Devil's Bar.* A woman in a purple overall. A little Honda 50 moped with a very large person in a green anorak and a red helmet in front of us now with L plates. Two little girls with bows in their hair looking like Madonna in a shell suit. Satellite dishes. Lads in bobble hats and sports gear. Turn off here. Don't want to go to Sunderland yet.

Easington village is uphill from Easington Colliery. Allotment gardens abound. And lofts full of racing pigeons. Crees. It was here in 1974 that I came across Robert and James Broxton, pigeon men, who scattered the ashes of Johnny their dead brother on the ground outside the cree so that the pigeons would always fly over him.

A man in his allotment is digging a pile of manure as big as a saloon car. Another allotment has a beautifully painted green gate. Everything is made from rubbish, things that other people have thrown away. Polythene, bits of roof, bits of old slate, bits of old door, bits of old gateway. Every plot is numbered. No. 26. *Fuck Your Cell Mate. Holy Shit* written along a fence. An old Reliant Robin three-wheeler with a flat tyre. A park bench at the top of Anger Street. A bright yellow X-reg Astra. Anthony Street. A few lads with Adidas sweatshirts on. Hooded anoraks. Nike sweatshirts. Albert Street. Austin Street. From here the site of the old colliery looks like the sort of place where you might build a motorway service station. Smooth and clean. No sign of coal or spoil tips. Occasional pieces of ground with freshly planted shrubs on them. A lot of public buildings boarded up. The Division HQ of Easington St John's Ambulance Brigade with wire on the windows. Office Street. Easington Colliery Officials Club. Station Road. Old lady standing out in front of the Station Hotel. Two men sitting out in the street on an old piano stool with a velvet cover. A man wearing brown boots. A woman with a handbag smoking a cigarette. Kids playing football. A blind man walking across the recreation ground with his white stick. More Manners FOR SALE. Used. Used up.

Briar Dene. The *Challenger* caravan. Glen Side. An overturned green wheely bin.

And we are up with the pigeon gardens again. There are pigeons flying everywhere. NO PARKING. KEEP CLEAR.

But the story. Yes, on with the story.

In the village there are crocuses on the green. And here is Regal Fry. How many of its patrons queuing this tea-time know of the famous stand made here by its previous owner, Italo Rigali the Glaswegian Italian also called Roy because he wore dark glasses like Roy "Pretty Woman" Orbison? Roy Rigali, aka The Evil Fish Fryer. Hero of the people, one time cabaret artist and author of "The Bollard Calypso".

Late one morning in 1974 – he served chips until long after the pubs had closed so he wasn't the earliest of risers – Roy woke up in his flat above the shop, and looked out of his window to see workmen planting bollards in the road right outside the shop. If customers couldn't park their cars they wouldn't stop for chips.

But Roy wasn't one to panic and he wasn't one to get angry. Instead he adopted a tactic rare and imaginative. He knew that Englishmen, particularly English men-in-charge, hate to be ridiculed. So he set about embarrassing those councillors who had caused the bollards to be placed outside his shop, embarrassing them into taking them away again. Roy had the kind of faith that could move bollards.

He wrote "The Bollard Calypso", a song in many verses. And, dressed in his white coat and tall chef's hat, he took it round the clubs. Pubs are mostly clubs in this part of the world: Engineers, Liberal, Boiler Makers, Labour. I have a photograph of Roy's hand-written poster dated Sunday 20 October 1974. WORLD PREMIER it says. THE EVIL FISH FRYER WILL SING THE BOLLARD CALYPSO AT THE LIBERAL CLUB. ALL VIRGO INTACTA WILL BE SUPPLIED WITH FREE DRINK. PLEASE NO CARA BOMBA.

That's my Roy. Who could refuse the offer of a free drink? Who could prove she was a virgin? And who except Roy would verify the claim before paying up? He liked his joke did Roy "Pretty Woman" Rigali. And how do you persuade people that you are serious? You make them think that you might be worth *bombing*. The IRA Guildford pub bombings were fresh in people's minds and Roy had his finger on the pulse.

He sang:

> See that John The Bollard in the middle of the park
> Is a monument to the Parish Clerk.
> The Evil Fish Fryer, the big nit wit,
> He want to do a Harvey Schmidt.[38]
> With a laugh and a cheer every time he goes through
> He puts up a V-sign saying "Bollards to you."

He had written the chorus out in bold lettering on a large white sheet of card and, like kids at the pantomime or Woodstock hippies singing along to Country Joe and the Fish, we belted it out:

> Bollard Calypso, Bollard Calypso
> To close all the roads the Council is keen.
> Bollard Calypso, Bollard Calypso,
> They have planted them bollards all over the green.

There were many verses:

> All these bollards don't come very cheap
> The Evil Fish Fryer sees them in his sleep
> They haunt him by night and they haunt him by day
> And he fights them in every way.
> Like a mad man he fights and there is no doubt
> If he sees any more he'll foam at the de mout.
> Oh, ooo . . .
> Bollard Calypso, Bollard Calypso . . .

With the Free Photographic Omnibus parked outside on the green we sang it into the small hours.

It took a month or two, but it worked. One morning later that year Roy woke up in his flat above the shop, and when he looked out of his window he saw Council workmen removing bollards from the road outside. There was parking. And access. Right outside his shop. With customers able to park their cars again they would stop for chips. He had won.

Get Carter

The *Hartlepool Mail* ran two articles with pictures and, when I returned in October 1998, 38 of the people I photographed in 1974 had been identified.

All of them were invited to attend the Sheraton Room of the Grand Hotel to be re-photographed. The *Mail*'s feature editor, Bernice Saltzer, had persuaded the hotel management of the publicity value of the event and no charge was made for the use of their premises.

Later she was to explain Hartlepool to me:

"They've spent a fortune doing it up. The marina and everything. But, even here in the north-east, Hartlepool used to be a bit of a joke place. You wouldn't come here unless you really needed to. People wouldn't say: 'Let's go and have a day out in Hartlepool,' whereas now they do. They've spent a fortune investing in tourism and stuff and they've done a good job with it."

I assumed I had chosen Hartlepool merely because I had received a modest grant from Northern Arts, but when I refer to my journal entry of 24 September 1974, I find that I particularly wanted to visit Hartlepool so that I could photograph the seacoalers at Seaton Carew. I was fascinated by the landscape of the coast there, an interest possibly sparked by the 1971 film *Get Carter*, with Michael Caine in the lead role as a London gangster.

The Way We Were

The *Hartlepool Mail* came up trumps. "The phones haven't stopped ringing," says Bernice. Many of the people photographed in 1974 were well known in the town. Bernice had the dope.

"On the left in No. 14, Paul Vicente, we know him really well because he went on to be a photographer at the *Mail*, though we've lost touch since he went to London."

Paul's hair and sideburns are a period piece. Another turns out to be a local villain, thinks he runs the town; he's done time you know. Jacqueline, in the smock and the polo neck with the shopping bag and her tongue sticking out, rang to say that Julie, with her in picture No. 4, was killed in a road accident.

What? Little Julie, so smart in her blazer with its shiny buttons and her neat tie? If it wasn't for the miniskirt she might be about to go riding.

And she's not the only young one to have died. Stephen had a heart attack while working away on the site of a power station. He wasn't yet 30. Alan's gone too.

We know who the two lads in No. 13 are now. They made it onto the back flap of the *National Portraits* catalogue with their fabulously conflicting patterns of dress: checks, tartans, stripes, squares and plains. V-necks and zips and – what *is* the pattern on that shirt? So much visual noise and yet such a straight demeanour. Nice lads, you'd say. Well turned-out. Anyway, they are Owen we think, or possibly Tony, and is that Alan Maddison with him? Or is it Des Kearns?

Michael, No. 7, the blond child with a round face, wearing tight dark shorts and a stiff denim jacket with bright metal buttons stamped "Health-tex" – such a knowing look he gave me with his right hand cocked ready to draw his imaginary gun like he *knows* this photo-thing is a shoot-out. Well, he got a First at Cambridge, you know. His mother rang in. He works as a computer consultant down south. Done well for himself.

No. 5, Steven and Anthony, are brothers. I had guessed that much. Steven, with the dirty hands and the V-neck jumper, I had down as secondary modern until No. 9 Debbie told me later that they all went to a comprehensive. Anthony I was sure was grammar school because he is in uniform with a badge and he is holding a key. A trusty. And smart. But who knows?

At least we know he didn't leave town. We have the address of a pebble-dashed house, rusting furniture lying about in its neglected front garden. The phone had been disconnected. According to a neighbour the brothers still go about together. "But they're never in." Anyway, why am I interested in them? "Try tea-time,"

she says. I try tea-time twice, and breakfast and dinner too. She's right, they're never in.

No one's heard from Leslie Fothergill, but No. 19, Robin Jones, with his arm round her in 1974, has recently married Bernadette. Jackie Johnson, who works at Robin's local newsagent, tore his picture out of the paper and, for a laugh, stuck it in her window with a sellotaped note attached: *Hey Hey Hey Mr Jones*, she wrote in biro, *You've Got A Thing Going On. Sing It!* Just a bit of fun. "Me and Mrs Jones" by Billy Paul, January 1973 . . .

National Portraits is full of hits. The headline writers have made good use of popular song titles because they are good for jogging the memory. In Barrow-in-Furness it was WHEN WILL I SEE YOU AGAIN? (Three Degrees, July 1974). In the *Guardian* it was THE WAY WE WERE (Barbra Streisand, April 1974). In Hartlepool it is EVERY PICTURE TELLS A STORY (Rod Stewart, the title of his second album in 1971) . . .

David and Mary Ingram, son and mother, from Hartlepool.

1974 1998

No. 17 is Paul Ingram, now a manager at a brewery. He is cousin of Mary Ingram pictured in No. 12 with her son David, who was two in 1974. Now David's a father himself, head shaved close as the fashion dictates, with an earring and a gold bracelet. His wife's a hairdresser. His son is three and his twin daughters are just four months old. He still lives with his mum and dad.

There's John and Mick and Micky and Stuart. There's Tom, Alan, Stephen and Malcolm. And No. 3, holding his cigarette like a dandy, is "surname believed to be Rickerby". And there's Maureen with her head on the shoulder of Stuart Fawcett in No. 11, and her arm around him too.

Margaret Wright with a bouffant black hairdo, a white minidress with buttons all the way up the front and dark glasses in her hand – rather glamorous – is with Olive Craven in No. 6. Olive was probably about 60. That she is dead is no surprise,

but Margaret wouldn't have been 60 yet and she has gone too.

The one I was certain would be dead is No. 1, Mary Clarke, in her nice camel-hair coat with the button hanging loose and a face so lived in it might have been round the clock twice. As it turns out, she was only 36 in 1974. During the *National Portraits* exhibition tour people often said to me: "You'll never find her again."

But the first shall be last. MARY COMPLETES THE PICTURE runs the headline. She has an article all to herself in the *Mail* because she is the last one to be identified. But she was also the first to turn up to be re-photographed that Saturday morning in 1998.

Mary Clarke, from Hartlepool.

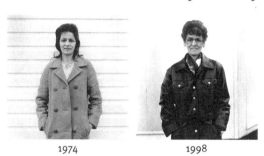

1974 1998

She goes straight to the table where the pictures are laid out. She's looking for her children. The five lads she had at that time. She broke up with her husband shortly after the picture was taken and she's lost touch with them all.

All?

Yes, all.

Her manner soft-spoken, but urgent, compelling. You have to listen, even though things keep coming out all back-to-front and jumbled up. "I've lost touch with them all," she says, but in the next breath she is telling me that the second one – she never mentions them by name – now lives in Bradford and sent her a card from Turkey in the summer. "He might show up before Christmas with the grandchild," she says.

MEADOWS: Do you really think so?

MARY: They'll need me before I need them, tell you the truth. There's two of them living in Hartlepool, I don't know whereabouts. I think they're married. One got married and he got divorced. Then he got on with a young lass and he got divorced again. So I don't have nothing to do with him.

MEADOWS: Do you miss them?

MARY: Not really. (*Pointing to picture No. 3, "surname believed to be Rickerby"*) That

one looks like my son, but he's got a cigarette in his hand and he never smoked. [*Mary smokes though.*] I told the doctor: "I'll give up the drinking, but don't tell me to give the cigarettes up. No. I like the tabs too much."

MEADOWS: That lad looks to me to be about 16, so he'd be 40 now. Was your lad 16 when you were 36?

MARY: No, it can't be him. When I was 36 the eldest was 18 [*42 now*], the second one 13 [*37 now*], the youngest one was three [*27 now*].

But it doesn't come out smooth like this. We need all of Alan's tape and more and I listen to it over and over to glean as much of Mary as I can. She talks freely and determinedly, she needs to tell us, but the order of things has gone from her. Our listening struggles to determine pattern in these fragments of her life retold.

MEADOWS: What did your husband do for a living?

MARY: He worked on the railway as a goods guard and he got made redundant because he had an accident. He lost his thumb between the vans. And he gets a pension every week now. He's 69, he's still alive, I see him every week down the town but I don't speak to him. 'Cos I call him names behind his back (*laughs*). I won't mention the names. I call him "Ginger". If he sees us, he like looks at us or he'll say to somebody else: "Seen her!" And I always say to my son: "Don't tell him nowt!" I know he goes to see his father, and I told him: "Don't you ever mention my name to him 'cos if I find out I will be down there and I will hit you."

I'm not one for mixing with people. That's why I always go drinking in The Engineers because I've mixed in up there. Thursday night and Friday night we play bingo. I've won a bottle of wine, I've won whisky. I've won all sorts. I've got two good friends in The Engineers. She's 72 and her husband is 65 and he's blind. We were both drunk last night. I went to the bar, there was a couple of blokes there who said "Seen your photo in the paper, Mary. Can we have your autograph?" I said "Yeah," and I signed it for them.

The next thing I knew was they sent a pint across and my friend said "Put it underneath the table," because I already had one on the table. Then all of a sudden there was a tray brought in to us with a big round paper plate full of food on it. I said: "What's all this?" It was a treat for us because they'd seen my photo in the *Mail*. They asked me: "Are you going to have your picture taken again?" And I thought: "I'll have to keep myself sober for tomorrow." But I got drunk anyway.

MEADOWS: What were you doing at the time when I took your photograph?

MARY: That was when all the trouble started. I was working in the canteen at GEC where they made the televisions. I worked from seven o'clock in the morning until half past ten. Part time. But then my husband stopped working because of his heart trouble and the manageress offered to take me on full time. It was smashing. The bairns being at school an' all. It worked out. I worked from seven o'clock in the morning until three o'clock in the afternoon. I did the meals in the kitchen – fish, chips, peas – and then I went in the canteen to serve it out. I really enjoyed it. On a Friday afternoon I used to get the buffer out and clean the canteen floor.

Then all the trouble started. When I went in one day the manageress asked me if I was all right and I just broke down crying and I told her that I'd left my husband. She told me to go home and get it all sorted out. "No," I said, "I'm leaving." She said: "What are you going to do?" Because, with the factory about to close down, I wouldn't get any redundancy money if I just left. And I said: "Oh I'll get some work. But first I'm going to a jeweller's to get my ring cut off." And that's the best thing I did do. I never did get any redundancy money.

But so long as I lived on my own I was all right. I used to just go to the bingo. I never used to drink then. I had a good reason for getting into drinking but I wouldn't tell nobody what it is. But I had a good reason for it. I just went on the drink. My husband used to say: "How much money have you got? What are you doing with this? What are you doing with that?" And in the finish I just said: "I'm going drinking." That's how I started the drinking and I've been drinking ever since. I had a reason for drinking

and I wouldn't mention it to anybody, even to the one I'm living with. He doesn't even know.

I've got a lot of friends in The Engineers. I used to go in The Boilermakers but I got barred out because I hit one of the committee men with my handbag. I got barred out for three months and then I was allowed back in again. Then, me and my partner went to a funeral, his sisters and his brothers and his brother-in-laws, and we ended up in The Boilermakers. It was his auntie's funeral. And we went there and were playing bingo when one of the committee men told our lad to tell us all to shut up. I said: "We aren't doing 'owt. I'm playing bingo." And I got up and hit him with my handbag. And we were barred out. Shortly after that it caught on fire and I got the blame for it. It's been set on fire twice. The second time, it was my birthday on the fourth of April. Me and my sister-in-laws went off for a drink. We went to Rio's in York Road. From there to The Jackson's Arms and from The Jackson's Arms to The Engineers. We were just pulling out when we saw the fire engines again. "Mary's set fire to The Boilermakers," they said. And I said: "Oh I wish I had done." In the end I got the blame for it so I might as well have done it.

I am awkward, but I'm not one to go out and cause trouble. I don't like Hartlepool. I don't belong in Hartlepool. I belong in Durham. I never liked Hartlepool since the day I put my foot in it. I was bred and born in Durham. My dad worked for the gas board. My mum had eight of us to fetch up. Me, Jean, Pauline, Valerie, Iris, that's the girls. The boys were Dennis, Edward and Benny. We were brought up to respect our elders. If we were in someone's house and they were talking privately, they used to say to us: "Kids should be seen and not heard." And we used to get a clip around the earlobe and get out. I lost my mum when she was 42. I was 21. I left Durham the following year, when my husband came to work in Hartlepool. I looked after my mum and I used to do the neighbours' housework as well. I used to stop in a lot and watch the kids. They are all still around. If they want me, they know where to find me. If I want them, I know where they are. I know the phone number, it's all down in the book.

I've got kidney trouble. I went into hospital in May for a heart operation. I phoned up my son and let him know. I left a message with his wife, Janice. He never phoned up to see how I was or sent a card. But I don't mind. I had two operations in one. They took so much of my bowel away. I've got a touch of cancer. So I'm just hoping. I've lost weight. I've gone down to six stone. I'm not bothered because my mother had it and she lived till she was 42. Well I've lived a few years longer haven't I? I'm 60. It runs in the family. I don't know if any of my sisters have got it because they don't even know that I've been in hospital. I just kept it to myself. But I'm going to phone them up and break it to them gently. And then they'll come across for us.

Monkey Hangers

In *Living Like This* I wrote about my visit to Hartlepool:

The Seaside pits of Blackhall and Easington have aerial cable-cars which carry coal-waste down the cliffs to the beach where it is dumped. Out to sea there is an exposed seam called the "Bell Hole" which has, for centuries, been the source of a powdery fuel, called seacoal, which is washed up on the shore. At Hartlepool the sea is black, seacoal black. Perhaps this explains why the ancestors of the present steel-workers, miners, oil-rig construction engineers, dockers and timber-yard labourers of the town were not surprised to see a black, gibbering creature stagger out of the sea. According to local folk-lore this happened during the Napoleonic Wars when there was a general alert for everyone to keep a look out for French spies. The fact that this strange creature was a monkey, recently escaped from a passing ship, didn't prevent the local constabulary from having it arrested on suspicion of espionage. Since its gibberish could not be interpreted as English, the jury at the subsequent trial at Redcar concluded that the monkey was indeed a foreign agent.

The defenceless creature was duly returned to Hartlepool where it was hanged on the public gibbet. The story is now used as an insult to the intelligence of the local populace, and the image of the hanging monkey is still to be seen in the art of the Hartlepool tattooists.

On the ebb tide the seacoal is deposited on the sand and local people collect it for fuel. It is a common sight to see men carrying shovels and pushing bicycles along the sands with bags of wet seacoal balanced on the crossbar or slung over the pedals. It takes a whole morning to gather about eight bags of seacoal; assuming, that is, that you know where it is coming ashore in sufficient quantities to make the gathering of it worthwhile.[39]

Robin Jones, from Hartlepool.

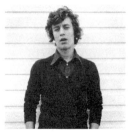 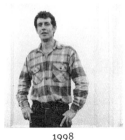

1974 1998

Robin Jones (with "a thing going on") shows up at the Grand Hotel. When first photographed he was 17 years old and serving his apprenticeship as an insulation engineer at Teespoint oil refinery. I photograph Robin, now 41, on his own and also with his bride of 18 months, Bernadette. Afterwards, on tape, he talks about the Hartlepool monkey.

ROBIN: Yes they still shout "Monkey Hanger" at us you know. "Chimp Chokers", yeah. And if there's a few of us travelling in a van to work, they'll call it "the Chimp Chariot". We answer: "There's plenty of rope left, you know." Or: "Is yer dad missing?" There's all sorts of answers you give to them. It's good crack. You're going to get called "Monkey Hangers" for the rest of your life so you might as well get used to it.

If you go down to where all the boat sheds are at Middleton by the new marina, they have a hangman's noose down there and when the lads are doing their nets, or what have you, they hang a stuffed monkey on it just for a joke. We've got the history you see.

People will laugh: "Monkey Hanger!" But we've got the answers to them. "Has

your dad disappeared?" "Your mum got married again?" There's all sorts of answers.

There are certain places still in the town – obviously if you're from out of town you come and you want to stay out of trouble you won't go there but – say "Monkey Hangers!" and there's some people there will take offence. But if you get it from someone from Middlesbrough then you say: "We didn't hang a monkey, what we did do was we sent it to Middlesbrough and we bred off it." We've always got answers for them.

Here indeed is the invisible kingdom.

Two Fat Girls Get It

Hartlepool is a nightclub capital today. No more sweeping up soggy coal dust off the beach. Everyone has central heating now and getting cold is a night-out novelty. Long queues of shivering young women, all cleavage and slashed-to-the-thigh in little more than their underwear, hug themselves in howling first frosts and queue for the *Pleasure Palace* to open at 9.30. The boys are all shaved heads, earrings, and a nice shirt hanging loose over tight trousers.

I saw some teenage girl-power numbers have a fight with two fat girls in a bus shelter. The platform trainers went in thud, thud, thud . . .

The bouncers in shiny black just laughed.

Journal of the Free Photographic Omnibus

Wednesday 25 September (my mother's 57th birthday) 1974, Easington (*extract*):

In Easington Colliery this evening I went for a drink in a pub and it was really dark in there and this bloke insisted I took his photograph so I shot it at an eighth of a second hand-held, God knows what it will come out like. I hope it's good because it was really quite nice. Miss Great Britain was on the television in the pub – a colour TV – and many a coarse comment was passed.

I put the bucket out to catch the rainwater from the roof of the bus and some bastard's nicked it. So I'm minus my bucket. Feeling pretty tired and fairly pissed off, I confess. If only it would stop raining and if only I could get some good pictures, then I'd be a happy man.

Good night.

It Doesn't Have to Be Like That

Martin and Debbie Pout, brother and sister, originally from Hartlepool.

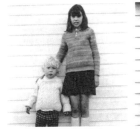

1974

1999

On 22 February 1997 Debbie Pout – now a graphic designer working for a printing trade publication in Tonbridge, Kent – read Val Williams's *National Portraits* article in the *Guardian Weekend* and recognised herself straight away, even though her picture was not shown.

These portraits are sombre and full of sadness. A girl and her small brother stand in front of a white slatted wall, faces in a grimace.

DEBBIE: I told my friends at work: "That's me!"

If we needed any convincing, these photographs show that growing up in the never-never land of post-war Britain was, for many, a dark and austere experience.

Then, in October 1998, Debbie's mother sent her a cutting from the *Hartlepool Mail*.[40] She rang in.

Debbie Pout (picture 9) called from her home in Marden, Kent, and remembers vividly the day she and brother Martin were snapped by Daniel. "We went shopping with my mother and we went to get our free picture taken," said Debbie, who was 10 at the time. "I remember I was really scared which you can probably tell by my face. I didn't even want to go back the next day to collect the picture!"[41]

On 8 May 1999 I drove to Kent, taking Debbie's brother Martin with me, so that I could photograph them together. They hadn't seen each other for three years.

"We're not the closest of families," she wrote in one of the e-mails we exchanged during the organisation of this reshoot, "so I don't really talk to him that often, but only due to apathy and laziness and not bad feeling."

Martin, 27, is a postgraduate sports scientist at Loughborough University. Debbie, who is single, now lives in as picturesque a garden-of-England village as can be imagined.

DEBBIE: Me, Martin, my mum and our neighbour Gladys Doherty were out shopping and I think we'd just come out of the Co-op and we were loading stuff in the car and we got sent over to have our free photograph. And I think I said something like: "Can't you come with us?" "No, we're busy." And I had to go on my own with Martin.

I don't know where my brother Kevin was because we were always together. Always. I was a very shy person and it was a very alien thing. This sort of thing didn't happen in Hartlepool, so I was very nervous about it all. And I think you said "Go and stand over there," and so I did as I was told, like I had been brought up to do. I remember holding on to Martin, I was very frightened, as you can tell from the photograph.

I was at primary school so we didn't have school uniform. But my brother Kevin and I had the same jumpers. The one in the picture was blue and he had a red one. We had our school photos taken in them. It was a horrible brown crimplene skirt. I hated wearing skirts. I was such a tomboy. It must have been a school day, 'cos I wouldn't have been wearing a skirt if it wasn't. People would kill for legs like that nowadays, but I hated them because they were so thin. It was very unfashionable to be skinny in the 'seventies. It was all very curvy.

MARTIN [*who was only two at the time*]: I don't remember the photograph being taken, but I do remember the photograph because it was one which was always in the photograph drawer at home and periodically I would go through it and look at the photographs. I kept seeing that photograph and I just made up my own story of it. Forever I've always thought it was taken in front of a garage which belonged to my auntie and uncle who live in an area of Hartlepool called the Fens. I always thought it was taken there. You tell me it's not, but I still think it is.

DEBBIE: We lived in a nice little pocket on a pretty horrible council estate. It was just a pocket of tranquillity and niceness surrounded by thugs and criminals on all sides. There was a church at the end of the road. My mum moved from there only recently. She was 25 years in the same house. Came as a bit of blow when she suddenly sold it, because we didn't get to say goodbye. It was No. 57 Dryden Road.

MARTIN: They were all poets round that area. Dryden, Thackeray, Chaucer, Swinburne . . .

DEBBIE: Macaulay, Marlowe, Shakespeare. A bit different to round here. Proper names. It's a typical modern estate. Contained. There's a firm in Marden called Sunburst Commodity Trading, and the bloke persuaded the council to let him name all the streets. So there's Sunburst Close, Roundel Way . . . which is his logo; Merchant Place, because he was an import-export merchant; Stella Close is named after his wife; and Napoleon Drive is called after his dog.[42]

It was about four years after the photograph was taken that our parents broke up.

Dad was a lorry driver. Come to think of it, he went through a phase of being a bus driver, so he could well have been on the buses then. They fought all the time. They just constantly fought. They met when Mum was a bus conductress, but she gave up working when they got married because I came along very, very quickly. She didn't work again. She stayed at home and she cleaned the house every single day. Everything was dusted and hoovered in the morning and she couldn't settle until that was out of the way, done. She couldn't go shopping or anything until the house was done. And she used to shout while she did it. Especially on Sunday mornings. She'd get up and start dusting and hoovering and shouting. "What are you lot doing in bed? I'm down here doing the dusting and hoovering!" I used to think: Well, don't do it! Will the world come to an end if you don't dust every day? She seemed to think it would.

Dad re-married – to the most extraordinary woman I have ever met in my life. Awful woman. He was married to her for almost 14 years, the same as my mother. She was a gypsy, not that there is anything wrong with gypsies, but there was a lot wrong with this one. Lorry driving is a dirty business and he'd often come back after a three-day trip and the first thing he'd do would be have a bath, throw his dirty clothes in the laundry basket . . . and she'd put them on! She'd fish them out of the laundry basket and put them on and then she'd go down the pub in them. She was an outrageous woman! She was thick as two short planks, but she's very sly and cunning.

My mum's never re-married. She had two long-term relationships since they split up. One with my Dad's boss, and now Bob, who I don't really know 'cos she met him after I left home.

I always knew that Hartlepool wasn't for me. I was always different at school. I was very tall and skinny so I stood out. I was the only one who ever took notice of my mother when she said "Don't say 'nowt' say 'nothing'" – so I had what was termed a bit of a posh accent. And I was very shy and I was deemed "stuck up".

The comprehensive that I went to – as far as I'm concerned – was very enlightened. On the estate that made up its catchment area there were so many girls who were

pregnant before they were even out of school and no prospects of jobs. You know, you get your bloke, you get your kids and then there's somebody to look after you. But there were a few teachers, particularly one called Graham Scarrott who was very passionate about teaching – he taught me French – and they said: "You know, it doesn't have to be like that. There are other things you can do. You have choices. You can make them." And there was a stress put on the fact that you don't have to have a boyfriend, you don't have to have children, you can do whatever you want to do. You don't just have to react to events, you can make things happen. They would tell the bright kids: "There's only so many building societies you can work in and you can't all work in them. Have some imagination." That was instilled in me from school.

I was very good at school and I just couldn't relate to the people around me. I was very, very bright. I was always in the top three and because of that I got more attention. And probably because I got bullied so much I think the teachers were protective of me. I thought school was fantastic, but it was always at the back of my mind that I wasn't going to stay. I was always going to go off and find things that were better. Everything in Hartlepool just seemed shabby and tawdry.

MARTIN: I didn't discover the outside world until I started working. I did sport. And I did it despite my background, not because of it. We weren't a very sporty family. And I wasn't the most healthy child – asthma type – and I always seemed to have a cold. Then, when I got to 13 at school I just discovered I was good at sport – everything apart from football. But I was not bad at rugby so they told me to go to West Hartlepool club and I started playing there.

When I was about 18 I started venturing out of the town. I worked in further education as a fitness instructor, I was in charge nationally of training Swallow Hotel staff to be fitness instructors so I used to travel around different five-star hotels and get everything free and I used to drive back into Hartlepool on the A19 from these five-star hotels where everything was so nice and lovely, albeit a bit plastic and false, and I used to come back to earth with a bump. I'd see all that industry and think: Well, it would

be industry if it was working. The scenery as I came back to reality was like a clip from *Blade Runner*. And I'd keep going away and coming back and then, once, I just went and didn't come back.

Eventually I went to Loughborough and did a degree, and then realised I needed more of a degree so now I'm just finishing off an MSc. And I realise I need more than that so now I'm planning a PhD.

DEBBIE: I went to art school, but I was trying to get onto a course down south because I thought that would be my way of getting out. Very specifically "down south". Home Counties, I wouldn't consider anywhere else. But I didn't get in. It was very frustrating. And then my mother got ill and she had a hysterectomy and, when I finished my course, I was stuck there.

Then I got a job on the Teesside *Times*. Unemployment then [*early 1980s*] was 25 per cent, so if you got a job you took it. And you stayed with it. I used to re-draw logos that came in to go in the ads. The NGA [*National Graphical Association, her trade union*] was a closed shop, you know, so the client sent in photocopies of their logos and these had to be re-drawn by a union member, which was me. I did design a few display ads but it wasn't going anywhere, sitting in Middlesbrough in the shadow of all that industry that wasn't working.

I quite enjoyed it, but it was a terrible atmosphere. The women I was working with were awful and I just thought: No, there's got to be more than this. So I sent my boyfriend at the time down south ahead of me, to get a job, so that we would have an income when I got into college. But I didn't get in and he was stranded down there. So, without talking about it to anyone – just to myself in my head – I handed in my notice and two weeks later I was gone.

I'm sure my mother thinks I'm still on holiday and I will go back one day but I won't. I enjoy going back for holidays, as long as they're not longer than three days. I just couldn't see myself up there. It's just not who I am.

When I first came south nobody could understand me. I moved to Windsor. At that

time people didn't move about the country as much as they do now and my accent stood out like a sore thumb. And people were constantly saying "What?" "Pardon?" "'Scuse me?" So, out of frustration, you do temper your vowels.

MARTIN [*who has retained his Hartlepool accent*]: I think your accent tends to change depending on the company you're with. If I'm with my girlfriend who is French, I've got to speak slowly, deliberately, otherwise she won't be able to understand me. Come to think of it, I had to do that with my English girlfriend, actually. I did make a conscious effort to change my accent when I first moved away, but I found it very difficult to maintain it. There are certain words that Hartlepool people can't master. "Funderal" for "funeral". "Fillum" for "film". And "Marza bar" for "Mars bar". I hate that one.

DEBBIE: At school we used to discuss the names we wouldn't call our children, because in Hartlepool people can't pronounce them correctly. Like Sarah. It just sounds ugly and awful. Rachel. Horrible. We have an identity crisis anyway because the boundaries have changed so much over the years. We started off in Yorkshire, then Cleveland, Teesside, Durham. Now it's just Hartlepool.

III

SOUTHAMPTON

feature

David Leigh, West End(left)

Ken Emery, Portswood

Lyn Brasher

Off the wall

WITH Sweet blaring from the radio the specially converted Leyland '48 rolled into the city as part of a 15-month whistle-stop tour of the country capturing the 70s on film.

It was May 1974 and twenty-two year-old Daniel Meadows stepped down from the converted machine in checked tank-top and stripped shirt and announced to the town his plans for the week.

He was setting up temporary residence in the city but wasn't offering guided tours of Southampton in his big red bus but the chance for people to have a professional picture taken of themselves

If you recognise anyone in these pictures call Daniel Meadows on 01222 874041 or Rachel Lamb on 01703 424496

to be used in an exhibition - but more importantly a chance for them to go down in history.

Scores of willing models flocked to the bus, which in one end housed a studio and dark room and the other living quarters, to take part in this social documentary of sorts; a cataloguing of an era.

In such an eclectic decade with change around every corner each photograph was bound to be different in many ways. Fashions, hairstyles attitudes and values were all changing and Daniel, who left his home in Manchester to travel the country, wanted to capture them all before time changed them again.

Daniel has fond memories of his trip and wants to re-visit the area and catch up with those he snapped way back then.

Now 47, and working as a photo-journalism lecturer at Cardiff University he remembers how he bought the bus for £300 took out the seats and in came a bedroom, cooker, sink, desk, bookcase and toilet. The trip cost £3,000 and Daniel spent many hours writing off to companies and organisations to get funding. Eventually the Arts Council gave him £750 and the Southern Arts Association plus others around the country gave donations, too.

"I met so many wonderful people. I wanted to catch things before they disappeared and now I'm coming back for more. I have managed to track down a lot of those whose pictures I took back then but I have been left with a selection who may have moved on or whose names I didn't get and I am now trying to find them all for a new book and a kind of now and then exhibition.

"I want to re-photograph them as they are now. I think it will be fascinating to see how they have moved on. I visited Barrow-in-Furness and Hartlepool in the same year and am doing the same search back there.

"If anyone you know is in any of the snaps shown here please give me a call."

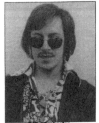

EJT, Winchester

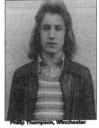

Philip Thompson, Winchester

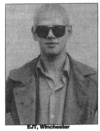

EJT, Winchester

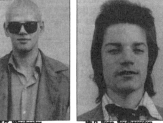

Mr G. Rose, Southampton

One of England's Heroes

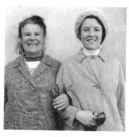

1974 1997

Looking through my negative files I came across the addresses of 44 people photographed on Wednesday 15 May 1974 in Guildhall Square, Southampton. Back in 1974, the Southampton authorities had granted me permission to run the portrait sessions there for one day only, leaving me no time to make prints and give them back before moving on. That's why I'd made a list of their addresses and posted the pictures.

In March 1995 I wrote to everyone on that list, enclosing a reply slip and a stamped, addressed envelope. The response was mostly disappointing. Too many people had moved away. Among the useful replies, though, was this one from a Miss Melody L. Gower:

> Sadly Mother passed away 23rd February 1995. But I, her only daughter, do remember the photo mentioned in your letter. I would help with your research.
> Yours sincerely,
> Molly.

A funeral notice, cut from the local newspaper, was attached.

We remember Gower, May Lilian. Dear little mother. We faced the world alone together, now you have gone aged 85 years and fallen asleep. I miss you.

When I photographed May she was 64. Twenty-one years later I had missed her by just eight days. Molly and I began to correspond.

14 May 1995

Dear Daniel Meadows,

I thank you for your fascinating letter of 20th April. Losing my Mother (best friend in all the world) has hit me pretty hard. Not only as a lady of nearly 86 yrs. But all her life's experiences as well. She was a Blitz survivor with an interesting long-life in service. House Maid – Ladies' Maid, House Keeper etc. In stately homes before the war.

For your research – I have just found the photograph you requested. Both mother and I, in black & white photograph – holding sunglasses in our hands. I am wearing a fluffy hat. We are both wearing our coats. Outside *C&A*'s store.

You must give me advice as I have tried to lift the photo off a sticky backed page of a photo album. The writing on the back the date etc. has torn away!!! But the shiny top picture remains intact. But I dare not detach it. Mother wished to go down in the records. I would like to help with your research.

Molly Gower.

We met on Saturday 13 April 1996 at a Butlin's holiday camp in Minehead, Devon, where Molly was taking a Christian retreat, a Spring Harvest Holiday. We chatted in her chalet and Alan Dein made the recording for the BBC Radio documentary *Living Like This*. I began by giving her a new print of the picture.

MOLLY: That's it! There's mum. There's me. I'm wearing a yellow mack and a pink fluffy hat. I've still got the hat, but I haven't got the mack. We shared the hat, mother and I, you see, whoever felt like wearing it . . . we got on very well. She was a very intelligent, interesting lady. I'd come back from work and she said: "I think we'll go down and have our photographs taken so that we can go down in the records." That's what she said: "We want to go down in the records."

At that time she was looking after me, doing all the housework, cooking my meals for me. And of course then there was a big reverse and I had to look after her and cook all the meals for her and do all the housework.

She had a stroke and I didn't quite know what it was; what had made her look the way she did. And we didn't have a telephone and I just ran screaming out into the street asking for help. And a neighbour phoned an ambulance immediately because I didn't know why she had a twisted face on one side and couldn't get out of her chair. I didn't even know what strokes were. And I depended on her a great deal for things and so it was a terrible shock to me.

But I wouldn't let her go into a home so I just learned to cope and struggle through. And I dressed and washed her and I learned to get very strong and to push a wheelchair over great distances.

MEADOWS: When did your father die?

MOLLY: Oh father's still alive. Yes. [*At the time of the picture*] I think the divorce might just have taken place. We had a disagreement. That was all it was really. You know the slightest thing seemed to upset one or other of them and, you know, the rows would start. So it was inevitable really. Mother was struggling on her own. And it was very hard for her not to have a husband because she'd been brought up in a family with lots of brothers around. All of a sudden she was responsible for the house, the finances, the bills and . . . and for me. It was hard on her and she worried about it.

MEADOWS: Then after the stroke you had to look after her.

MOLLY: Yes the roles were reversed, and that lasted until her death last year, February 23rd, 1995. She only seemed to have a head cold and they kept pumping her full of antibiotics. I asked my Named Nurse to try to pump her lungs out. She was a very strong lady apart from the stroke, you see. And the nurse told me she didn't have time to do that. So I don't think they put enough time and care into her because they could have saved her. I think I could have got her better, so I feel very, very bitter about it 'cos she was my best person, my best person in all the world and I've lost her. (*Sighs, tearful.*) When I was looking after my mother I had something like £59 as a carer and mother had sort of £100 – something like that or just over – for her disability. The Social Security took that whole lot away from me and I had to support myself and my home

on £46 a week. £46 a week! I couldn't do it. I went down to the Social Security, I really said: "I'm crying now."

People started giving me odd tins of food. I got by on that. This country is very, very tough on carers, you know. After all I'm one of England's heroes. I worked eight years to keep a mother from going into a nursing home and yet they hardly want to give me any money now. They kept me for six months on £46 a week. I've been terribly emotionally upset over that, apart from the bereavement.

I've managed to get my mother buried out in the countryside. She came from the parish of Netley Marsh. And as I walked into this very pretty place with the fields round, and this lovely old church, I knew she'd gone home and I felt better about that. It is a double grave so I can rest there too. And I know it might seem rather morbid but I'm very pleased about that because I intend to live until I'm a good 90, otherwise I will be cheated. She was cheated of a few years.

And there's spring flowers growing around, and a hedgerow. She's very near the hedge. There's a beautiful mature tree. I can sit there you know and . . . So I'm very pleased that there's a plot waiting for me.

On 2 March 1997 Molly sent me a card – a notelet with a picture of a cat on it with her own caption: *My cat, Angel Face.*

> Our church organist lives by the church at Netley Marsh where my mother is buried. For the first time last Wednesday they gave me a *lift out there in the car*; a journey my minister must have done many times and only just remembered that I have no transport! I cannot afford a headstone yet with her name on – but I found a mystery bunch of orchids left there on a borrowed wooden cross?

Later that month she wrote again:

> In 1994, around July/August, mother and I were filmed walking down through the gate to Number 10, with the crowd. We joined a Civil Rights march and were

photographed by newspapers and television cameras . . . I pushed mother all the way in her wheelchair and got in behind the barrier on a Saturday. We all cried out, "What do we want? CIVIL RIGHTS. When do we want it? NOW." I was caught on film pushing mother and waving my cardigan over my head.

On Saturday 12 July 1997 Molly took part in the filming of *Changing Faces* made by Florian Beck and Christian Schnelting for German satellite television.[43] Carrying the same pair of dark glasses she had held 23 years before, she posed in the exact spot where she had been photographed with her mother. She described the photographer who had taken her picture that day: "And do you know he was very good looking then – like something out of *Jesus Christ Superstar* we thought, with a lot of lovely curly hair."

Sniff This

In May 1998, this time in the catalogue to the exhibition *Look at Me* "Fashion and Photography in Britain 1960 to the Present",[44] Val Williams wrote that the bus portraits "are a remarkable record of youth fashion in the 'seventies."

She included six *National Portraits* in the show, two of them life size enlargements measuring six feet in height. They hung alongside Cecil Beaton and Terence Donovan, Brian Duffy and Hans Feurer, Juergen Teller and Norman Parkinson. Strange company.

But the "forgotten decade" with its "nasty secrets" that she had written about in her essay for the *National Portraits* catalogue had now become the *remembered* decade and my people held their own. She wrote:

Unlike later photographers, including Derek Ridgers and Nick Knight, who also documented youth sub-culture, Meadows had no particular interest in fashion;

his photographs are remarkable in that they picture not the extraordinary clothes which young people began to wear, but the very ordinary ones. In his photographs, young working-class men wear sports jackets and knitted jumpers. Every so often, a touch of fashionability impinges on their outfits – a round-lapelled shirt, a denim jacket, a tartan jerkin. Everywhere are the wide lapels and big buttons of 'seventies mass fashion.

And she was right. Fashion as a subject for photography has never interested me. I know it's about self-expression and being distinctive but the self-indulgence of it offends the Quakers in me who sit in there muttering all the time that we exist only to serve others and that we shouldn't run about shouting "Look at me!"

As with advertising, the demands of fashion can never be satisfied. Yet the sickness of it is endemic. The gurus of taste and behaviour and spending patterns are at it all the time, always rubbing our noses in the inadequacy of our cool and handing out labels, units of measurement to define the limits of our potential and to keep us aspirational and in our place.

Although in 1974 it was not yet the standard textbook it has become, John Berger's *Ways of Seeing*[45] sums up perfectly the thinking that informed the practice of my generation of documentarists. Here, for instance, Berger expands on the thoughts of German critic and philosopher Walter Benjamin in his essay "Works of Art in the Age of Mechanical Reproduction" (1936), by deconstructing the meaning of advertising (or, as he calls it, "publicity") photography.

The purpose of publicity is to make the spectator marginally dissatisfied with his present way of life. It suggests that if he buys what it is offering his life will become better. It offers him an improved alternative to what he is . . . Publicity is addressed to those who constitute the market, to the spectator-buyer who is also the consumer-producer from whom profits are made twice over – as worker and then as buyer . . . All publicity works upon anxiety. The sum of everything is money, to

get money is to overcome anxiety. Alternatively the anxiety on which publicity plays is the fear that having nothing you will be nothing . . . According to the legends of publicity, those who lack the power to spend money become literally faceless.

A function of the Free Photographic Omnibus was to give the faceless faces and, living in a Leyland bus that had spent most of its passenger-carrying life plying the streets of Nottingham, I had cast myself in the role of Robin Hood thieving from the marketing and publicity budgets of some of capitalism's bigger UK players – Calor, Granada, Hambro, Sun Alliance – and redistributing their wealth to the masses in the form of photographs.

Today Berger's words echo in the manifestos of anti-capitalist organisations like the Vancouver-based Adbusters Media Foundation which "attempts to challenge corporate takeover through media manipulation, direct action and a magazine. A critique of post-industrial capitalism, Adbusters argue that we live in a totalitarian society defined by the leisure industry, patrolled by the media, controlled by the corporations and sold on mass merchandising . . . Progress is how much you earn, not how much you care."[46]

National Portraits has no label except "ordinary" and it is a good word, the best word I know to describe those of us on the receiving end. People on TV, in the adverts and in magazines barely resemble us ordinary people.

People in adverts do what we do, but in a way that we would never dream of doing it, because we've got more sense . . . these effortless wannabes in the darkness of our ambition with their laughable lives. They are insured against absolutely every eventuality and they know strange things about coffee, and hair. They have the right holiday and the right girl. Their trains arrive on time. They have well-dressed partners who are always pleased to see them. Their complexions are spotless and their unmentionables unmentioned. Their unsightly stains are removable. Their teeth are almost as good as the teeth of those they go to with their anxieties. They use unlikely words, pull

unlikely expressions, and make use of unlikely chemical formulae. They are fancied, they are sexy, they've got muscles and their soft focus grannies rock. Their kids are cute, treasured, easily cleaned and amused by encyclopaedias. They brush their teeth strangely and talk a lot about toilet tissue, which they never use. No one ever farts in an advert. They're trapped behind their screens and the intention is that we should feel frustrated that we aren't in there with them. They want us to contract the contagion of their greed.

Of course, if they suspect that out here we are laughing at them, they set off on all kinds of fresh subterfuges of subversion, only with irony featuring big time. Little stands in the way of their offensive. And offensive it is. Fiction without hope. Here, sniff this.

So I like it when I see ordinary folk up there on the walls in the art gallery, the Kunsthal, holding their own alongside adverts people. Allow me to introduce you: *National Portraits* meet Helmut Newton. How nice. See his sophisticated ladies with their hats and their make-up and their hair and their red lips, porcelain skin and dangling cigarettes, their white gloves and canapés, and their perfect bodies against a green background. But just here – don't be shy – are Karen, in a sensible coat, and her big round mum Barbara, in the wig, posing for my Rolleiflex with their shopping bags. At last, a little balance is achieved.

Over there, Marc Lebon's scrawny dames, all lipstick and nail varnish, ripping men's suits off each other in a public toilet and necking up a sweaty knee-trembler, while just there, two young lads outside C&A in Southampton, one in a chainstore suit, the other in his Wranglers jacket, give us their picture straight. There's nothing to laugh at in the cavorting of Helmut and Mark, but there's often a giggle in a National Portrait. (Now then, what did *my* hair look like in 1974?)

In the summer of 1998 *The Face* magazine ran the "Boot Boys" picture – those five lads from Barrow-in-Furness. It prompted a phone call from New York: Scotsman Joe McKenna, stylist, sometime fashion editor at *Vogue*, and collaborator (I later discover)

with high-flying photographers like Bruce Weber and chic dames like Lady Harlech. He has a nice way with him does Joe. He tells me about his magazine, *Joe's*. It comes out once a year and is an expensive $80. It's his thing. His personal publishing space. An outlet for a man with a little money to spend on something he cares about. He wants to send me a copy and he wants to publish some *National Portraits* in the next edition.

Large format and heavy to hold, mainly in black & white, *Joe's Magazine* is lavish all right: beautifully produced. The advertisements it carries are often personalised just for Joe. He is clearly on the inside: Agnès B, Paul Smith, Elizabeth Arden, Romeo Gigli, Giorgio Armani. The famous names keep coming: Vanessa Paradis . . . Bardot . . . Nico . . . Jean-Paul Goude . . . Chanel . . . Paolo Roversi . . . Dirk Bogarde . . . Bruce Weber . . . Weber's story in pictures shows some blond young men undressing each other, rolling in the bracken and embracing – knobs a-plenty.

I sent Joe some pictures; he sent me a cheque. "A very small cheque," he called it. Not small to me. Let me explain – just in case you are under the illusion that I'm in this for the money – there *is* no money to be made from documentary photography. Not the way I do it anyway. If I didn't have a real job at a university I couldn't have afforded to do all this. Outside teaching I finance this crazy detective work by running photography workshops in Eastern Europe and the developing world during my holidays, selling pictures for publication, writing for radio and whatever comes along.

If you want to earn money from your photographs, you've got to get into corporate work or advertising. The Quakers won't have it though, and they're right. I'm told we turned down Saatchis last week. Good.

Most People Go for Sunsets

Dave, Maggie and Steve Summerton, mother and sons, from Southampton.

1974 1999

When petrol was a reasonable price and she had a car Maggie Summerton liked to go "out skiving" with her boys Dave and Steve.

Mother and sons came together to be re-photographed in October 1999. Dave, now a materials engineer ("PVC, polyurethane, paper") has a daughter, Eloise, aged two, the age he was when he posed for the Free Photographic Omnibus. Steve, now a primary school teacher, is 29.

MAGGIE: Before the boys were at school and we had the whole day free, we'd spend a lot of time skiving. I used to work in a chippy in the evenings. After the boys had gone to school I went back to work full-time. I'm a hospital cleaner.

MEADOWS: What happened to the picture?

MAGGIE: I've got it at work. It's on my wall among all the coloured ones. It's one of just two black & white photographs there. The other is of my mum when she was a little girl. It's about 90 years old. My brother had it before me. I've got a room to myself, I'm supposed to keep all my tools in there, which I do on one side, but the other side is all my pictures. I've got a little camera of my own and I love flowers and I take sunrises.

MEADOWS: Sunrises? Most people go for sunsets.

MAGGIE: Well I get up early. Being a cleaner I have to get there early and so I see the sunrise. In winter.

Maggie and her husband still live in the same house they lived in in 1974. Mr Summerton drives 60 miles to work every day, to his depot near Heathrow airport, leaving home

168

each morning at 6.15. During his working life he has been made redundant four times. As a travelling company rep on the road he "got used to driving and doesn't mind the journey". He was ten years with fibreglass, now he's in portable building systems.

Fax from Joe McKenna (6 December 1998):

> The magazine is finally out! . . . People who have seen it have really enjoyed your pictures and the subjects you photographed . . . I'm very pleased that you allowed me to publish them. Let me know what you think? Take care!

Bruce Springsteen and Neil Young

Ken Emery and Ed Murphy, friends, photographed in Southampton.

 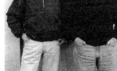

1974 2000

In the darkroom, printing pictures of people identified only by a reference number in the negative files, I tend to invent nicknames for them. The lads in D47.5 were always Bruce Springsteen and Neil Young. *Glory Days* and *Southern Man*. Now I know that really they are Ken Emery, with the checked shirt, and Ed Murphy with the mullet hairstyle.

The process of identifying and contacting Ken and Ed established both of them as holders of *Now & Then* records. In Ken's case it was that of Most Recognised Individual – for, after seeing his *National Portrait* in the *Southern Evening Echo* on 2 October 1999, no fewer than 17 people phoned in to say they knew him. Ken is a college lecturer, and a popular one it seems.

When I sent Ken a copy of the *National Portraits* catalogue – along with a note apologising for dropping into his life so unexpectedly – I enclosed a letter for him to forward to Ed. Ken was confident that Ed could be found. He replied:

Thank you for sending me the book. I found the project unexpectedly moving. I have sent your letter to Ed in Bermuda and also a photocopy of the newspaper article. You have not brought me any unwanted attention. On the contrary, some people with whom I had lost touch contacted me. Best wishes for the new project and I hope that Ed and I can be part of it.

When, four months later in February 2000, we all eventually met up in Southampton, Ken admitted that his knowledge of Ed's whereabouts had been based on an out-of-date address and the process of finding his old friend had been far from straightforward.

KEN: I had an address which we'd been sending Christmas cards to for 20 years, but it was the company address and not the home address. So I went to an Internet site for Bermuda where you can post questions. I wrote: "Does anyone know Ed Murphy?" And within hours there were about three people who had replied giving us his e-mail address.

And so Ed's own *Now & Then* record was set: he was the first subject of a *National Portrait* with whom contact was re-established as the result of an Internet search. On 30 November 1999 Ken received the following e-mail from Ed:

Hi, Ken
Bit strange about the photograph – I actually remember the occasion very well, my recollection is that the photographer had approached you whilst my attention was elsewhere. You came over and said there was someone who wanted to take our photograph, and proceeded to ask me if I thought you should tell him where to go (or words to that effect!). My impression was that you thought he was a bit strange! I still have the copy of the photograph that he sent to us later on. This whole thing, particularly the photo, was a source of much amusement to the kids.

Ed also e-mailed me:

Greetings from Bermuda! I am writing to confirm when I will be in the UK. I think you may be the last person I met who actually wanted to take my photograph, so I thought the least I could do was make an effort if you wanted to repeat the exercise!
 Look forward to meeting again,
 Ed Murphy (aka, apparently, Neil Young).

Ken is the son of a Welsh coal miner. He comes from Gelli in the Rhondda Valley. Ed's father came from Tralee on the west coast of Ireland and his mother from London. He was brought up in Staines, Middlesex. In May 1974 they were students on the same course and living in the same house.

Ken is three years older than Ed, but they had a lot in common, not least the fact that they were "working-class boys". They were both bright enough to get into grammar school, yet they both left school without sufficient qualifications to get into university. Ken left at 14 to start earning money and to go travelling. Ed, who made it to the sixth form, nevertheless left school early, impatient to get on and content to pursue a diploma.

KEN: I can vaguely remember the bus, and I remember getting the picture back ever so quickly. I've still got the photograph and it's got your name on the back. Then, a few years ago, I saw that *Weekend Guardian*, and immediately I saw the pictures – the stamp is so obvious. I showed my wife and the kids and said: "I was involved in this." I probably like the picture more now that I can look back. It's not like a one-off where you'd gone out, dressed up and posed for a photograph. (*To Ed*) That's exactly how you were every day.

ED: I think I must have just had my hair cut in that picture. It's looking incredibly well-shaped. The other photographs I've got of myself from that period I look much rougher. That haircut is more the kind of Rod Stewart, Sweet and Slade-type haircut.

MEADOWS: Is that the music you listened to at the time?

ED: Rod Stewart, Slade, David Bowie . . .

KEN: David Bowie *Ziggy Stardust* . . .

ED: David Bowie lives in Bermuda nowadays.

KEN: . . . that was a big album, wasn't it? *Ziggy Stardust*. And Crosby, Stills, Nash and Young.

MEADOWS: Ah, Neil Young! So I *did* have it right.

KEN: We had a lot of albums then that I've since bought on CD: James Taylor, Moody Blues, Stevie Wonder. Still good albums actually.

ED: I never followed music that much and, even now, when I buy CDs it's just because I feel I ought to have a few around the house.

KEN: I'm addicted. I can't stop. I really do like music. I buy CDs all the time. I liked music that attracted girls. (*Laughs*) Marvin Gaye and Curtis Mayfield.

Ed was a good football player. I played rugby. (*To Ed*) You always had long hair then. Play on the wing with long hair, like. Stereotype of a footballer. Willie Morgan.

I always supported Cardiff City, but now that I live in Southampton I do a lot of work with Southampton Football Club because we train what used to be called the apprentices. Now they're called the scholars. They all come to my department and I teach a lot of them. They do a GNVQ Advanced in Leisure and Tourism. Some of the very bright ones do A levels. I know so many who've been through the ranks and are now dotted around the country playing professional football. Alan Shearer was one of our students, Jamie Redknap was one of ours, but it wasn't as well structured in their time. They did six weeks catering, six weeks business studies, six weeks computing, six weeks car mechanics, and the idea was that if it [*the career in professional football*] didn't work out they'd have something to fall back on. Now they live in an academy and come to college one-and-a-half days a week for three years. It's better.

I remember that shirt. I probably lived and died in it at that time. A red check Wrangler. It didn't have buttons: it's got little pearl poppers. It was definitely a weekday.

I've got a little Parker Pen tucked in the pocket of my shirt, so that's a sign I would have been at college and come out for a little wander. I'm fairly certain Ed and I had been at college and we'd maybe wandered up for a coffee or something.

ED: It was a business studies course . . .

KEN: . . . at what was then Southampton College of Technology.

MEADOWS: Ken, on the phone you described Ed as being "more exotic" than you. What did you mean by that?

KEN: Although I've made a move coming from South Wales to Southampton, I've just settled. My wife teaches in a local school, and I'm quite settled. I've just swapped one settled existence for another. But I think Ed has made a really major move, living so far away.

ED: I got to know my wife right at the end of school. She was at the university here and, when we left, we worked in London for three or four years. When we got married Ken was my best man. And then we decided we would go and live overseas. Bermuda was actually the first place where we both got jobs. It could have been Barbados or the Bahamas but it was Bermuda. I think the first place I got offered a job was Saudi Arabia, but she couldn't work there so we gave that a miss. We intended to stay in Bermuda for a couple of years, but never really got round to leaving.

I work for a shipping and forwarding and transportation company and my wife works for a big insurance company over there. Then the kids came along and it's been a really nice place for them to grow up. Laura and her younger brother Paul are finishing off their education [*in boarding schools*] over here in England at the moment. She's just finishing her A Levels at a school in Shropshire and he's doing his GCSEs in Cheltenham.

Bermuda has a reputation as a fairly glamorous place. An extremely affluent group of people live there and there are no poor people. I think one of the reasons why Bermuda's been a successful tourist place for well-heeled tourists is because they don't have to look at poverty all day long. I've travelled a bit round Central America and, if

you've got any kind of social conscience, you can't walk around those places, they're just horrendous. People living in packing cases at the side of the road with goats tied up next to them. Whereas Bermuda is completely the other end of the spectrum. It's in the top rank of well-to-do places in the world. Comparing my kids' background with my own upbringing, it's like night and day. It really is.

Yes, we've had a swimming pool in our last two houses. And my wife – just like Ken and me – she came from a background of limited means and you try, when you bring your kids up, to at least make them have some appreciation of the fact that they come from what is a pretty well-off background. Even so, they can find their way around the airports of the world far more easily than they can around the bus stations of the world. Bermuda's a nice place to live and we never got round to leaving. We've been there 20 years. It's hard to walk away from a well-paid lifestyle.

KEN: I've got a 19-year-old son called Gareth, he's at Warwick University doing politics, and a 15-year-old daughter who's at the local school.

MEADOWS: Your son, Ken, is two years younger than you were when I took that picture. What do you think of when you look at that picture now?

KEN: It's really strange. It is clearly me. And people say things like "You haven't changed," but I was probably a completely different person then. I think maybe because I came from South Wales, maybe because I was a bit older, I may have had a chip on my shoulder. I think I was probably a little bit difficult. I was used to a culture of pubs and clubs and drinking and fighting. I wasn't a violent hooligan or anything, but I was just a little bit assertive probably.

ED: We were all thrown into a house together: Ken, me and Mick from Manchester. Mick was the product of a rich family, whereas the two of us obviously weren't. We'd head out to the bakery and work twelve-hour shifts two or three nights in a row to get ten or twelve pounds to get you through the next two weeks.

KEN: And we worked for British American Tobacco. It was dirty work, cleaning up machinery. I used to work in the offal room – strange name – where all the tobacco

dust from the factory was sucked in, bagged and chemically analysed so they could claim back the duty. At the end of the day they took an air-hose and hosed you down.

ED: Yes, I worked in the tobacco store there.

MEADOWS: When you look at that picture, do you look back and have any regrets?

ED: No, I don't think so. (*To Ken*) Do you?

KEN (*Thoughtful*): If my wife and I had been the parents of that person there (*points at his picture*), I think he would probably have gone in a different direction. When I went to grammar school, that was the furthest anybody in my family had ever got. My parents – no disrespect to them at all – but they didn't understand the system. I don't think they understood O levels, A levels, university degree. My father's ambition was to get a trade – that's what he always thought would be an ideal thing to do. And I think maybe I could have done with a little more guidance.

This sounds really dreadfully conceited but, at eleven, I must have been reasonably bright getting into the county grammar school, and I should have done a degree immediately. It was only later, when my son was born and I was taking a degree part-time and really taking to it, that I realised I wasn't stupid. But I have no regrets, because if I hadn't taken that route I probably wouldn't be quite so philosophical about life. So, in the grand scheme of things, I've won the Lottery: I've got two great kids, I live in a nice place, we've both got jobs, we've got all the comforts . . . and there are people living in cardboard boxes under bridges.

You know, I do the Lottery every week but actually I dread winning it. It's silly, isn't it? There's a sense that what you do defines your life. And if I didn't have to get up for work, there's a real fear in me that I would be so feckless that I'd drift aimlessly and lose direction. A friend of mine who's a psychologist said: "Well, you wouldn't, because you think about it and you worry about it. It's the people who never address it who would be taken by surprise and couldn't cope." I wouldn't like not to work.

But, if I was able to retire early, then maybe I could actually do a few things that I would consider useful. I'd quite like to work for a charity or even a political party. And

actually put any expertise that I might have in administration, fund raising, whatever, to something that needs it. I'd like to escape going to work, being busy, hectic, dealing with people. It's frantic: the organisation, the structure – often bureaucratic and difficult to deal with – you are at the whim of every governmental change and that causes problems. And you go home, the first thing is glass of wine, sit down, settle down, have a meal, have a chat, go to bed, get up and maybe do the same thing again. And occasionally I wouldn't mind saying: "Take a bit of time out. You're doing all right."

There are a lot of people who are looking for some assistance, say, driving a minibus to take old people out for the day. I'm not a do-gooder in the sense that I'm looking to do good, but I wouldn't mind putting a little bit back. When my children were small I used to help with the Scouts, help with the rugby coaching, but now they don't need it any more, I've gone back into my own little niche. And apart from my work I don't do a lot else in the community that I live in. And I think that I could do and it's probably that I'm a bit too lazy and a bit too tired and I blame work.

The King of Gibraltar

Fax from Meadows to Joe McKenna (31 January 1999):

> I wonder what the people in my bus portraits – particularly the ones who were young lads at the time like the Southampton teenager whose name I think might be Philip Thompson (not that I've been able to trace him yet), the one with his arm in plaster and "Fluff" written on it – would think about finding themselves between the same covers as Kate Moss in the complete buff. I think they'd probably be chuffed, don't you? Thompson would be about 42 now, old enough to be Moss's father and yet there they are both young and together courtesy of Joe's time machine.

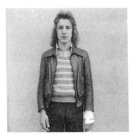 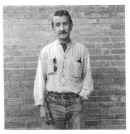

Phil Thompson, originally photographed in Southampton.

1974 2000

It was at The Bell, a pub on the edge of Winchester, that I met Philip Thompson in June 2000. He was 18 when I photographed him in May 1974 and 44 when I photographed him again. It was a warm lunchtime and we sat in the beer garden.

PHIL: When you first wrote to my parents' address [*in 1995*] I thought you were insane. You know that, don't you? There's this mad man chasing me all over the world, what's the matter with him? It's only an old picture. There's nothing special about it. I thought of getting on to Scotland Yard: "Listen I've got a stalker." (*Laughs*) Anyway I just couldn't be bothered. Sorry if it sounds rude but you weren't that important to me. But you are very tenuous aren't you . . .

You're like a bulldog, you don't give in. A bit of the British bulldog, when you hunt a bit of skin you don't leave it alone do you?

I'm very well known in Winchester, and this is like a very close town, so of course as soon as you put a picture of me anywhere my parents and everybody else sees it. "Oooh look! There are you in the *Guardian*." "Oooh look! There are you in the *Echo*." And so everybody was cutting them out and giving them to me. That was a gobsmack between the eyes. People said: "What's this two seconds of fame for you about then?" "Why have you acquired this?" And I'd say: "What's the matter with you? It's my smart gear, isn't it?" And you do, you tease. A lot of friends of mine have cut the pictures out and framed them, you know. Oh blinkin' hell, it's my claim to fame.

And this *Joe's Magazine*. Wow! Well, I'm impressed, really, that is quite amazing. This is incredibly interesting. Can you sell me that? My parents live in Spain now but they would be incredibly impressed. Are you coming back again in another twenty years?

MEADOWS: I'm not sure.

PHIL: I'll tell you something for nothing, that picture wasn't taken in Southampton you know.

177

MEADOWS: It was.

PHIL: No it wasn't.

MEADOWS: I know it was.

PHIL: It wasn't! It was not Southampton. It was in Minden Way in Winchester. And you actually parked your large bus in our road, a hundred yards from our house – you might have been boiling a cup of tea – and you drew our attention. It was such an unusual sight. I remember your bus. I don't forget anything, I've got a very precise mind. I was not going to work because I had a bad arm and I thought: "Wow, it's not often we see one of these up here and that's how we met."

MEADOWS: Philip, the picture was taken in Southampton.

PHIL: No it wasn't. It was Winchester. Minden Way.

MEADOWS: It was Southampton.

PHIL: You're wrong about that.

MEADOWS: No I'm not. Memory plays tricks. Anyway tell me about the clothes you are wearing in the photograph.

PHIL: Well, starting at the top, my hair. That was because I liked Rod Stewart.

MEADOWS: What was your favourite track?

PHIL (*thinking*): Hmmm, I can't remember its name. Let me try booting up the old hard disk a minute, plug in some extra RAM; hang on . . . (*starts humming*) . . . still loading . . . "coldest winter in almost 14 years . . ." What was that?

MEADOWS: Er . . . can't remember. What about the clothes?

PHIL: Well in them days you got about £8.50 a week and you had to give some to your mother. The rest you spent on clothes. Ben Sherman shirt, leather jacket, Tonics [*trousers*]. My first job was as a trainee manager at Curry's [*electrical goods*]. I remember the manager's name to this day, Humphries. I went there as trainee manager before I started my apprenticeship. It meant van boy. I just humped fridges around all day you know. And I'd go in wearing my new sta-prest and my Tonics and all the best clothing to impress the manager. And this woman's dog bit me once and, swear to God

big style, ripped my Tonics. But luckily Winchester is quite a conservative and wealthy area and she felt sorry for me. She said: "Well how much were your trousers?" And I said: "£7, that's my whole week's wages and you've ruined them." Next day Mr Humphries came to see me and said: "The lady's just popped in and here's £7, go and buy yourself another pair."

But we weren't really co-ordinated. None of it really matched. It all depended on what bit of fashion I really liked. If a particular thing came out you would have it. Checked bits would come in . . . we used to have the Bay City Rollers and all that. And you would follow a particular fashion bit and if they cost you so much then you had to match-and-mingle because you couldn't keep up with it every single day of the week. So sometimes you weren't just so co-ordinated. I mean the jacket cost me thirty pounds, you know, so I was going to be wearing that whether it's gone out or not.

MEADOWS: And how did you break your arm?

PHIL: It was the wrist. I'd broken a small bone in it, not a big one. I was an apprentice at the time, painter and decorator, and that was done falling down a large siren pole at the fire brigade office. In them days there wasn't health and safety at work like there is now. They let me down on a large rope. I was the youngest feller so they tied me on and lowered me down . . . a bit roughly as it happens and I fell.

MEADOWS: Why is "Fluff" written on the plaster?

PHIL: Oh that. Ever since I can remember I'd always wanted to grow a moustache. But it wouldn't grow. I once got it to an "eleven-a-side" (*laughs*) – fair and sparse. And I was always asking my elders: "Is there any difference?" "Bum fluff" they said. That's all it was. Bum fluff and the name stuck. Fluff. Then one day I got hold of some hair dye and put it on my top lip. No one told me that it would dye the skin as well as the hair and when I looked at myself in the mirror I looked like whatsisname from the Marx Brothers.

MEADOWS: Groucho?

PHIL: Yeah, Groucho. I didn't go out for two weeks after that. Never answered the

door to anybody whatsoever. And there was a worse situation, it was only shortly after you left Winchester. As all teenagers do, we're all worried about spots, and of course I used to Top-X myself every day. Top-X got rid of blackheads and stuff. And so I'd give myself a liberal coat of this no matter what. It used to come in a tube. And one day I am in a mad rush because I'm going out and I'm going to the disco with my favourite girl. And My mother came in and she said: "Oh my God! What are you doing? That's my Immac!" Hair remover. I'd got the tubes mixed up and I lost my eyebrows. They fell out. I was trying to wash the stuff off and my eyebrows were falling out that quick. And it was nearly four weeks that I had to stay in that time. I had to go to work and I got the mickey taken out of me big style. You can't paint them in 'cos it looks stupid. So I had no eyebrows and my famous tash that I had all the rubbish for left me too. I was bald as a coot facially.

MEADOWS: What age were you when you finally managed to grow your moustache?

PHIL: This'll sound really bad. Probably about 26. God's treated me really badly that way. Swine. He wouldn't give me facial hair when I wanted it.

Between 18 and 25, as you go through, you get that really vast change to do with your preferences. First of all it's just clothes, then you want to do the beer bit with your friends, and then it's girls isn't it? I have to look smart but I need to take her out too. So you have to compromise and then that strong-felt desire to be a leader of fashion edges off a bit because she's quite nice. Your aims change. You deviate slightly and the deviate becomes bigger and bigger and bigger and all of a sudden the shirts don't count and she counts, that's all.

MEADOWS: So did you have luck with the girls?

PHIL: I wouldn't say I was a Don Juan or whatever, but I've never been left wanting if you know what I mean. I've been married twice. I got married to Sharon when she was 23 and I was 26. We spent ten years together, had two daughters, and . . . most people who know anything about me will tell you I'm a reasonable man and I will sit down and I will talk and I will understand your side of the argument. I don't sit there

shouting, you know, I'll listen to you first. If I think you talk rubbish I'll tell you so. But I will go out of my way to listen to your side. After ten years we just fell out of love basically. So she said: "I want to do this" and I said, "Well, as a matter of fact, I want to go that way. So why don't you have the house, Sharon, and let me go?" And we actually broke up amicably. And then I wanted to do most of Europe which I did, travel over Europe, and then, at one time, I was King of Gibraltar.

Yes I was King of Gibraltar at one time. If you worked on Gibraltar you worked for me. I used to run a company there called Eagle Team. I went across there for the PSA when they were building all the bits for the Falklands. That's the Public Service Agency, you'd call it the Department of the Environment now. That was 15 years ago or more. But if you worked on the island you worked for me. Any form of construction on Gibraltar you worked for me. I had a really nice three years there. Unfortunately the locals learn very quickly – they can only be taken once if you know what I mean – and if you even move from your throne for one second you're usurped.

I was usurped because my wife got pregnant and there were complications. Debbie followed me all round the world, I didn't want to get married again, I'd had all that bit, yeah? I was having a great time but I just love her to death and eventually I said: "All right we'll get married." And the health service well . . . it would cost you an arm and a leg in Spain, or you went down the naval base where it was dead basic. There was no high quality mother and baby unit so I did some research and I discovered that Northampton was the most experienced with premature babies and so I flew Debbie to Northampton and made sure that she had the best. We've got two sons now. Of course when I got back to Gibraltar most of my business was missing. You know? It's just the way things are.

Three years was fine. I actually did have a really good time. I used to drink with the labour president in his own chambers with all his Masonry there to insist that I employ their children. It was all handshakes and that.

At that time I owned about 30-odd vehicles. Of a morning I used to paddle out

into Coleta Bay in a paddle-boat with a newspaper and a large vodka and coke, and sit in the sea watching the men arriving for work. Most of the blokes I employed were Geordies and they came working there for six months or so. I paid them in cash and they earned good money. Mad dogs and Englishmen working in the midday sun. Then I would paddle in to sign the documents.

I used to drink in *Cornwall's* bar, belonged to a local Gibraltarian, and I ran a tab there during the week for everyone who worked for me. I paid it every Friday. When they finished work they used to go in there and drink and I'd give them something to eat. My bar bill per week was £1,200. They were making me lots of money you see and all I was doing was giving them a facility and they used to think I was the best bloke in the world. Working for me in the midday sun sweating to death, they were making me money.

I've never been a greedy man and so I like to make some but then I don't need to make everything and if I can give back I will. So I was happy with my lifestyle. I could sit around in the sun, I could drive any cars I wanted. I used to drive over to Spain in a Porsche. They were making me money, weren't they?

MEADOWS: So what are you doing now?

PHIL: Well I've lost my driving licence recently. I've a 20-year-old Merc. An SE 350 Mercedes that I've personally had rebuilt just for me to drive in. It's the largest, widest and best one they ever did and it's mine. It's quite wide, it's quite big and it's quite "poash". It's well known, its got a stupid little number plate and bits on it. I can be quite flash when I want to be, yeah? But I'm banned just now.

MEADOWS: Has it got personalised registration plates?

PHIL: No. (*Laughs*) I'm not telling you.

MEADOWS: Tell me. PT1. I bet that's it.

PHIL: It's not too bad.

MEADOWS: PT2 . . .

PHIL: No. I'm not telling you anything. Daniel! Twenty-six years, yeah! There's no

need to get too deep here immediately. Look I lost my licence. I don't need to go to a church or anything like that. I know when I do bad and I know when I do good, yeah? I don't need anybody to tell me. I don't need to go to a church for someone to advise me on that. I walk around with my own church here [*taps his chest*]. I'm a humanitarian. I think perhaps religion has caused too much problems. I'm just a human. I think I'm pretty cool on that one. It does for me.

So now I'm the stores manager for King Alfred College up the road here. You have to be multi-available nowadays, yeah? I unload lorries, I do all sorts of things. There's always that little plaintive bit on the end of your contract isn't there? "You must be very flexible with and within the parameters" and it's worded so well. It means they can make you do anything they want. I am *in situ* there until January the eighteenth next year. I'm actually quite enjoying it to be honest with you. I got it because I lost me licence. I can't be idle, I need to do something and you can't really do any forms of business on a mountain bicycle, can you?

MEADOWS: So what will you do when you get your licence back?

PHIL: Computers. I can't leave anything half done, I have to know everything. So if you put me on to a subject, you know, I have to know all of it and two per cent more than what you were showing me. Now I can do the hard drive, replace chips, I can put in your CD-ROM, I can load your software, I can NT network, I can partition a bit. I've learned all that purely because I wanted to know what it was about and I've got so frigging good at it it's unbelievable. So I will start a business.

You see Winchester is quite cliquey. It's all sort of Masonry and church-owned. Well, the God Players were playing with a caff down Jury Street for a year and a bit, but they're not business people, yeah? And they lost £375,000 to the church. And now they've lost it and I'm speaking to them so that, if I can get the rental, I will turn it into the first cybercaff in Winchester for all those teenagers, all those students, all those tourists and university people who want to use the net. And guess what? The government wants to give you money to help you to do it, don't they? So why not utilise that

situation and perhaps Philip can make the odd pound. In Winchester everyone has to be switched on to the net and no one is doing anything like that here because everyone is too wealthy or too bored to do any different.

Look, can you sell me that *Joe's Magazine*? My parents would be so incredibly impressed. Even I am myself. You must be proud too, aren't you? A badge of recognition, yes?

MEADOWS: I guess so. But that's not why I do this. I do this because I think we pay too much attention to the lives of celebrities and not enough to our own lives. Our stories are good ones and they should be written down

PHIL: But Daniel, there's a double entendre there. By studying ordinary people and showing your work, you may turn them into celebrities. Which will defeat the object in the first place. (*Laughs*) That's a quandary, isn't it? That's a bit of sideways thinking.

MEADOWS: Oh, I've remembered that Rod Stewart title. "Mandolin Wind".[47]

PHIL: Yes, "Mandolin Wind", that's it. Are you coming back in another 20 years?

MEADOWS: We can keep in touch if you like.

PHIL: No, on second thoughts I'd rather you just appeared out of the mists. Out of the mist comes a trundling bus and loads of film. I'd prefer it that way.

Fax from Joe McKenna (31 January 1999):

I am not sure if you liked the magazine or not (?) but the only reason your photographs are included is because I liked them very much . . . they are not retro, they don't appeal to me purely on "street-chic" fashion level . . . I just liked the people you photographed and the project was obviously very personal to you and that's always very interesting to me!

Cover Girls

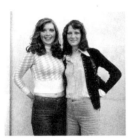
1974

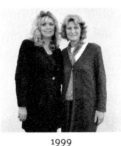
1999

Lyn and Stella (née Brasher) took a lot of finding. For 25 years I'd considered them lost. In 1974, when I'd asked them for an address where I could send their bus portrait, they'd given me a false one because they weren't sure whether to trust me or not. "Our parents had instilled that kind of thing in us," said Lyn. But even though they didn't get their portrait, they did see it because, shortly afterwards, it was published in the *Daily Mirror*.

STELLA: I was working in a holiday camp at the time, in a summer job, selling newspapers and people were coming in and saying: "You're in this newspaper today." And I was saying: "No, I can't be." But I was. And under the picture it said TWO ORDINARY GIRLS FROM SOUTHAMPTON and, of course, Lyn's modelling had taken off a bit by then and she said: "How dare they say I'm an ordinary girl when I'm a model!"

It was on Saturday 13 November 1999 that we met at Stella's house in Hampshire. Lyn had driven down from Surrey where she lives with her husband and her eleven-year-old son. Stella is married to a civil engineer and they have four children: two boys and two girls, the oldest of whom is 15. It's a busy household.

LYN: We're far from ordinary (*laughs*)!

STELLA: Absolutely (*laughs*)!

LYN: Nobody's ordinary!

STELLA: Once it had been in the *Mirror* and I'd seen it, I never thought twice about what would happen to that photograph. It wasn't until I was going out with a boyfriend

who came back from shopping one Saturday and said: "Here, Stella, I've bought you a present." And it was the book with the photograph of us on the front.

LYN: I bet that was Phil.

STELLA: No it was Fred. And he said: "Look I've found this book and you're on the front cover and he was all excited and I was oh . . . quite surprised.

LYN: Then she rang me up and I went out and bought it. It was in W H Smiths.

STELLA: And we'd always wondered why you'd taken our picture and why it had ended up on the cover. I thought it was because Lyn's midriff was showing.

LYN: Oooh Stella! That is so podgy! (*laughs*)

STELLA: I was quite impressed – because this chap was quite stingy – that he'd actually spent his money on buying it, that he didn't just drag me down to the shop and show me.

MEADOWS: How old were you at the time of the photograph?

LYN: My birthday's in October so, in May 1974, I was 19.

STELLA: And I was 17. I was at college doing a childcare course. That's what we all did. There were three of us girls, we have a younger sister Barbara. And we have an older brother, Paul.

LYN: Our father was an engineer and we lived at . . .

STELLA: . . . Fairoak near Eastleigh.

LYN: We were all born in London. Finchley, Margaret Thatcher (*laughs*). We moved out to Harpenden . . .

STELLA: . . . then we moved to Fairoak and that's where we all grew up, until I was 17.

MEADOWS: What would you have been doing on the day of the picture?

LYN: My flatmate was called Richard, he worked for CBS Records. And he'd given us a lift to town. Had we been to a party the night before?

STELLA: I don't know. We'd been out somewhere and then we'd gone to his office that morning and he gave me that Three Degrees album with "When Will I See You Again?" on it. My birthday is in April, but he'd given that to me for my birthday.

They had all glittery dresses on, the three of them on the front.

LYN: God we were laughing.

STELLA: And we left there and we walked into town and it was shortly afterwards that . . .

LYN: . . . we bumped into you on our way into town.

STELLA: We didn't go into the bus. We were walking by and you just jumped out at us and said hello.

LYN: And that made us laugh as well, because we weren't really taking any notice.

STELLA: We just thought it was a giggle, didn't we? "Oooh. That man's taking our photograph."

MEADOWS (*to Lyn*): What were you doing at that time?

LYN: I've got an awful feeling I was go-go dancing in *Friday's* nightclub! I desperately wanted to be a model (*laughs*). I knew that's what I wanted to do. I went in for "Miss Southampton" that year as well because Richard took me down there to the pier. And there were only two of us in it and I came second . . . and last! (*laughs*) But I got a bouquet of flowers [*even though there were*] only two of us in it! I was happy. I think I got £15 as well. Richard drove me down and I think he also bought me a swimsuit. But, um . . . I think I was dancing in a cage in *Friday's* nightclub. For a year.

STELLA: I remember going there. In fact at this time we spent a lot of time together. I used to go on gigs with you when you were dancing.

LYN: Did you? In those silver boots, platform boots . . .

STELLA: . . . and tassels.

LYN: Yes (*laughs*). And they had strobe lights underneath and I got £3 a session and I had to dance four times throughout the evening. Nine o'clock, ten o'clock, eleven o'clock, twelve o'clock then go home. But my rent at Richard's was only £7 a week so that was good money. I was doing quite well dancing. I knew I didn't want to carry on dancing, I knew I wanted to model, but it was a "way in" like the beauty competitions. I just didn't know how to get into it. Then, when I won "Miss Portsmouth" somebody

saw me in a newspaper and that's when I got my first modelling job.

STELLA: And you ended up going in for "Miss Great Britain" too.

LYN: England. "Miss England". I came into the last seven. I was very green, I was just . . . I don't know. That wasn't really what I wanted to do. Anyway an agent saw me and, once I'd got an agent, that was it. I was on my way. I was hitch-hiking and I got a lift with Anne Scott [*the agent*] and she said: "Oh you ought to be a model." That was about a year after you took our picture and I'd lost a lot of weight by then. I should have brought my book [*portfolio of modelling pictures*] to show you. I got it all ready and then went and left it behind. I was very thin, very thin.

MEADOWS: And Stella, what were you doing at that time?

STELLA: I was at Fareham Tech, and I left after the first year 'cos I was bored of it and I moved to London, worked as a nanny and they looked after me . . .

LYN: . . . she worked for a wonderful family . . .

STELLA: . . . and then I got bored of living in London and decided I wanted to go to America and I nannied out there for a year. And then I had one failed marriage – no children luckily – and then met Mike and carried on just having children. I had lots of jobs in between and I worked for a good friend of mine on the Island for years in a crystal manufacturing business.

LYN: Stella's very good at making things. She can make lots of wonderful little things. Gorgeous little things.

STELLA Floristry work and things.

LYN: You did a floristry course, didn't you?

STELLA: Yes.

LYN: I married a local man, a Hayling Islander actually.

STELLA: Yes, you've had a failed marriage too. We're both divorcees.

LYN: I was living in Southampton with this chap called (*laughs*) Jeremy. I shouldn't be saying this . . . but that didn't work out so I came home just for a respite, just to pull myself together before getting a flat in London. And I met Peter, the boy next door, and

his father owned Sunshine Holiday Camp on Hayling Island (*laughs*) – knobbly knees competitions and all that – and he was quite wealthy, wasn't he? Quite flash I suppose. Well he was a bit, wasn't he? For Hayling Island.

STELLA: He was different.

LYN: So I married him. Mum and Dad liked him too. That lasted three months. I remember the photographer sent a letter to me asking if I'd like some copies of my wedding photographs and I said: "No, thank you, we're separated."

STELLA: That was terrible, wasn't it?

LYN: It was just awful. I'd married him on the rebound. Then I went up to London. I went to modelling school, to Lucy Clayton in Bond Street. I'd found out all about it from *The Lady* magazine and the fees were about £150, a lot of money then. Plus you had to have black high-heeled shoes, black skirts, you know, there was a list of what you had to have. So I had to take a nannying job for a little while and save up. Then I went to London, got a flat, got a house in London, and worked. I met Kevin when I was 26. We dated and, um, we took a pub. I was still modelling, but we took this pub for two years and that's what set us up. And we've been married now for 15 years, together for 20.

NINA [*Stella's daughter*]: And you've got a swimming pool . . .

LYN: Yes . . . and we've got a swimming pool. And electric gates. Very flash. And security cameras. Kevin's very security conscious, we've got security cameras everywhere and we've got televisions in all the rooms and you can press a button and see who's outside (*laughs*). And we've got one over by the swimming pool as well so we can see if anyone's drowning. I'm supposed to watch it when I'm in the kitchen, if children are swimming, but I forget to turn it on (*laughs*).

MEADOWS: Are your parents still alive?

STELLA: Father died six years ago. Mother still lives on the Island in a warden-controlled flat.

LYN: She's just 70 this week and we bought her a hot-air balloon ride . . .

STELLA: . . . and I'm going to send her up with a pin. (*Everyone laughs.*)

LYN: She's a very bright lady, our mother. We had a lovely, lovely childhood. We just had a super time. We lived in the country in a nice-sized house with lots of garden and my parents allowed us to do most things – tents and . . . and do you remember when you dug that pond right outside the back door and dad came home and said; "Oh Stella, I think you need some help with that." He didn't go mad and there was this massive hole . . .

STELLA: . . . straight in the middle of his best lawn. (*Everyone laughs.*)

LYN: And Stella used to build runs everywhere for all her animals. And I was always upstairs putting make-up on.

STELLA: Our parents didn't worry about our education. They worried about Paul's education, [*but*] they never cared what we did at school. They never showed us any encouragement or said we needed to get an education, so we didn't bother.

LYN: We all did CSEs and I got an O Level Art.

MEADOWS: Do you mind that you didn't get a good education?

STELLA: I do now. Because these girls [*daughters*] go to a good school, a local Church of England secondary school and they expect them to work hard and they expect good grades and I'd like to see both girls do well and have good jobs. That's something I've always resented that I never was channelled into doing anything. I'd like to have done some engineering. I could really see myself as a civil engineer. And you get lots of girls in that nowadays. I'd love to have had that type of career. A proper career. I've enjoyed having the family, I love having my family. I don't work now, I don't want to work, I'm privileged to be able to stay at home and look after them and be here for them. But when they've grown up I'm often thinking: "What will I do?" I'm creative and I've never had a career and I do resent that slightly.

MEADOWS: What became of your brother?

STELLA: He's the only one we don't keep in contact with really. He keeps himself to himself.

LYN: We love him.

190

STELLA: He finds us three girls too overpowering, I think, or . . .

LYN: We've all done quite well and he . . .

STELLA: . . . struggles with life. But he is the apple of my mother's eye and he is the one she would like to phone or to come over and he doesn't.

MEADOWS: Where does he live?

STELLA: Not far away, in Porchester. When he was in his teens, it was right in the middle of the 'sixties and although he had a good brain . . .

LYN: . . . he was very clever . . .

STELLA: . . . he was just into flower-power and give-peace-a-chance and he never got himself off the ground.

LYN: And then he had three marriages with children in each one.

MEADOWS: Bit of a hippie?

STELLA: Yes.

LYN: You'd like him. He's very nice, very laid back, very quiet . . .

STELLA: He's a nice guy.

LYN: He sees what we've all done, you know, successful marriages, things like that and he just thinks "Oh I'll never catch up." He can't compete. He's just managed to get himself a little council house hasn't he? I've not seen it, Stella's seen it and it's tiny. Weeny.

STELLA: We adore him, but he just keeps himself to himself. We'll invite him for our millennium get-together, but he won't come. He'll work that night because he's a taxi driver.

Confloption

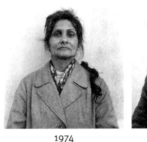

1974 1999

Florence Alma Snoad – Floss – was 48 when I photographed her in May 1974, and 73 when I photographed her again in September 1999. What follows is put together from her letters and also a tape-recorded conversation we had at her home in Southampton.

Born in 1926 in Rajputana, northern India, into a large Anglo-Indian family called Franklin, Florence went to live with an uncle and aunt at the age of three. She was, she says, the "odd one out". In due course they adopted her and brought her to England in 1936. They had planned to live in Southampton only briefly, but the uncle died soon after they arrived so they stayed put. A teenager during the war, she met and married a sailor, Frederick William Snoad, from London, by whom she had two daughters, now both in their 50s, who have careers and families of their own and live in other parts of the country. Florence remains in touch with her daughters and often visits them.

We looked at the 1974 picture and I asked what she might have been doing in Guildhall Square on that May morning.

FLORENCE: I had probably just finished one of my mop-and-bucket jobs and was hanging around "being a yob" (*laughs*). I used to just sit about. Sometimes I'd do a bit of painting and drawing.

She showed me some of her brightly coloured paintings done in a pointillist style, landscapes mostly, with horses and windmills.

FLORENCE: Just waiting for them all to come out of the offices so that I could go back in and get on with the cleaning.

I used to get up very early. I worked for an agency that sent you out on different cleaning jobs. Offices, hotels. An early shift, and a late shift. I used to work on my own. Always a loner.

I wasn't really suitable for factory work. I'd given it a try. But I knew very well that whatever job I went for I would be hopeless, but they have to give you a chance, don't they? I knew always that I would be fired, or I'd be no good or there'd be an excuse to get rid of me. It wasn't a race thing. It wasn't racist. It was just that I was always pig-in-the-middle. It wasn't discrimination.

Right from the start I was one of life's losers, you know. And it is pathetic, isn't it, that I am just nothing. No friends, no future. Only just wandering round the streets. At school the teachers would tell the other children to ask their families if they would like to befriend Florence, take her home, and the hands would go up yes, yes, yes and I'd be so hopeful. And then, a week later, they'd all say no. I'm ever so sorry, mother doesn't like her, father doesn't like her, the cat doesn't like her, the dog . . . and there was always some excuse. I got used to it.

People are always offering to pray for me, I don't know why, but I didn't ever feel I belonged to any particular god, Jesus Christ or anything like that.

When I was a mother, I wasn't conventional. My daughters brought *me* up I think (*laughs*). The other mothers all worked in shops or in factories and they had their circle of friends. If you couldn't get work then you were supposed to stay at home and do your cooking and your cleaning, but I didn't have any need for that because my husband, who was a practical man, worked away a lot, he never came home at a fixed time and he could do his own cooking anyway. And my daughters, once they were teenagers, they lived independent lives.

Of course, I might have been on my way to a modelling job that day when you took that picture. Life modelling. Just rag and bone and a hank of hair, wasn't it? During the

war in London we'd lived down in the underground and we'd seen it all. My husband said it was okay so I did it. They would send me a little telegram from the art school in Winchester telling me when they wanted me. So perhaps that's where I was going after you took that picture.

Or dancing. I used to go off on my own dancing. I didn't often get a partner. So I used to do my own thing, my "fan and feather" as I call it. Down at the Guildhall. They'd have someone playing the keyboards, or a tape and I would dance. Towards the end I would remove my skirt and I would just have my black stockings on like the old-fashioned Victorian naughty girls, and a few strands of coloured grass instead of a skirt and I would have feathers sticking in my hair and a garland of flowers round my bosom. I did a combination of all the ethereal dances, the dying swans. Often I would be left alone on the dancefloor just with my fan and feathers and flowers. They liked it. Mr Goater – he'd been in the Air Force during the war and a councillor, mayor and all the rest of it . . . the senior citizens still have the Fred Goater afternoons, but I don't go any more. I stopped four or five years ago. After my husband died I lost all incentive.

Frederick Snoad died in 1996, while the council were in the middle of renovating their house. Florence used the word "confloption" to describe the chaos of that time. She was nursing her dying husband on a bed in the living room while all around her builders were busy refitting fireplaces and preparing to install double glazing. Frederick died in hospital shortly before Christmas. The stress of it was all too much and Florence "collapsed".

FLORENCE: I was terribly depressed and I had nobody to turn to. I couldn't get about because I wasn't well. And the welfare people all expected me to conform with what everybody else did, should do and be like. They gave me a carer for a little while, but we didn't get on really. She came one day and said she didn't have much time. She took me to Tesco's and she started doing a "hurry up" session with me. "Hurry up, now! Hurry up!" Anyway I got fed up with this. I had a little list of what to get, but she was

getting on my nerves because of all this "Hurry up! Hurry up!" So I wasn't very nice to her and, right there in Tesco's – on a Saturday in was – I went down on my hands and knees and with my hands like this (*she cups them in front of her, like a beggar, and bows*). I went: "Thank you very much," "Thank you very much," "Thank you very much," "Thank you very much," – on and on like that. And I got the people at the checkout to get me a taxi and I told them "No way am I going anywhere with this person, get me a taxi to take me home." I gave her a bit of a working-class hurry-up session of my own, you see, because I'd had that all my life and I knew how it was done. Anyway I left her there. I didn't want to be taken out walkies!

Fed up with moving Frederick's ashes from room to room all the time, Florence decided she would do without the renovations and sent the workmen away. (Three years later the work was still unfinished.) She decided to scatter his ashes at sea.

FLORENCE: We got on to one of those big pleasure boats showing day-trippers the sights of London from the river, and we managed to find a sheltered bit at the back of the top deck and, on the way back up the river, we emptied the container and all his ashes just blew out and landed on the water to be carried away on the tide out to sea. He was with us in spirit there because he loved London.

He's a very nice ghost, but it is very lonely without him. His garden does what it likes, it dies with the seasons and the birds do the same thing, nesting and escaping the cats. They nest all through the year – they don't read the nature books so they don't know that they shouldn't. People talk about the community, but I'm not even one of the community, just the odd one out. I live in my ghost home and drift through each day from one empty void into another. It's all an unsettled life for me still – I have no other nationality, only British. My time is my own and quite free to do what I wish, I have no close friends, only officialdom which I am used to their forms. Autumn is here and I have not altered the clock for two years. It gets a pointless ritual when you are going nowhere and doing nothing. I am too old anyway to be of any use, just one of the

dregs of this world and now compost to be scattered somewhere over wild mountains and flowers, my hair to form frost and icicles over cherry and fruit blossom.

I am trying to survive alone and remain as active as possible. It is a depressing life and very lonely. Other women have done and been career women and good housewives or family people, but I have reached the end of working life doing it all wrong – and not socially acceptable anywhere at any level. Living alone my lifestyle is rather like a prehistoric hermit. The modern inventions are useless to me – the everyday domestic utilities like fridges and washing machines no longer in use – gradually everything is wearing out and useless so I'm letting it.

I do go into the outside world and wander about wet cold streets and use trains, buses, taxis – sometimes a visit to the country – wet cows and animals. I am allowed to go on living here, they assess my personal life and have told me all the other alternatives, so I'm aware there are monasteries – prison cells, idiot homes, old people's – and everybody praying for me.

I am not of any religion, as the practical things of life have to go on and any Holly Holy Spirit will scatter me around for the stars to enfold, there is no earthly place – my husband is there waiting for me. Maybe I'll have some friends some day. I think all our lives are different, I don't think you can put everybody in a category, ever.

PART THREE

GATHERING COINCIDENCE

Planet Waves

In 1974, on the bus, running out of money and short of audio tape, I attached the microphone of my tinny tape-recorder to the loudspeaker of my little transistor radio and (God forgive me) recorded – over a precious interview done with the subject of one of my photographs – Bob Dylan's latest album, *Planet Waves*. But I had my priorities right. Dylan had been on board ever since I first heard him sing "take what you have gathered from coincidence" on *It's All Over Now, Baby Blue* and, at the time, one interview more or less was neither here nor there. I was travelling England as a documentary adventurer, not a bloody auditor.

Lilliput

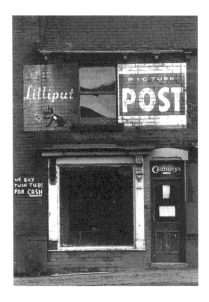

There is nothing new about the idea of juxtaposing two images. I first saw it done – or anyway consciously noticed it done – in the summer of 1972 when I entered a second-hand bookshop in Whitby, Yorkshire, with Martin Parr and found some copies of *Lilliput*, a pocket-sized magazine full of photographs that had been paired off to give loaded messages; messages which, although intended by the editor, existed only in the reader's mind. I still have the magazine I bought that day.

Motorcars look like sea creatures. Seen from

above bare-breasted girls in tight spangly costumes and high heels lie on the stage of the Folies Bergères and opposite them there's an open box of slippery fish. Get it? (The photographer in this case was Brassai.) A pair of strange birds imitate the conversational posture of two upper-crust ladies at a literary luncheon. Caption: A DISPUTE BETWEEN CRANES. A group of bemedalled English toffs in full evening-dress, complete with handlebar moustaches and monocles, stare across the fold at three half-naked Zulu women, their breasts tied around with beads. Caption: DECORATIONS WILL BE WORN. Some of the best pairings show politicians and bankers looking like old goats and fat cats. A sneering Neville Chamberlain, then Prime Minister, is compared with a tooth-gnashing llama; while Sir Thomas Inskip, then Defence Minister, is uncommonly like a "sea-elephant". Mussolini beside the Hungarian Premier are a pair of frightened rabbits. Bonnet, the then French Foreign Minister, is a salmon-breasted cockatoo. The likenesses are remarkable. Hore-Belisha, then War Minister, peers across the page up the ballooning skirt of a pretty girl. The then Minister of Labour, Ernest Brown, is depicted in his pomp opposite an unemployed man holding up the sign KICK WITH US FOR WORK OR BREAD; Chamberlain and Mussolini appear next to a primed NIPPER mousetrap complete with cheese and an inquisitive white mouse. Cabinet ministers are made to look like inmates of a zoo with the caption SEA LIONS IN CONFERENCE; and a baying Lord Halifax, then Foreign Secretary, is perfectly mimicked by a laughing horse. Caption: CHAMPION TROTTER "GREYHOUND".

Magical juxtapositions and all the work of Stefan Lorant (1901–97).

Lorant was a Hungarian of Jewish extraction, a supremely self-confident chameleon who believed he could do anything he set his mind to and who experienced many of the extreme political upheavals of the twentieth century at close quarters.

A student during the brief period of communist government in Hungary in 1919, he ran a hospital for undernourished children in the former home of an aristocrat. Then, having fled to Vienna to escape a right-wing backlash and following a chance meeting with Franz Kafka, he began a career in the film industry, first as a violinist and

later as a director. He made 13 silent films before settling in Germany and turning his attention to picture magazines.

In 1933, as editor of the *Münchner Illustrierte Presse*, the first modern photo-journalistic paper in Europe, he was gaoled by the Nazis; a six-month sentence that resulted in his best-selling book *I Was Hitler's Prisoner* (1935).

After a spell as editor of the Budapest magazine *Pesti Naplö*, Lorant arrived in England in 1934. The picture magazines he edited in the late 1930s and early 1940s earned him the title of "the godfather of photojournalism". He turned in healthy profits for his proprietor Edward Hulton (paradoxically an admirer of Oswald Mosley), while all the time leading a campaign against appeasement and poking fun at the aristocracy.

In his long life Lorant had three wives and several different incarnations both in Europe and America. He was present at many of the key moments in twentieth-century history and was the friend of great men and beautiful women. He was an ardent champion of Winston Churchill in the run-up to the outbreak of the Second World War, while, in the early 1960s in America, John F. Kennedy used him as an adviser on election strategy. He knew Marlene Dietrich, Greta Garbo and Marilyn Monroe.

Lorant's first British magazine was the *Weekly Illustrated*, originally called *Weekly Illustrated with Clarion* – *Clarion* being a small newspaper with an honourable name, which, according to its assistant editor Tom Hopkinson (later Sir Tom) remained little known outside Labour Party circles. Hopkinson had been unable to increase *Clarion*'s circulation, so it was incorporated into a new publishing venture, *Weekly Illustrated*, with Lorant as its picture supremo and Hopkinson his caption-writer.

Lilliput, Lorant's second British magazine, was launched in 1937. But a year later he created Britain's only truly successful weekly picture-led news magazine: *Picture Post*, with Hopkinson as assistant editor. With a peak circulation of 1.75 million, *Picture Post* dominated British magazine culture throughout the war and for a decade afterwards. *Lilliput*'s circulation, on the other hand, reached only 300,000 at its peak in the mid-1940s, and, although it outlasted *Picture Post* by three years, it was

eventually swallowed up by the girlie mag *Men Only* in 1960.

Picture Post's distinctive cover design was much copied, indeed the look of my own *Living Like This* owed it something, the title being set in a red box against a large black and white picture of two pretty girls, a classic *Post* formula. Perhaps this is what first caught Alan Dein's eye when he (also prowling a second-hand bookstall) first discovered the Free Photographic Omnibus, for Alan is a *Picture Post* fan. Shortly before coming to interview me, he had been sent to the USA – also for *Talking Photography* – to interview Stefan Lorant, then living in retirement in his 60-acre estate in Lennox, Massachusetts surrounded by the clutter of the filing cabinets that documented his life.

Picture Post's huge and immediate success in the late 1930s did little to calm Lorant's fears that, as an immigrant from Germany, he would eventually be interned. Indeed, when he returned to Britain from a trip to America in 1939, the authorities refused him nationality, classified him as an enemy alien, and even confiscated his bicycle. So, in July 1940, he left Britain for America for ever (sailing, incidentally, on the same ship as Noël Coward) and Tom Hopkinson was appointed the *Post*'s editor.

Driving *Picture Post* through the difficult days of the Second World War, Hopkinson used the magazine to lead the popular debate over what kind of country Britain should become once the war was over and, in so doing, he established a unique brand of picture-led journalism at the very heart of the country's democratic process.

In 1950 Hopkinson resigned from *Picture Post* following a now legendary argument with his proprietor over editorial integrity and, in due course, he too left England, moving to South Africa to edit *Drum*, another picture-led title. During the 1960s, in Kenya and Nigeria – before returning to the UK – he set up the very first training courses for African journalists. In 1970, in Cardiff, he created Britain's first university course in journalism, and so it is that today I find myself working at Cardiff University out of the Tom Hopkinson Centre for Media Research.

As a young photographer I knew nothing of *Clarion*, the left-wing publication that Hopkinson had failed to save back in 1934. But one day in 1976, while working as

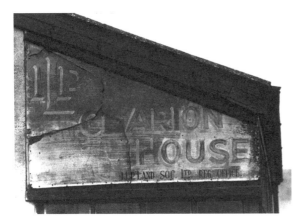

artist-in-residence to the Borough of Pendle in Lancashire and looking for stories to tell, I came across a dilapidated ramblers' café – a hut in the countryside near Nelson – called Clarion House.

I took some pictures and wrote about it for *Lancashire Life* magazine:

When Robert Blatchford launched the Socialist weekly *The Clarion* in 1891, circulation was boosted by Clarion Cycle Clubs formed throughout the country to sell the paper and hold meetings. Clarion huts were built by volunteers as refuges where the cyclists could eat their sandwiches and drink pots of tea brewed by local Labour supporters. Before long, the huts became centres for weekend picnics and discussions. Now [1976] it is believed Nelson's Clarion House at Dimpenley is the last still functioning in England.

Stan Iveson and Doug Hoyle sharing a joke in Nelson's Clarion House.

My piece was a picture story showing members of the Independent Labour Party (ILP) and ramblers sitting in their Clarion hut drinking tea. The occasion was a conference entitled "A Consumer's Guide to the Social Services". There were about eight people in attendance. High up on the kitchen wall was a framed portrait of the Scottish miner who had founded the ILP in 1893: James Kier Hardy, pacifist and Westminster's

first flat-capped MP. Present in person were the local Labour MP Doug Hoyle and the then National Chairman of the ILP, Stan Iveson.

The Quakers in me liked Stan. He provided a privileged glimpse through the firebox door of English socialism. Not the whole thing, of course, but enough of a red glow to be warming – it's not a history you hear discussed much these days – and so, one evening in the early summer of 1976, I took a stroll up one of Nelson's steep, cobbled streets to interview him.

The Only Plumber in Walton Gaol

Stan Iveson was born on 29 June 1912, coincidentally the same day that the ILP bought the land on which to build the Clarion House.

STAN: I started work as a weaver when I left school. In the mill. Both my parents were weavers. My sister was a weaver. My wife Ivy was a weaver. I went tentin' [*an unskilled assistant*] but I didn't stick it. Three months it lasted, then I started in the building trade, Nelson Co-Op. The third of October 1926. The year of the General Strike. I'm a plumber. The strike was over by then, except for the miners who were still out.

The ILP started in 1893 with an inaugural conference in Bradford, but there was an ILP in Nelson before the official inaugural meeting. We've been going that long. We had a big set of rooms here in Nelson right through until disaffiliation from the Labour Party in 1932. In Nelson, when I were just starting out, the ILP had roughly a thousand members and a full-time organiser. Clarion House was the third building we had for Socialist Fellowship, there had been two earlier buildings before we moved there.

As a nipper I used to go up to the Socialist Sunday School in the ILP Hall on Vernon Street, in fact I was wheeled over there in a pram. It wasn't teaching religion. It was teaching ethics. We always maintained that ethics weren't something confined

to Catholics, Protestants, Methodists or any other church. Ethics can be talked about without talking about Almighties. Socialism had its precepts like the church had its commandments.

In Nelson the teachers and the superintendents were all members of the ILP. Even though the Socialist Sunday School movement had no particular political affiliation, they ran it. So to us as kids the ILP and the Socialist Sunday School were one and the same thing. When I grew up I used to teach in the Socialist Sunday School and I taught what I knew as an ILPer. There was an adult class with 50 or 60 members.

I joined the ILP at 14, which makes 50 years this year. I've got me certificate. I took the Chair in a debate on capital punishment and I've been anti-hanging ever since. The ILP's always been against medieval practices like that.

Anyway there were strikes galore, and a lot of them held their meetings in the ILP rooms. We ran food kitchens in the ILP rooms during the Depression. In 1928, together with another apprentice plumber, I fixed the big boilers they used for making soup to feed the hungry. I were brought up on strike pay, and lock-out pay, and unemployment pay. My parents were always on strike . . . over a fourpenny mantle once. Somebody broke a mantle [*the element of a gaslight*] and was required to pay for its replacement and the union brought everyone out on strike.

We took part in every demonstration there was. I was in that one in 1932 – I were, what, 20? – the one they call the Battle of Pendle Street, when the weavers were on strike against the "more looms system". And mounted police charged them with batons drawn. I wasn't a weaver, but if the weavers were against it, we were against it. And I were there when the stones were being thrown. I don't throw stones, I'm not putting any halo round me head, I just don't think it proves anything. But I was there when the batons were bashing about and when one gets you like that and you feel the waft of it it's pretty hefty.

I wasn't hit but I was caught. Outside the old Liberal Club it was. There was a painter there, in the crowd, one of the mildest types I ever knew, wouldn't say boo to

a goose. And when the police grabbed me a little circle gathered round. A lot of women, and women can often get very tough can't they? And this painter. And I can see that feller today. I were more surprised than the coppers. He said: "Let that lad go!" And his eyes were flashin'. And that young bobby was scared to death and he let me go.

When the Jarrow Hunger Marches were on I was still only an apprentice and I remember crying outside Nelson Weavers, not at the poverty, but because they wouldn't let me join the march.

I went cycling a lot as a boy. But, you know, there wasn't a Clarion Cycle Club in Nelson at the time, so I rode with the Nelson Weavers' Cycle Club. Thousands would set off on a Sunday morning from round here.

I must have been in a hundred and one demonstrations. There used to be a Speakers' Corner in Nelson, near where the Arndale Centre is now. I got a lot of my training there – in the rough way – arguing with Mormons, Catholics, Communists, even the Tories used to have a do up there. We'd argue into the small hours on a Friday night. That was my training, that and the ILP classes. They ran speaker's classes, they ran classes on current affairs. And every one of us were active in our unions. I were on the committee before I were out of me time. When I were 20. And at 23 I were the Union Secretary.

The ILP was involved in everything. The majority of the Co-Op committee was made up of ILP members. The majority of Nelson Weavers Committee were members of the ILP. Some of the General Workers. The ILP was the association which held the dances. We had concerts; a billiard team that played in the Socialist Sunday School League. We had a cricket team. We'd a football team. Really, it was the ILP that played a major part in the town until 1932 and disaffiliation.

The big division between the ILP and the Labour Party was about its attitude towards war. Nelson had a very high concentration of Conscientious Objectors during the First World War. The highest percentage in the country. And there were a lot in the last war too. There were scores and scores here. And they were treated very badly during the First World War.

We didn't have it anything like as bad during the Second World War. I was a Conscientious Objector and I've been in prison twice. In 1942 and '43. In fact I probably were treated one of the best of anyone in prison.

You see, prison is like the capitalist world: there are good jobs for the few, good positions, and the many gets the rough end of the stick, don't they? Well a fellow goes in without a trade or er . . . well, I wouldn't say any of us has a high mentality, but many of these criminals, well, I always thought they were a bit lower than me! (*Laughs*.) They gave them mailbag sewing, the real scruffy ones – I shouldn't use them words, should I? But you'll know how to sort them out for me – anyway the rougher type, if you like, they got whitewashing to do and that sort of thing. Well our lads, conchies or COs, all got something pretty good.

For instance, Gilbert Kinder – who was wonderful at writing – the screws had him as a cleaner on the landings. Now, outside your cell door is a big board with VEGETARIAN on it or ORDINARY DIET, what your job is, your date of release and so on and so forth, there's quite a number of tickets slotted in. And Gilbert did these tickets in this wonderful lettering for his screw. So he had quite a pleasant job. Others got in the kitchen, some were in the stores but I . . . I was the only plumber in Walton Gaol.

When they found out I was a plumber they gave me a lot of latitude because there weren't a plumber tradesman amongst 'em. I was never short of customers in Walton Gaol.

Not like Nelson, where there was always one or two customers who would refuse to have me because of my politics. I could mention one in particular who wouldn't have me until, shortly after, she had a burst pipe and I was the only plumber she could get and she were desperate. But I wouldn't turn out for her (*laughs*). I shouldn't swank about that, but I can't help swanking a bit! For all I know the ceiling's still running through (*laughs*). One does get satisfaction out of such things . . . but one shouldn't, I know.

With remission I came out before the six months were up because we'd all appealed

while we were in prison and my appeal was upheld. It was part of the game to appeal against the sentence. Politically it was important to appeal.

Out of prison I was offered ambulance work, fire brigade, hospital work, land work and so on. And I turned them down. Gilbert went draining. Well I refused to do that. Some of us took the view that it weren't just the thing to do, to go on the land and maybe turn a feller off the land whose job it had been. So I was sentenced again for refusing a tribunal order. Three months I got this time. Ivy got some anonymous letters after that while I were away.

I never had a lot of hostility from people in Nelson because – and I've always said this to Ivy and I think she agrees – had I gone in the army people would have been more critical about how I'd backed down, with me being known for so long as a pacifist.

The People Have Got Clean Hands

During my visit to Hartlepool in September 1974 I drove over to Durham one evening and parked the bus in the narrow road outside Pat MacIntyre's house.

I was carrying with me a message of good will from Derbyshire, where, earlier that spring, I had interviewed and photographed a councillor from the village of Clay Cross, David Skinner, brother of the now better-known Labour MP, the outspoken Dennis Skinner, "The Beast of Bolsover".

I had taken the bus to Clay Cross out of curiosity, for it was there that eleven rebel councillors of the all-Labour Urban District Council had led a rent strike against the Tory's 1972 Housing Finance Act – a protest that had escalated after the government decision to stop providing free milk for school children. This was the event that first thrust Mrs Thatcher into the public eye and also gave her the nickname "Thatcher Milk Snatcher".

At the time of my visit the Council was raising money under the 1963 Penny Rate Act in order to keep the milk flowing, an action which had caught the public imagination. Also their stand against the £1 a week council house rent increase had resulted in court action and, in the spring of 1974, it seemed likely that individual councillors would shortly be held accountable for their share of arrears totalling £120,000.

My meeting with David Skinner took place in his kitchen while he was having breakfast and opening his post, which, as it happens, included that day a letter of support from a Mrs Pat MacIntyre of Durham:

> You said all the things that many people including us feel about this rotten capitalist society. I have felt moved enough to write a song which I have dedicated to you in Clay Cross.
>
> My only published one is on a Spinners record, it's called *Kick The Cat*. All my other songs have been rejected because they were too political. We are like you in this house, we are rebels and militants. I do just a little in my way to commemorate your heroic stand on behalf not only of Clay Cross but of all of us.

> > Along came the Tories to the country one day,
> > They turned on the workers and this they did say:
> > "You're getting too strong,
> > "But it won't be for long,
> > "We're determined to smash you and we'll make you pay."

There were many verses including this one:

> > Along came old Thatcher in satin and silk,
> > Determined that she would put paid to school milk,
> > To fatten the rich
> > Was the aim of this b— Minister of Education,
> > But she didn't know Skinner and those of his ilk.

Pat MacIntyre

No record exists of what Pat and I discussed that September evening. All we remember is that I brought greetings from Clay Cross; that I sat at her table with her children and ate a tea of sausage and onions. But I did keep a transcript of her poem and she kept the photograph I took of her. It hangs on her living room wall to this day, framed.

In 1996, curious to see how her socialist principles had stood up to 18 years of Tory rule, I went with Alan Dein and his tape-recorder, to see Pat. Why, I asked her, had she written that letter of support to David Skinner?

PAT: I was very angry because, even pre-Thatcherism, you could see the signs of what was going to happen and I think, also, I was very pleased that people like Dennis and David Skinner were standing up. That somebody was saying: "This is wrong."

I'm a socialist. I've been a socialist all my life and I come from a socialist family. I've been a member of the Labour Party since I was old enough to join. My mother, 86 this year, is still agitating over in Stockton North constituency. My grandfather also was a socialist and a good trade unionist. I learned my politics very young and I've always tried to be active in politics. I realised that things were wrong when you have just a few people with a lot of power in the country and a lot of people with no power at all. I was so pleased that the Skinners stood up for the people who had no power at all.

Pat has suffered all her adult life from rheumatoid arthritis. When I first met her she was in a lot of pain and had been forced to abandon her career as a teacher. However, by the 1980s, advances in medicine had brought new medication and, supported by an understanding husband who did most of the domestic chores, she was gradually able to live a fuller, more active life; something she made the most of, taking herself off to study politics at university. Today she has a PhD. Doctor Pat MacIntyre. She has also notched up a long list of credits as a political activist.

PAT: The first campaign I was involved in was the anti-Youth Training Scheme (YTS) campaign. I am a member of the ILP – Independent Labour Publications,[48] a pressure group inside the Labour Party. The government was wanting to deregulate everything and young people were taken on at very cheap rates so that they would get used to low pay. They were at the mercy of a lot of cowboy employers and they weren't learning their trade unionism, as they would have done if they'd had proper apprenticeships. Also the health and safety aspect of YTS was something that grieved me – indeed all the stories about that have yet to be told; there were people who got killed, there were people who lost limbs – and these were only young people. We could see what was happening and we didn't like it.

And, looking back, I think we were justified. The end result of YTS was even worse than we predicted. What we now have is a diminution in trade unionism, much lower rates of pay than there should be, people are demoralised, people have very few rights at work.

And then of course in 1984 there was the miners' strike. We were involved from May of that year. I think when the miners' strike started none of us realised that it was going to go on for so long. But once the strike had been going for some months we started getting reports that people – particularly single men who were not getting any support from the State and also people with young families – were suffering considerable hardship. So my husband got a resolution passed in our constituency

saying that we would form a miners' support group. And we started from that.

At first we were just going round knocking at doors asking people for food. And our garage was used to store it. But soon we outgrew the garage. We started to get supplies from supermarkets and ultimately the big cash 'n' carry stores. By the end, we were dealing with importers, shippers. We found we had over a thousand mining families in the area and – between May 1984 and March '95 when the strike ended – we managed to get a weekly food parcel to about 800 of them.

We worked an 18-hour day. We hardly slept at all. There were only twelve of us involved on a daily basis, with another 50 or 60 people in the wider community who helped out from time to time. Over the nine months we raised £120,000, with another £20,000 in kind. We had cheese and butter from New Zealand; we even had help from America.

I had a great time during the strike. It was the most incredible year I've ever had. A wonderful time in one way, but it was a very sad time in another way. Obviously it was no fun for people who were starving – and believe me a lot of people really did go hungry – but there was a certain excitement in the solidarity people showed. Even when you were tired, you were also inspired by people who had discovered the joy in sharing and caring about other people.

The miners' strike made me even stronger against Thatcherism, because it made me realise what an evil, cruel woman she was to even contemplate closing down people's jobs. It isn't that going down the pit is a nice thing. It isn't. It's an awful thing, really, and I don't think even the miners were wedded to the idea of always working down the mines. But they were wedded to the idea of having a steady job. If you haven't got a steady job then you can't live a decent family life. The idea that a senior politician could quite deliberately do this as she did – it was all planned you know – struck me as terribly cruel.

And the strike was really a terrible failure. We failed. We failed to make enough people realise that once the miners' union had gone down the rest would follow. And it was a failure because the pits were closed.

But it wasn't a complete failure because so many people came together during that strike, there were so many alliances made among people and you learned who your friends were. That was the most important thing that I learned. People who I thought were good people, marvellous people often failed to support us when the crunch came.

But you're never at a loss for something to be against while the Tories are in power. There was the anti-Poll Tax campaign. And the anti-Gulf War campaign. (We were bothered about the smart bombs that weren't so smart.) And anti-water privatisation and anti-privatisation of the railways . . . I think everybody is against that – left, right and centre.

And I've kept writing the songs, you know. During the strike we had weekly socials and at one time I had to come up with a new song just about every week. So I would just write some doggerel and put it to familiar tunes.

There's a wonderful man up here, Mike Elliott – he's a prince of a man. He used to be a club comedian but – for the whole of 1984 to '85 the year of the miners' strike – he played gigs for free to raise money for the miners. He is one of my favourite people and I wrote a song for him called "PC-One-One-Five-Oh", which he recorded to the tune of "Bladon Races" and put on the album *Heroes* that was sold to raise money for the sacked miners.

The song was inspired by two stories. One was that people kept on seeing on picket lines – dressed up as policemen – lads who they knew were in the army. The other was the story of a lad who'd been given a lift to a picket line by what he thought were fellow pickets, only to discover that they were really soldiers in plain clothes and they beat him up.

> Oh me lads I'm PC one-one-five-oh,
> Tomorrow I'll be one-five-oh-one,
> Or maybe five-one-one-oh.
> Why does my number change so much?

I'll bet you'll never guess.
It's all protective cover for
The boys in the SAS.

In civvies we beat up this bloke
Who was going to the line,
He thought we were all pickets
So everything was fine.
But when we finally stopped the car,
He saw he was defenceless,
And all of us had lots of fun
Kicking him till he was senseless

Oh me lads I'm PC one-one-five-oh . . .

Today I'm one-one-five-oh,
And to Scunthorpe I am bound,
And tomorrow it might be Ravenscraig,
I'll turn me number round.
But to all who've crossed the picket line
We must extend our thanks,
If together we can't break the strike,
She'll have to send in tanks.

Oh me lads I'm PC one-one-five-oh . . .

At Durham University Pat studied under Huw Beynon[49] and the radical South African Ruth First.[50] She was inspired by her teachers.

PAT: My PhD began as *The Politics and Ideology of Labour in Durham 1900–1939*, but inevitably it ended up being about the miners' strike. University opened up all kinds of ideas for me – things I'd never thought about. New horizons. Absolutely wonderful.

After the strike we set up a Women Against Pit Closure group in Durham City and, because of all the international connections that nationally the movement had, we were invited to find a person to travel to various places. I was asked would I go to Chile? And I just said "Yes". It was 1985 and I went representing the National Union of Mineworkers. I had a letter of introduction from Arthur Scargill, and from the local branch secretary in Durham. I went to Lota, the mining area about 500 miles south of Santiago. There was a group of eight of us and we lived with our Chilean hosts.

No one prepared me for the poverty I saw in Chile. It's strange because it has a very old democracy but – since the coup in 1973 when Pinochet came to power – Chile had been moving towards monetarism and, as we have seen all over the world, the consequences of this are that the poor have got a whole lot poorer.

There were lots of people out of work. In the rural areas I saw people who hadn't the money to take their children to the doctors. The difference between the medical attention for the poor and the medical attention for the rich was obscene. Really obscene.

All over Santiago you'd see white handprints all over the walls. When I asked what it meant, they told me: "It means the people have got clean hands, but the government hasn't."

I went into prison while I was there, to visit people who were under sentence of death. In fact I actually smuggled something out of prison, for some nuns – not at all like our nuns, they wore T-shirts and jeans – who noticed that, because I'd accidentally been misdirected, I was searched four times over by the same prison guard. And they guessed that she wouldn't want to search me again. Anyway I was wearing a shirt with one little chest pocket and one of the nuns put a little flat folded piece of paper into it. And, just as the nuns had guessed, the prison guard who had already searched me so many times ignored me – just gave me a perfunctory pat – and out I went. Outside

somebody came up to me and asked had I got something for him and I took out the piece of paper and I handed it over.

And I went on the International Women's Day March. It was on the 8th of March, and in Santiago there is a river that runs right through its centre. And attached to it, on one side, is a park which had tennis courts and trees and a kindergarten school. And it was about five o'clock in the evening, a beautiful day. And only women and children were there, lots of them. And the Chilean women had loudspeaker packs on their backs and they were singing into microphones. And they were putting their arms round us and we were dancing round with them. All very peaceful. And then all of a sudden we saw some white smoke in the distance and somebody said to me in English: "Bombs!" And I thought, Dear me, I wonder what's coming next?

So we moved further away from them and then someone told me to start running. So I ran. And then smoke started coming from this little playground so we had to turn round and run back, and then, all of a sudden, I saw this little white van approaching alongside a fire brigade tender. And it was putting a very fine spray up into the air. And the van had a hole in the side with a tube coming out of it. And the next thing I knew we were all on the ground, because what they were doing was pumping a nerve gas through the water on to the marchers. And you went down, your legs went first, you felt as if you were going to be sick, you also felt as if your bowels were going to open. Horrible it was. And we were lying on the ground.

By this time the army had arrived and they were driving in among the women who were trying to get out of the way. Then they set the dogs on us.

I was just sitting in the gutter by this time feeling decidedly sick, and then suddenly there was a tap on my shoulder and I looked up and there was the most beautiful face I have ever seen. A woman. And she said to me: "You are with the British women?" I said, "Yes". She said: "You must come to my flat now." And she took me and several others up to her flat that was overlooking the park. And it turned out she was Joan Hara, the wife of Victor Hara, the guitarist who'd been murdered in the Santiago stadium.

What happened was that, as a left-winger, he'd been taken in for questioning and – to keep his spirits up as well as the spirits of the other prisoners – he'd got them all singing. So, when his turn came for interrogation he was called out in front of everyone, asked his name, told to put his hands on the bench and someone just chopped them off. But he kept singing and with his bloody stumps he started conducting the other prisoners in a song. So they shot him. Joan spent a long time looking among the bodies before she was able to identify his.

Joan is English, a dancer. And we stayed with her and it was there that I saw the most incredible sight I'd ever seen in my life. We were able to look down on the street and watch the demonstration breaking up. The rush-hour had started by now and the traffic chaos was amazing. Have you ever seen a film of a bullfight? That moment when the toreador has absolutely bamboozled the bull? And he turns his back on the bull and he trails his cloak on the ground? Well it was just like that; five women lined up across the road and walking slowly, slowly, slowly, with all the cars going slowly, slowly, slowly behind them. They held the street for a good long while and only stopped when *they* decided it was time to go.

Fantastic women! Fantastic. They were the bravest people that I have ever come across, because they could pay with their lives. I had a passport, I was coming out. They didn't, and they could have just been picked up any time and been disappeared. Which a lot of them were.

I cried when I came away.

Stefan Lorant and Tom Hopkinson, *Clarion*, the Independent Labour Party, *Weekly Illustrated*, *Lilliput*, *Picture Post*, Alan Dein, Stan Iveson, David Skinner, Pat MacIntyre, Professor Huw Beynon, now we have another name: Mike Hallett, my old tutor from Manchester Polytechnic and Stefan Lorant's biographer.

In April 2000 the Irish Gallery of Photography in Dublin showed, together and for the first time in the same space, my two exhibitions *National Portraits* and *National Portraits: Now & Then*. After a lecture in the gallery I invited questions from the floor and someone in the audience whom I could not see, but whose voice I recognised, spoke up. It was Mike Hallett, in Dublin for a sixtieth birthday treat organised by his wife Carol.

Afterwards, over a drink, he was telling me how he had only just arrived in town and stepped out of a taxi to find himself staring at a poster advertising my talk. Suddenly Carol, very excited, came to drag us back into the gallery where, almost speechless, she pointed at one of the *National Portraits*.

"It's Susie," she gasped. "Look. Susie and Peter!"

"Goodness!" said Mike. "I do believe you're right."

"Susie and Peter?" I asked.

"Susie Gatesy," said Mike. " Stefan Lorant's niece."

I Always Loved Pearls

Peter and Susie Gatesy, son and mother, originally photographed in Brighton.

1974 2000

Susie Gatesy lives in Malta where, in 1970, she and her late husband established the manufacturing base for what is now Toly Products, a group of companies specialising in luxury packaging for the cosmetics, fragrance and skin-care industries.

In the early summer of 2000 Mike and Carol Hallett were Susie's guests on a holiday in Malta and during that time they organised a reunion for us. And so it was that on 10 September, while Susie was on a brief visit to England, I was able to meet her again, with her son Peter, and take a new photograph.

SUSIE: We spent a lot of weekends on the south coast. I honestly don't remember the photograph being taken. But then at that time a lot of people used to be on the front taking snaps of one, and then giving you a little ticket saying "You can order it here". So I'm sorry, but I really don't remember.

MEADOWS: Did you come and collect the picture the next day?

SUSIE: No, I don't think we did.

MEADOWS: What do you think of the picture?

SUSIE: Well, I looked at some of your other photographs and I thought you could definitely tell they were the 1970s, whereas here I felt quite proud because I didn't feel that we were very dated. Perhaps Peter more so, with his striped pants, but as an eight-year-old it wasn't so conspicuous.

PETER: What way-out trousers I'm wearing!

MEADOWS: One of the things that interests me about those trousers is that they have a little patch on the knee. A badge, I think, but I can't quite make out what the logo is.

SUSIE: It's covering up a little hole.

PETER: I wouldn't have known it was taken in Brighton. But now that I know that, it does bring back memories of walking on the beach, picking up pebbles. And I do remember these clothes and I wouldn't be seen dead wearing them today!

MEADOWS (*to Susie*): You are wearing the same ring today as you were in the photograph – although on a different hand – and also the same pearls.

SUSIE: I am, the same pearls. My husband bought the pearls for me. I always loved pearls and he had them made up for me in two rows. The ring is like two rings locked into each other, a rope of gold with some platinum and tiny chips of diamonds. It has a strange story.

On our way to Malta in the early 'seventies we would travel through Europe by train, stopping at different places in Italy and outside Naples is a school where they teach the young lads to cut the cameos. Torre del Greco. And we went there and my husband loved jewellery. If he travelled on business he always bought me a piece of jewellery

back. And he was really quite insistent that he wanted to buy me something. I didn't like the look of cameos, I thought that was much more for the older person. I was quite young then. And he said: "We've got to buy something." And the students were also taught how to work in gold to set the cameos. And they had a small shop and an exhibition place. And this ring was done by one of their leading students, a one-off and it was just in the showcase to show how they were working in gold as well. And we fell for this ring. They didn't want to sell it to us, but my husband insisted.

Later on my husband found an Omega watch which has exactly the same rings. I've got it, but in Malta. An evening watch and it matches the ring.

I wear those kind of jumpers all through the winter, usually with a skirt. I don't often wear trousers these days, but down by the sea that was quite important.

It was just such a surprise when Michael came over to Malta and showed me the picture. We bought the flat in Hove in 1973. At that stage the children were old enough to have ruined any furniture we had in our flat in London and we wanted to change it. What do you do with second-hand furniture? It's quite useful to have a weekend place to put it into. That's why we bought the flat down there.

MEADOWS (*to Peter*): To what extent are you aware of the connection with Stefan Lorant and the part he plays in the photographic history of Great Britain?

PETER: A great deal. I didn't meet Stefan Lorant on many occasions, but the occasions I did meet him were family occasions and very close. I liked him. Stefan would always tell me lots of stories.

SUSIE: Peter's brother, Andy, only met Stefan on a few occasions, but Peter met him many times both in America and even once in Germany.

PETER: I was doing six months' work experience after school. I wanted to go and learn another language and I was working in the company in Germany. I took the night train down to Munich and we had two days together and there was nobody else and it was wonderful. He was so proud showing me what he knew. It was great. He took me to my first opera. He always remembered people's birthdays, he'd send a

postcard: *Dearest Peter, wishing you a very happy birthday.*

SUSIE: If ever there was something in the paper about him he would always send the cutting: "I thought you might be interested in this," "I thought you might be interested in that." And always the bit of paper that went with it was two inches by eight inches, a little strip, and half of it crossed through and re-done. I have quite a good collection of his books. Some of them belonged to my mother.

MEADOWS (*to Susie*): Tell me about your family. When did you come to England?

SUSIE: Stefan Lorant started *Picture Post* on 1 October 1938 and he had a lot of photographs and he wanted to build up a picture library. He wanted someone to run it he could trust and rely on. Who else but his brother, who was my father, Imre. Imre Lorant.

My father worked first in a bank in Hungary and then in some big car showroom, I'm not exactly sure what he did, but I think on the financial side. There was Stefan, there was Imre and there was a younger brother, George, who didn't take too much part in things. The two older brothers were very close, there was less than two years between them in age.

When my parents left Hungary I was three years old. That was in March 1939. It was originally just for a year, but war broke out in September 1939 and we were effectively stuck here. At least I was told that it was originally just for a year, but I know that we brought all our furniture out of Hungary, so it must have been thought about that we would stay for longer.

My mother used to say that she had to sit with me in nursery school [*in London*] because nobody could understand me and I couldn't understand them.

When Stefan left for America in 1940, my father didn't see any point in continuing at *Picture Post*. We lived quite close to where I am living today, in Hampstead, in a top-floor flat, and during the Blitz the roof was blown off. We were in the shelter of the house, but the furniture was out in the open and it was a question what to do. And we moved down to North Wales where we had a distant relative who said: "There's plenty

of accommodation, you can bring your furniture, you can live here and there's not going to be much sign of the war down here." And so we moved down.

It was a very big farmhouse. My mother used it as a guesthouse. My father then, within a year, joined the BBC, in the monitoring service which was in Evesham, at Wood Norton. He was in the Hungarian section. He spoke about six languages.

My mother had the guesthouse open only from May to September and during the winter she came up to Evesham. I was at boarding school in Bangor. In the summer term I was a weekly boarder, but in the winter terms I was a full boarder. I just came home to Evesham in the holidays. And then the monitoring service moved to Reading and my father moved with them. So, when I came out of boarding school I was at school in Reading. From the age of about 13 to 17 I was at the grammar school in Reading.

MEADOWS: Did you feel like a refugee?

SUSIE: No. Today I speak Hungarian fluently, but I didn't speak it as a child. I learned it from my husband after we got married in 1959. In Wales during the war, when I was five, I had learned to speak Welsh. Until I married a Hungarian I was quite a stranger to Hungarians, I was very English. But my mother, who died in 1992 at the age of 85, always had a very strong accent, although she'd been 50 years in this country. My husband had a strong accent, my brother had a strong accent, and Stefan never lost his accent of course. But nobody ever knew that I was anything but English.

After Reading, in 1951, I got a scholarship to come up to London to a trade school. I did fashion designing and pattern-cutting. A two-year course at Barratt Street Technical College. And the first year I travelled up every day from Reading, but it was at the time when there was a lot of fog and the trains used to get in late. So my parents decided that we'd get a flat, and, the second year of my college in London I lived in Chalk Farm with my mother, while my father, who anyway worked very unsocial hours, stayed in Reading and he would come up to be with us on his days off.

I finished college in 1952 and then I started working in the rag trade. I worked for seven years with a lingerie firm. The owner was Austrian and I was her sort-of right

hand. Today she's 93. She gave up the business, but I still see her regularly. She helped me a lot and she was a very dynamic lady who had also escaped from her country and started life afresh here and built up a tremendous business. I worked with her until after I was married.

My husband was called Zolly. His original name was Zoltan but he was known as Zolly and he changed his name officially. Zoltan was a very Hungarian name. He was a refugee from Hungary who came out to England in 1956. He was a tool-maker by profession. We met here in London.

At that time my father was very ill and I used to spend a lot of time with my parents in the evenings. And we would visit a nearby block of flats where there were quite a few Hungarians, including one who was my husband's partner. And my husband came across to borrow something while we were having coffee and that's how we met. We were married in March 1960.

As it happened my father died in September '59. I wouldn't contemplate leaving my mother on her own, and anyway we hadn't arranged to get married then. But my mother had a big flat and she said: "Look there's no reason why we couldn't share the flat if you want to get married." And we did and we lived with my mother for a year while we saved up to rent our own flat and get our own furniture. It was just down the road here. So I haven't moved very far, have I?

My husband knew his profession inside-out. At first he worked for another company, but only for six months, and then started on his own. So we had a tool-making business over here in London.

When we started out it was just the two of us. He was the tool-maker and his original partnership came apart and it was quite a shock. I don't really want to go into that too much, but we already had our own flat so we needed to have the up-keep and an income coming in. Nevertheless my husband said, "I'm starting off as quickly as I can."

One of our main customers was also making tools. Perhaps you know Airfix? Well,

we used to do a lot for the household division. When they found out that my husband had left the company and knowing that he was the technical person, they didn't want to carry on giving work to that company without him being there. So they phoned us at home and said: "We have a terribly urgent job and we need you to do it." I remember very clearly it was an egg tray for twelve eggs. And my husband said: "I've got no factory, no machinery, I can't possibly." "You have got to do it," said the technical director there. So my husband said: "Well, if you help us, we'll do what we can." And they advanced more than half the cost of the tooling and they said: "Go out, find premises and get going." And we were recommended to a firm in Maidenhead, Thicket's Corner, that was dealing in small machinery.

We had no background for finances – young married couple, just got our own flat – and we went down to this place for the machinery and we needed lathes, drills, surface grinders, and my husband explained that he needed a finance house to help him. And the man who sold us the machinery stood as our guarantor for the loan. We found out later that his own son, who was the same age as my husband, had recently got killed in a motorbike accident, and he had been hoping the son would take over the business. And he just clicked with my husband and he said: "I'll give you all the help I can because you look honest people, and if anything goes wrong I'll just take the machinery back." And that's how we started on our own. It was incredible. He just had great faith in us. He arranged for the hire purchase, we found a small premises in the back of a greengrocer shop in the Harrow Road and we started off there.

There were wooden floorboards, I remember, and when we put the machinery on them it nearly went through, but we were in such a hurry and we could only concrete it in stages. And we made the tool for the Airfix egg box. Airfix did a lot of things for Woolworth's: bowls and buckets, bigger things than we could cope with. We started off with the egg box. And then we started working for Airfix on the model kits side. We did an awful lot, also for Ravell. My husband used to get drawings of the original aircraft, ships and cars, because the models were all to scale.

Then we were on the tool-making side, but in due course we opened our own company, called Impact. It was the year that the film *Those Magnificent Men In Their Flying Machines* came out, and we did the model kits for that. The Blariot, the Gloster Gladiator, the Fury, the Avro bi-plane, the Avro tri-plane. I can't remember them all.

My husband thought: "If we've done all these kits for other people, why can't we do them for ourselves?" And it was very successful.

By now there were twelve people working for us. Quite a few Hungarians, because it was after '56 and the Hungarian tool-makers were really very clever and they'd heard that there was somebody starting up. And then we got two injection-moulding machines and the business grew.

We are now very much involved with cosmetic packaging. And we got into that because our company in those days was called AP Plastics – A for Andy, and P for Peter, my sons. And, of course, in the trade directories, it came right at the front of the list. And Revlon had been let down very badly by some tool-makers who had been contracted to produce a sedan chair to put some Christmas packaging in. The Revlon people looked up in the Yellow Pages and came to us to ask if we could finish the job and my husband said, "Yes".

He worked day and night and made this sedan chair, and everything was ready for Christmas. From then on we were in the cosmetic world. We couldn't find too many staff at that stage and it was very expensive to get bigger premises. So my husband went to seek in areas where there was a lot of unemployment. To Ireland and to Wales. And our accountant at the time, a friend, went to Malta where they were trying to build up industry and there were a lot of advantages. It was 1968. So my husband and his lawyer went over to see what the situation was. He quite liked the idea because new factories were being built and then he was allocated one and we started there in 1970.

My sons were both at school in England, at Highgate School. It was a boarding school, but they went as day boys. So we stayed in the Hampstead flat in the term time and only lived in Malta during the summer holidays and Easter holidays, but

not always at Christmas, because the boys liked to be here with their friends.

Today our main thing is colour cosmetics for eye-shadow boxes, face-powders, solid powder, wet-and-dry. We also do caps and collars for perfume bottles. Chanel is one of our biggest customers today – in North America we provide 85 per cent of the plastic which is used. In the Coco Chanel range, for example, you don't see the perfume, you just see the black casing. We do all that. And Chanel's main centres are New York and Paris. We do a lot for the French, but not as much as we do for the American side.

We still have the tool-making base here in England. We have moved from Harrow Road and we now have a factory in the Wembley Arena area. All the research and development is done here for the new customers. The trials are made here, but not the production. Then it goes over as a package to Malta where it goes on the production line. In London I think we have between 35 and 50 employees. We also have a second tool room in Windsor.

My husband unfortunately died in '91 – he'd been very ill for a long time – and Andy, my older son – who had done mechanical engineering at Nottingham University followed by an MBA at the City – he was always very interested to go into the business. Andy today is our chairman and overall head of the company world-wide – and I say world-wide because the marketing is done through our own Toly offices in New York, Paris, London, and Holland, and we have agents in other parts of the world. Andy is only 36, but he runs the whole thing. He fell into it and just had to swim or sink.

It's really very sad that my husband died when he did because he had an awful lot to live for and he worked so hard. He had major heart surgery in 1979. Andy was 15 and Peter was 13 and they hadn't finished school and my husband had five by-passes. They thought he wouldn't make it and it was a question: "What are we going to do about the business?" It was nowhere as big as it is now, even though we had Malta already. And the boys sat together at that age and said: "Please try and hang on, because we are both very interested to come into the business." So we did hang on. And now Andy runs it and Peter is more involved here in London.

Peter's more on the technical side, and Andy is more on the management side. Peter did more technical school rather than university, but he did live in Malta for about ten years. In fact he came into the business earlier than Andy did, because Andy was doing his MBA. But Peter has not been very well, he had major surgery about six years ago and it slowed him down a lot. Peter is based in our London office now.

My husband wanted me to be overall in charge of the Malta set-up, but I take a back seat now. I have to know what's going on. I never went every day. I just did more of the socialising, showing people round and so on. But now I don't do too much of that because Andy is married to a Maltese girl and she does most of that. I would still like to do it, but I am no longer in that position. I am semi-retired. But I have to take part in all the board meetings and so on. I really like to know what's going on.

The Bus Snapped its Crank

I sold the bus in spring 1975 to a group of train-spotters: the Tameside Railway Society. Their wives were fed up with being left at home, and they wanted a bus so that they could take their families with them to do a spot of sightseeing and shopping every time they had "a bit of a set-off". They were a nice bunch.

I met them again four years later while I was working as a television researcher. We used to make short films to fill the slot vacated when the main evening magazine programme went off air during the summer holidays. In 1979 we did a series about people's hobbies and my report was on the Tameside Railway Society. That was the last I saw of them and the last time I drove the bus. They wanted me to. For old time's sake.

Then, sometime in the early 1980s, the bus's crankshaft snapped and it was left to languish in a run-down mill near Oldham, gathering dust and pigeon droppings.

In due course it was bought by the Birmingham and Midland Museum of Transport at Wythall, near Birmingham. My bus was thought to be the last remaining model of its class and type. The museum has open days during the summer months so, on payment of a small fee, you can go and see it.[51] Say hello from me.

Restoration is a slow process, not least because the museum has little money and the work is done by volunteers in their spare time. The engine has been repaired and rebuilt, but the task of restoring the bodywork, both inside and out, has yet to begin.

When I met the dedicated restorers of JRR 404, they knew all about its horse-power and the engine type, its transmission and its leaf-spring suspension, its transfers, vacuum-actuated drum brakes and the service number (473). But none of them knew about its experiment with alternative living, its unwritten history, when it tried to

change the world, dropped out, did its own thing, and became for a brief twinkling moment the Free Photographic Omnibus.

They were glad to find out, though, because it explained how the lining of the ceiling upstairs near the back had been torn.

You see, once this hippie took out all the seats, made a partition, and built a darkroom . . .

Daddy of This Job

After the bus. December, 1976. The first snow on the ground and I photographed Cyril killing his pigs.

Cyril, a tenant farmer with a few acres in the Yorkshire Pennines, reared pigs and killed them each Christmas. I remember the big sow. She weighed 30 stone. They tied her, rolled her on her back on the killing stool. It took four men to hold her down. With a curly knife Cyril slit her throat and, in rhythmic jets, her heart pumped her blood out into a bucket.

Cyril's wife, Elsie, made the best black pudding in the county. Boiled rice, chopped onion, sage, seasoning, a few breadcrumbs and, of course, the blood – all baked in the oven. "For a few hours," said Elsie. "No special recipe."

The men scalded the skin with boiling water and scraped off the sow's hair. Barber, barber, shave a pig. Everett, the old butcher, then cut out her eyes. They hung her from the beams of the outhouse and butchered her, split her down the middle. They cut off her head, sliced away her cheeks for curing and used the rest for brawn. Thirty-six yards of sausage skins they got out of her. Twelve 16-pound buckets of lard. And millet, and mijorim craps and the lace fat off the belly. Such words. "The only thing that's wasted with a pig," said Elsie, "is its squeal."

The hams and the flitches were salted, rubbed till they sweated and then sprinkled with brown sugar. Saltpetre was pushed into the shoulder bone. Spare rib hung up. Three weeks passed. Then, with the curing well under way, they softened the flitches by pounding them on the kitchen table – Cyril swinging the mallet above his head – until they were curled into a roll a foot in diameter and four feet long, like lino. They twitched up the rolls with a picking stick and secured them with bands of string every six inches.

"We're the daddy of this job," Cyril said at the end of the day when he stood back and looked at the hams and the rolled flitches hanging in his kitchen. "There's not so many do it now. They kill the pigs in a factory, too small, and just dip the bacon in brine. Inoculate it with chemicals. Everybody used to be proud of their bacon pig hung up and they used to regard them as pictures. Yes, we used to call them pictures."

The pig is a picture.

You should know what you are looking at.

NOTES

1 The Who, "Magic Bus" reached number 26 in the charts in October 1968.

2 *Summer Holiday* (1962) directed by Peter Yates.

3 Extract from an article by Ray Harris in the *Independent*, 31 May 1995.

4 Christopher Ward, *Daily Mirror*, 2 August 1974.

5 *Living Like This* at London's Institute of Contemporary Arts, October 1975, and *Living Like This* (Arrow Books, 1975).

6 Gordon MacDonald in the *British Journal of Photography* (5 August 1998, p. 13):

"Among the foremost events of the Arles diary are the spectacular large-scale slide shows held in the théâtre Antique. This picturesque Roman amphitheatre has been converted with plastic chairs and a gigantic screen: like a prop from *Thunderbirds* it is lifted hydraulically before each performance and lowered at the end. The shows are computer driven and have a smoothness and rhythm between still and moving visuals and sound which would be unobtainable with regular slide projection and sound equipment. The events are not simply photography shows, there is real emotion and atmosphere surrounding these nights.

"The most talked about, and popular, of these this year was *Les Anglais vus par les Anglais* which would more realistically be named the British look at the British, such is the mix. The show was neatly intercut between well-established photographers, Martin Parr, Anna Fox, Paul Seawright, Daniel Meadows, Mark Power and Paul Reas, and relative newcomers Rebecca Lewis, Clare Strand, Hannah Starkey and Chris Harrison, among others. The images were punctuated by neat graphics and cuts from British TV commercials and pop videos, most notably The Verve's *Bitter Sweet Symphony*, and one was left with a feeling of the great cultural richness of Britain.

"The universally acclaimed piece of work in *Les Anglais* was Daniel Meadows'

Free Photographic Omnibus, portraits taken between 1973 and 1974 on the streets of several English towns; a more precise record of the faces and fashions of a time is hard to imagine. These are the images which opened the show and the reaction of the audience was tangible."

7 *British Journal of Photography*, 9 September 1998, p. 17.

8 William Stott, *Documentary Expression and Thirties America* (University of Chicago Press, 1986, Preface pp. x, xi).

9 Ibid. p. 49.

10 Ibid. p. 18.

11 James Agee and Walker Evans, *Let Us Now Praise Famous Men* (Houghton Mifflin, 1941).

12 Published in A. D. Coleman's collection *Depth of Field, Essays On Photography, Mass Media, and Lens Culture* (University of New Mexico Press, 1998).

13 Belinda Rathbone, *Walker Evans* (Houghton Mifflin, 1995, p. 140).

14 Ibid. p. 136.

15 Walter McQuade, "Visual Clues To Who We Were, And Are" (*Life*, 5 March 1971, p. 12).

16 Simon Armitage, *All Points North* (Penguin, 1999).

17 John Szarkowski, *Walker Evans*, exhibition catalogue (New York Museum of Modern Art, 1971, p. 20).

18 William Eggleston, *The Democratic Forest* (Doubleday, 1989).

19 Nan Goldin, *Ballad of Sexual Dependency* (Aperture, 1986).

20 Nick Waplington, *Living Room* (Cornerhouse, Manchester 1991).

21 Richard Billingham, *Ray's A Laugh* (Scalo, Zurich, 1996).

22 Debbie in marketing at Levi's Northampton tells me Levi's didn't begin selling T-shirts over the counter until the 1990s. Before then all Levi's T-shirts were "specials" – this one would be a collector's item today.

23 I came across this in poet Adrian Mitchell's introduction to *Greatest Hits* (Bloodaxe Books, 1991, p. 11). He is talking about a writer's responsibility to his audience:

"I try to work out if they'll understand what I've written. Otherwise, if I only considered my own understanding, I could write: '24 Rainbow Woods marched on 3 Monkton Combe' and nobody but me would know that 24 is lucky and 3 is unlucky, that Rainbow Woods were Heaven to me and Monkton Combe stood for Hell."

24 Neil Ferguson, *English Weather* (Victor Gollancz, 1996, p. 55). Neil Ferguson is keen to make clear that these sentiments belong to a fictional character and not necessarily to the author.

25 From a live interview on BBC Radio 4's *Midweek*, 26 February 1997, following publication of pictures from *National Portraits* in the *Guardian Weekend*.

26 Extract from an article by David Brittain published in *Dazed & Confused* magazine (No. 59, October 1999).

27 Richard Neville, *Play Power* (Jonathan Cape, 1970, p. 263).

28 Ibid.

29 Julian Colbeck, a musician and resident of California, is the only person from my school days with whom I still keep in touch.

30 *The Face*, 16 May 1998, p. 195.

31 *The British Journal of Photography*, 31 October 1975, Volume 122 No. 6015, p. 984.

32 Richard Allen, *Boot Boys* (New English Library, 1971.)

33 Ibid. pp. 14 & 15, the commencement of chapter two.

34 This is an extract from my interview with Phil Tickle, on 11 April 1996, for the BBC Radio 4 documentary *Living Like This*. Alan Dein made the recording.

35 The Scottish pop group the Bay City Rollers made their chart debut in September 1971 with "Keep on Dancing", but it wasn't until February 1974 with "Remember (Sha-La-La-La)" and its top-five follow-ups "Shang-a-Lang", "Summerlove Sensation", and "All of Me Loves All of You" that they caught the imagination of the nation's teeny-boppers. "Bye Bye Baby" was at number one for six weeks in 1975.

36 Deep Purple: a British heavy metal band whose definitive five-piece line-up, circa

1975, included vocalist Ian Gillan, bassist Roger Glover and lead guitar Ritchie Blackmore. The band broke up in 1976, but has since enjoyed a number of revivals with several different line-ups. In the picture, David Balderstone (*right*) is carrying what was then the band's latest album (their eighth), *Burn*, released in February 1974. It reached number three in the album chart. Deep Purple's riff-heavy hit singles include "Black Night" (1970) and "Smoke On The Water" (1972), which was also a top-five hit in America.

37 Tommy Docherty, manager of Manchester United 1973–77, was Scottish and had brought with him to the club a number of Scottish players including Lou Macari and Alex Forsyth. At this time Manchester United fans dressed in tartan and were known as Doc's Army. The history of this particular supporters' jacket is uncertain. I have subsequently discovered that it is unlikely to have been an item of official merchandise since the Manchester United museum has none in its collection.

38 Reference to British Olympic horseman Harvey Smith, famous for making an obscene gesture.

39 Daniel Meadows, *Living Like This* (Arrow, 1975, p. 114).

40 Hartlepool *Mail*, 5 October 1998.

41 Hartlepool *Mail*, 21 October 1998.

42 This turns out to be a rural myth as Debbie later explained in an e-mail dated 29 September 2000. "I was chatting to some people at a Labour Party meeting the other day and I found out the truth about Sunburst Close and the neighbouring streets. Nobody knows where the Sunburst Commodity Trading theory came from, but it's completely wrong. The estate is called Cherry Orchard as it is built on the site of a cherry orchard. Sunburst, Merchant, Roundel, Napoleon and Stella are all types of cherries. So there you go."

43 *Changing Faces* made by Florian Beck and Christian Schnelting, broadcast 21 August 1997.

44 *Look at Me*, a British Council touring exhibition curated by Val Williams and Brett

Rogers (catalogue published by the British Council and written by Williams) began its international tour at the Kunsthal Rotterdam in May 1998. It then travelled to the Trussardi in Milan; the Centre for Contemporary Arts in Warsaw; the Mali Manezh in Moscow; to Estonia; Tallinn; Copenhagen; Pamplona; Salamanca; and finally, during the Fotofo Festival of Photography, to the House of Art in Bratislava, where, in November 2000, I accompanied it and gave a lecture about *Now & Then*.

45 John Berger, *Ways of Seeing* (BBC/Penguin, 1972).

46 *Dazed & Confused*, No. 61 (December 1999).

47 Track off Rod Stewart's second solo album *Every Picture Tells a Story*, 1971.

48 The initials live on even though the party no longer exists. "Oh you know Stan Iveson, then?" she said. "He's dead now of course. Wonderful man."

49 Huw Beynon was later to become Professor of Sociology at the University of Manchester. A historian of the structure of labour movements and industrial organisations, he is best known to photography-lovers for the book he produced in collaboration with Nick Hedges, *Born To Work – Images of Factory Life* (Pluto Press 1982). Today he teaches at Cardiff University. Indeed I park my car outside his office most days of the week.

50 In 1982, while living in exile in Mozambique, Ruth First was assassinated by a letter bomb destined for her communist husband Joe Slovo, the former head of ANC military operations.

51 Or you can visit their website at www.bammot.org.uk, where it is listed as "exotica", under "other" and "rare".

APPENDIX

Ten Thousand Miles

The Itinerary of the Free Photographic Omnibus

YORKSHIRE

22 September – 4 November 1973: York; Selby; Silverwood Colliery; Goole; Doncaster; Sheffield; Attercliffe; Leeds; Huddersfield; Ripponden; Sowerby; Bradford; Baildon; Keighley; Bingley; Middleham; Todmorden; Middlesbrough; Staithes; Scarborough; Lebberston.

THE MIDLANDS

28 November 1973 – 20 March 1974: Nottingham; Market Harborough; Wellingborough; Goyt Valley; Clay Cross; Kimberley; Stoke-on-Trent; Shrewsbury; Telford; Bakewell; Burton-on-Trent; West Bromwich; Wednesbury; Cradley Heath; Stratford-on-Avon; Malvern; Blists Hill.

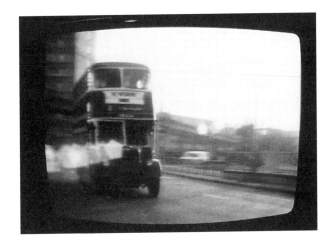

THE SOUTH

26 April – 7 June 1974: Portsmouth; Emsworth; Shoreham-by-Sea; West Lavington; Devizes; Chippenham; Oxford; Southampton; Staplefield; Brighton; Horsham; and Epsom for the Derby.

GREAT WASHBOURNE

1–14 July 1974 where, with the exception of my own family, I photographed everyone who lived in the village.

DORSET

15–28 July 1974, Weymouth.

CORNWALL

7 August 1974, Newlyn Fish Dock. (I took a few days off at the beginning of August to go fishing with two of my former tutors from college.)

NORFOLK

14–?? August 1974. Here the record is incomplete. Certainly I visited Fakenham; King's Lynn; Walsingham and Binham, but the caption sheets for the remaining days of the visit are blank or missing.

THE NORTH (I)

9 September – 28 September 1974: Bowness-on-Solway; Haltwhistle; Newcastle-upon-Tyne; Hartlepool; Backworth; Easington; Darlington; Alwinton; Lindisfarne.

THE NORTH (II)

14 October – 2 November 1974: Workington; Barrow-in-Furness.

Also visited and photographed during the year:

Hulme (February 1974); Marbles Championship at Crawley,[*] Sussex (Good Friday 1974); Bacup Britannia Coconut Dancers,[*] Lancashire (Easter Saturday 1974); Frampton-on-Severn Elver-eating Competition[*] and Heythrop Hunt point-to-point,[*] Gloucestershire (Easter Monday 1974); Penrith Avenue, Sale (19–22 April 1974);[†] my sister Diana's wedding, Dumbleton, Worcestershire (19 May 1974); Heptonstall Fête,[*] Yorkshire (30 June 1974); the Royal Agricultural Show,[*] Stoneleigh, Warwickshire (1 July 1974).

The gaps between trips were spent in Manchester where I used the polytechnic's facilities to plan the next leg of the journey and to make sets of prints to fulfil obligations to my various sponsoring organisations.

[*] Events marked with an asterisk were photographed during a visit without the bus. Either I hitch-hiked, travelled with friends, took public transport or went by car.

[†] This was done for its publicity value. The *Sunday Times* had sponsored the project and wanted to report something exclusively. Ever ambitious I tried to repeat a project Martin Parr and I had completed the previous year in June Street, Salford, where we had photographed, seated in their front rooms, everyone who lived in a street that had once been used for the filming of Granada TV's soap opera *Coronation Street*. This time, though, because it was a "middle class suburb" I would shoot in colour. In the event Penrith Avenue proved too much for my limited skills. Too many of the residents were unimpressed with the bus and the colour pictures proved too costly to make. The article, however, appeared and was given a prominent slot, with a picture of the bus printed across five columns along with an article by Chris Ryder under the headline PENRITH AVENUE SAYS CHEESE FOR POSTERITY.

ACKNOWLEDGEMENTS

The Free Photographic Omnibus didn't just happen. As a non-commercial venture with its heart set against the worst excesses of the free-market economy, it has always swum against the tide and has frequently been derided as eccentric or written off as inconsequential. It has needed the support of friends and enthusiasts and now is the time to thank them all publicly.

Some climbed on board almost 30 years ago. Val Williams, for instance, whose unflagging energy ensured that the *National Portraits* touring exhibition of 1997, along with its accompanying catalogue, not only happened but were noticed far and wide. She above all others has helped me to understand my own pictures. Also with a ticket-to-ride in the 1970s were The Arts Council of England (of "Great Britain" then) – which gave the project two awards (1973/4) and also a publications grant (1997) – and Royal & Sun Alliance Insurance (then Sun Alliance and London Insurance Group Ltd) who, in the first instance, supplied free motor insurance for a 21-year-old student with an endorsement on his licence to drive a seven-ton public service vehicle, and later paid for the printing and framing of *National Portraits*. It was support without which the project would never have happened.

Others bought a ticket for the virtual ride of the Free Photographic Omnibus. Foremost among these is Alan Dein who discovered the bus in the early 1990s and ever since has donated his time and his tape-recorder to helping me interview many of those whose stories are told here. My friendship with Alan has deepened with the years and has been one of the great blessings of the project. Some of the interviews we have done together (most notably those with Molly Gower and Phil Tickle) were commissioned in 1996 by Mark Burman of the BBC for a Radio 4 documentary also called *Living Like This* and I owe a big thank you to Mark for allowing me to reproduce them here.

Also fuelling the bus in the 1990s were Simon Grennan of Viewpoint Gallery in Salford who had the imagination and energy to commission and tour the *National Portraits* exhibition – his unquestioning faith in the idea was vital, together with his infallible knack of writing successful grant applications – and Greg Hobson at the National Museum of Photography, Film and Television in Bradford who expanded *National Portraits* so that it would fill a major venue.

When it came to mounting the *Now & Then* exhibition, I did the organisation myself, but it would never have happened had not Hannu Vanhanen of Tampere University in Finland commissioned its first showing for the Backlight festival in October 1999 and it would never have toured had not others given their time and energy to it: Alessandra Capodacqua and Martino Marangoni in Florence; Roseleyne Bergé-Sarthou and Joëlle Noguere of L'Association Photographie E, Tarbes in France; Tanya Kiang of the Gallery of Photography in Dublin – who with imagination and feeling hung *Now & Then* alongside *National Portraits* for the first time; Vlada Kuznetsova, Lucian Perkins and Bill Swersey who invited me to Russia to present *Photobus* at InterFoto Moscow 2000, and also Lynne Wealleans of Photofusion who launched *The Bus* in London in the spring of 2001.

Work on this book could not have taken place without the support of colleagues in the School of Journalism, Media and Cultural Studies at Cardiff University where I teach photography and digital storytelling; the encouragement of Professor John Hartley (now Dean at the Faculty of Arts, Queensland University of Technology in Australia) who helped me to see the research value of this work and who also sponsored me for a spell of sabbatical study in 1998/9, was particularly important; also that of Professor Terry Threadgold, supervisor of my studies. Another colleague and champion has been my dear friend Colin Jacobson, editor of *Reportage* (www.reportage.org), with whom I have travelled widely teaching photography workshops – mostly in Eastern Europe – earning from the British Council, the Reuters Foundation and *Gazeta Wyborcza* the money I needed to take me back to Barrow-in-Furness and Hartlepool.

As the work of revisiting those I first photographed in the 1970s expanded into

writing as well as picture-making, I needed yet more help. Especially kind was Pedro Meyer, founder of the Mexican website www.zonezero.com, with whom I have enjoyed a long relationship developed through hours of e-mail duelling. In 1996, Pedro published on his site my first article on the new work, a piece about the "Boot Boys" of Barrow-in-Furness, some of which I have re-worked here. Thanks are also due to Liz Jobey of *Granta* who commissioned a return trip to Southampton, and whose meticulous editing of almost 40 pages of *Then & Now* pictures and stories for publication in December 1999 showed me the appeal these tales have for a wider audience.

Thanks also to my former tutor at Manchester Polytechnic, Mike Hallett, and his wife Carol, who facilitated my reunion with Susie and Peter Gatesy; and also to David Brittain, editor of *DPICT* (formerly *Creative Camera*) who championed *Now & Then* in the pages of *Dazed & Confused*.

The publication here of photographs, newspaper clippings, extracts from songs, novels, broadcasts, private letters, e-mails and faxes, all take place with the permission of their authors. Thank you to Joe McKenna, Libby Purves, Gordon MacDonald, Julian Colbeck, Neil Ferguson, Pat MacIntyre, Scott Wicking, Martin Parr and Ray Harris; and also to the *Independent* newspaper and the editors of the North West *Evening Mail*, the *Hartlepool Mail*, and the *Southern Daily Echo*.

Also thank you to my publisher, The Harvill Press, especially Christopher MacLehose, who showed up at my house one day in February 2000 offering to turn an idea into a book; and to my editor Ian Pindar who has painstakingly shaped a coherent work out of this crazy jigsaw puzzle of a project and repeatedly saved me from myself with tact and patience.

But the people to whom this book belongs are the ones in it; to them goes the biggest "thank you" of all. You are the real heroes.

DANIEL MEADOWS
Wales, 2001

If you were photographed by the Free Photographic Omnibus
between 1973 and 1974 and would like to be re-photographed
please contact the author via the Photobus website:
www.photobus.co.uk
Daniel Meadows is always happy to hear
from those he has photographed.

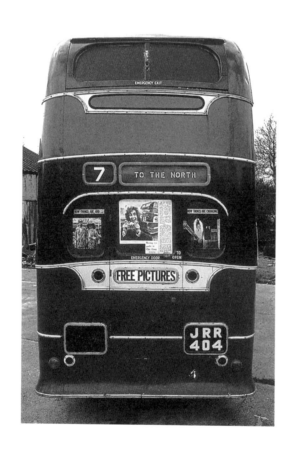